Sarah Kent studied painting at the Sl[...] was active as an artist until 1977 wh[...] exhibitions at the Institute of Conte[...] Until then she also worked as a part-t[...] and for London University Extra-Mu[...] Higher Diploma in Art Education at t[...] ...ucation, London University and gained an MA in the history of art at University College, London. Her career as a critic began in 1974 when she was invited to review exhibitions for *Studio International*. She is now Visual Arts Editor of *Time Out* and *20/20* magazines and also writes for *Art in America* and *Contemporanea*. She appears on TV and radio, contributing regularly to *Kaleidoscope* (BBC) and *Meridian* (World Service). She has written numerous catalogues, contributed essays to *Lichtbildnisse* (Rheinland Verlag, 1982); *Fotografie als Kunst, Kunst als Fotografie* (Dumont, 1979); *Elisabeth Frink: Sculpture* (Harpvale, 1984) and *Jacqueline Morreau: Drawings and Graphics* (Scarecrow Press, 1986) and edited *Berlin a Critical View: Ugly Realism 20s-70s* (ICA/Berliner Festspiele GmbH, 1978). She is struggling to complete a book on English artists for Faber & Faber and also takes photographs.

Jacqueline Morreau was one of the organisers on the exhibition *Women's Images of Men*. She was born in Wisconsin, U.S.A., was educated in California and moved to England in 1972. She has contributed to many other women's initiatives, including *Power Plays* with Marisa Rueda and Sue Coe, and *Pandora's Box*, the exhibition which arose from *Women's Images of Men*. She has written and lectured widely on women's work. Her most recent exhibitions include *Myth and Metaphor*, a retrospective originating in Hull, shown in part at Odette Gilbert Gallery who now represent her. A volume of her work was published in 1976 by Scarecrow Press, New Jersey, and a catalogue, *Myth and Metaphor* in 1989, to accompany the exhibitions.

Lill-Ann Chepstow-Lusty, *Lovable Nuts*, photograph, 1978

Women's Images of Men
Editors: Sarah Kent &
Jacqueline Morreau

PANDORA

LONDON BOSTON SYDNEY WELLINGTON

First published in 1985 by Writers and Readers Publishing Cooperative Society Ltd.

Published by Pandora Press, an imprint of the Trade Division of Unwin Hyman Ltd, in 1990.

PANDORA PRESS
Unwin Hyman Limited
15/17 Broadwick Street, London W1V 1FP

Unwin Hyman Inc
8 Winchester Place, Winchester, MA 01890

Allen & Unwin Australia Pty Ltd
P.O. Box 764, 8 Napier Street, North Sydney, NSW 2060

Allen & Unwin NZ Ltd
(in association with the Port Nicholson Press)
Compusales Building, 75 Ghuznee Street, Wellington, New Zealand

British Library Cataloguing in Publication data
Women's images of men
1. Men. Attitudes to women
I. Kent, Sarah, *1941-* II. Morreau, Jacqueline, *1929-*
305.3'1

ISBN 0-04-440461-1

Typeset by Windhorse 01 981 1407
Printed in Great Britain by The Bath Press, Avon.

This book has been published with a subsidy from the Arts Council of Great Britain.

Notes on Contributors

Joyce Agee was born in the U.S.A.. She was one of the four women responsible for the conception and administration of the exhibition *Women's Images of Men* in which she also exhibited. In Australia she has continued to work as a freelance photographer for film, TV and magazines. At the same time, she has continued to exhibit work and curate exhibitions including *The Naked Male*, ten women photographers on the theme of the male nude, *Stills Alive*, the first exhibition on contemporary Victorian photography for the Australian Bicentennial.

Gertrude Elias was born and educated in Vienna. She emigrated to England in 1938 where she worked as a graphic designer and illustrator for many publishers such as Bodley Head and Collins and contributed cartoons and articles to political journals. Her own cartoon series are in the collection of the British Museum and the Victoria and Albert Museum. She organised some of the first political/feminist shows in England, *The World As We See It* in 1976 and 1978, as well as a documentary exhibition *One Hundred and Fifty Years of Women's Contribution to Liberation of Humanity*, in 1982, which toured extensively, including Edinburgh and London. She has just completed her autobiography.

Catherine Elwes was born in France. She was one of the organisers of *Women's Images of Men*, and of *About Time*. She is one of Britain's best-known feminist video artists. She is also a writer, critic and theorist on video art with a special interest in women's work. She has recently selected and introduced a programme of women's work for the *Video Positive '89 Festival*. She is currently making *Three Seasons*, three short pieces for Channel Four television. She is a lecturer at Coventry Polytechnic and a member of the Arts Council of Great Britain film and video panel. Her work is distributed by London Video Access.

Susan Hiller was born in the U.S.A. and studied at Smith College and Tulane University. After anthropological field work in Central America, she came to Europe at the end of the sixties, living in France and England, with long periods of travel in North Africa, India and the Far East. Since 1973, she has lived, worked and taught in London and has exhibited widely. She is represented by Pat Hearn Gallery, New York.

Sarah Kent see note on editors.

Jacqueline Morreau see note on editors.

Roszika Parker was co-editor with Griselda Pollock of *Old Mistresses: Women, Art and Ideology*, 1981, and *Framing Feminism*, 1987. She is author of *The Subversive Stitch: Embroidery and the Making of the Feminine*, 1984. She was one of the original members of the *Spare Rib* collective and worked with them from 1972 to 1980. She has since trained as a psychotherapist and is currently in practice in London.

Pat Whiteread was born in Cheshire, England. She was one of the four organisers of *Women's Images of Men*. Since 1973 her work has focused on the impact of science and technology on the environment, and the effects of that environment on the inhabitants. Her most recent slide/tape at the Camden Arts Centre, *Zero Survivability Situation*, continues her examination of the language as well as of the imagery used to camouflage potentially disastrous governmental and technological initiatives.

Contents

Pat Whiteread, Joyce Agee, Jacqueline Morreau and Catherine Elwes worked together for two years to organise and select the exhibition *Women's Images of Men*. Each brought to the task different perspectives and abilities. The considerable work was justified by the exhibition's popular appeal, its controversial critical reception, the continuing interest in the exhibition and its ideas, and the publication of this book!

We would like to thank the original organising committee which included, besides Jacqueline Morreau, Joyce Agee, Catherine Elwes, Pat Whiteread and all those who have helped to make this book possible. First and foremost are the artists and writers who have contributed their work, time and advice to the book; and all those others who gave their efforts to the success of the original exhibition particularly Zoe De Ropp Weinmann, Deborah Law and Lisa Tickner who helped with the organising and/or selection; and to Sandy Nairne of the Institute of Contemporary Arts, London for mounting the show and organising its tour.

We must also thank Frances Borzello for her help in shaping the final form of the first printing of the book and Ram Ahronov, Lisa Appignanesi, Frankie Finn, Patrick Morreau and Naomi Pfeffer for reading the manuscripts at various stages and making valuable suggestions.

The Arts Council of Great Britain deserves recognition not only for their financial assistance in the publication of this book, but also for their support of many of the venues to which the exhibition toured. Thanks are especially due to Glenn Thompson for persuading us to embark on the book, through his insistence that these ideas should reach a wider public.

We are grateful to *Spare Rib* for permission to reprint 'Women's Images of Men' by Rozsika Parker and to *Art Link* for permission to reprint Susan Hiller's talk 'I don't care what its called'. We should also mention those who are carrying some of our efforts on into the future especially Mouse Katz, Gill Calvert and Jill Morgan who have organised the exhibition *Pandora's Box*, a worthy successor to *Women's Images of Men*, and the many organisations which have sprung up following this example such as *Women's Eye* founded by Gill Connacher, Rosemarie McGoldrick, Dee Jackson et al.

Our apologies go to all those whose work was not included due to lack of space or of an appropriate context, and our especial thanks to our families and friends for their help and patience during the long gestation of this book.

Sarah Kent and Jacqueline Morreau, October 1984

Preface

It's now more than four years since *Women's Images of Men* was first published and nearly ten since the exhibition that inspired the book opened in London at the Institute of Contemporary Arts. Both events are part of history, then, but in order not to allow them and the issues which they raised to fade from view, it seems worthwhile to reprint the book in its original form, without introducing new material or making any changes.

In the meantime, of course, the climate of opinion has altered considerably and updating the text would have meant completely rewriting it — drafting a new volume that would encapsulate the present situation, rather than retaining the arguments of the original. Better, we felt, to leave the book intact as the record of a particular historical moment and the concerns that were uppermost in people's minds at the time. It is hard to recall the atmosphere in 1980 and to comprehend how a theme show of figurative work by women artists could have seemed such a foolhardy enterprise. But it challenged numerous, deeply entrenched prejudices. Theme shows were thought to demean the artists by minimising individual contributions and so were deemed appropriate for educational purposes only. Now the didactic exhibition is valued as a useful vehicle for presenting ideas, is commonly employed in public venues like the Hayward, Serpentine and ICA and appears in commercial galleries as well. The nude male, in particular, was considered an inappropriate subject for a serious artist of either gender — he had simply faded from the iconography. If known at all, the American photographer Robert Mapplethorpe — now famous for his eulogies of the masculine form — was regarded as a marginal outsider and his preferred subject a taboo area. The male nude may since have been rescued from exclusively homosexual representation but he has nevertheless remained the possession of men so that the homo-erotic nude still occupies our horizons, and women who deal with the topic continue to be looked at askance.

But in taking the male as their subject, the artists in *Women's Images of Men* were investigating much broader topics than the male nude as flesh. Inevitably the sexual politics of their own social and personal positions became the focus of thought. The exhibition therefore marked an emergence from the dark ages of silence or misinformation concerning gender issues.

Nine years ago figurative painting was seen as innately conservative, now it has returned to the forefront, filling the galleries, and abstraction has, for the moment, been relegated to the sidelines. In 1980 presenting an exhibition of women's work was a confrontive move, now such an event would be unremarkable. Innumerable women artists are presently enjoying critical acclaim and commercial success and they are no longer

perceived as a phenomenon dangerous enough to arouse dismay. Other changes have helped make the situation for women artists less problematic. They are less often patronised with eulogies about the 'feminine' qualities of their work — its frailty, delicacy or charm — or reproached for making artworks that are considered 'masculine' in scale, address or presence.

Some of the work in the exhibition was criticised for being insufficiently informed by feminist theory — because the artists were not concerned with precedent or worried about censure, many of their ideas had the freshness, but also the naivety, of work made in rebellion. Now that feminist attitudes have been absorbed to become part of informed opinion, the atmosphere is more relaxed — feminist ideas permeate the thinking of most women artists and an awareness of gender issues informs much of their work. Reiteration of the analysis is no longer necessary and artists do not feel constrained to make work that confirms feminist ideology. Strategies now tend to be either less naive or less orthodox, but lack of overt political content is no longer viewed as a sign of conformism or retrenchment. Women are freer, in other words, to work as they choose and their art is more likely to be discussed on its own terms than to be judged by a predetermined set of expectations or prejudices.

Self-assertion is also more possible. Instead of focusing on the repressive aspects of the patriarchal system — what 'they' are doing to or saying about us — women are able, positively and unapologetically, to focus on their own positions and interests without the results appearing anodyne or aggressive. Less time is spent analysing masculine misconceptions and more on clarifying women's own perceptions and stating the female case.

Success is within our grasp. Joining the mainstream is no longer a unique occurrence and entering the commercial arena need not mean selling out. Paula Rego and Therese Oulton have rapidly risen to fame with work that has a clear feminist orientation and numerous others — Helen Chadwick, Hannah Collins, Eileen Cooper, Amanda Faulkner, Nicola Hicks, Susan Hiller, Shirazeh Houshiary, Karen Knorr, Lisa Milroy and Alison Wilding amongst them — enjoy considerable reputations with work that makes no effort to hide its female origins.

Now that more established women artists are visible to provide successful role models, younger artists are encouraged by the knowledge that ambition is no longer considered indelicate or deviant. Despite the cuts in the education budget that have all but eliminated female staff from the art schools, many more women are able to assert their desire to become serious professionals, with more confidence and fewer qualms.

But change is not irrevocable — one cannot afford to take for granted the gains that have been made and it is, therefore, essential to remind ourselves of the battles that were fought and the attitudes that had to be exposed and overcome. *Women's Images of Men* — both the exhibition and the book that celebrated it — were important events because they made a substantial contribution in bringing about many of the changes that have occurred. We must not let them slip from memory.

Sarah Kent and Jacqueline Morreau

Scratching and Biting Savagery
Sarah Kent

The brilliance of *Women's Images of Men* was that it fused three issues that had been fermenting for some time — the rebirth of figurative art, the use of art as a vehicle for political comment and the emergence of women artists as an important force in the artworld. Their fusion proved both potent and popular — its reverberations are still being felt today.

It is still hard to believe the response that the exhibition received — large numbers of visitors and unprecedented media coverage, most of it hostile and including abuse of the 'scratching and biting' variety[1] — especially as two earlier exhibitions had not succeeded to the same extent. Timothy Hyman's *Narrative Painting*[2], shown at the ICA a year before, had alerted artists to the continuing importance of figurative work, but its lack of a political dimension had made it less inviting to the public. The year before that *Berlin a Critical View: Ugly Realism*[3] had attracted enormous public interest with its scathing political content, but the show had been too early to make a strong impression on the artworld.

Women's Images of Men was, then, perfectly timed. It came just as the abstraction that had dominated the galleries had begun to stifle in its own rarefied atmosphere. The British public had never really warmed to these pure manifestations of colour, texture, line and form — concerns which seemed remote from their own lives. It had also been difficult for women to gain access to mainstream galleries — even a fine painter like Gillian Ayres had been consistently undershown and underrated in relation to her male colleagues — so it was commonly supposed that nearly all artists were male. The ICA season came like an explosion, demonstrating that dozens of women had been working away unseen and in figurative styles.

The seventies had also been a period of fierce political ferment with many artists determined to contribute to political change by means of their work. This meant devising artforms that were both

accessible and didactic. Performance art grew out of the street theatre of political demonstrations of the sixties. Others used film, photography, montage or video to make political points, while the 'conceptualists' felt that a rigorous analysis of the practice and social function of art was necessary and aligned themselves with disciplines such as sociology and philosophy.

But the public failed to respond to any of this 'experimental' work, since even when the media were familiar, the content was obscure and spoke mainly to the converted. This proved an especial problem for feminists anxious to contribute to the important task of consciousness raising by addressing large numbers of women, on the one hand, while on the other professional ambition encouraged them to think in terms of making a contribution to the language of art — opening up the boundaries of what could be said and the means with which that communication could be made.

These two ambitions seemed hopelessly incompatible. Mary Kelly made one of the most courageous feminist artworks of the decade. In images and texts *Post Partum Document* studied her relationship with her son over the first six years of life, illustrating and extending Lacan's analysis of the negative postion of women within the patriarchy. In its sophistication — both theoretically and formally — the work, however, spoke mainly to those already conversant with the issues it raised and the theories to which it referred.

How to combine professional credibility with political cogency, while remaining sincere to both ambitions, was a key dilemma for feminists and other radical artists during the seventies. Could one be both politically and artistically effective or did being radical in art preclude being effective within radical politics?

One of the few artists to have successfully negotiated this knife edge was Alexis Hunter. Early photographic sequences which discussed aspects of female repression, frustration and aggression were accepted by the feminist avant garde, but were also shown in public places such as pubs: 'it is obvious that galleries and museums are glutted with art that is geared towards the fantasies and ideals of men ... I want to reach an audience that has been ignored in the past — the women who have to bear the burden of change in our society and the fear and guilt that induces.'[4] In *Solace II* (1977) a high heeled shoe is toyed with in a series of fetishistic images, then burned as a symbol of female bondage, restricting movement and destroying comfort. Recently she has returned to painting, using it as the vehicle for virulent attacks on patriarchal values. *Considering Theory* (1982) shows a woman in mortal conflict with the phallic serpent that has been the instrument of her downfall and the excuse for restricting her

Mary Kelly, *Post Partum Document* (detail of Documentation IV) 1973-9
mixed media

potential. The painting's title also encourages one to read it as an attack on the academicism that stifled individual expression throughout the 1970s and discouraged painting and sculpture.

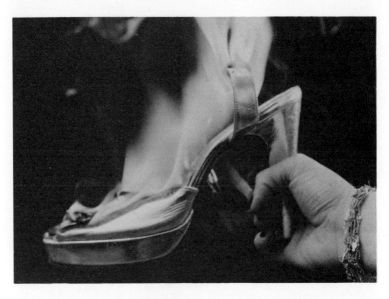

Alexis Hunter, *Solace II*, colour photograph (one of series) 1977

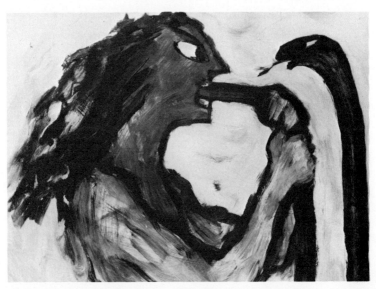

Alexis Hunter, *Considering Theory*, oil on canvas 1982

These traditional media were held by avant garde artists and critics to be innately conservative and hopelessly individualistic. The possibility that they could be used to make cogent political comment was, therefore, not given credence, while radical snobbery precluded the serious consideration of work that was thought to be ideologically 'unsound' and intellectually unsophisticated.

As a result, painters such as Monica Sjoo whose *God Giving Birth* (1973) had been banned as blasphemous each time it was shown because it portrays a female Godhead giving birth in the sky, had been totally disregarded by the feminist avant garde, despite her insistence that 'I see my work as an integral part of women's struggle for liberation.'[5]

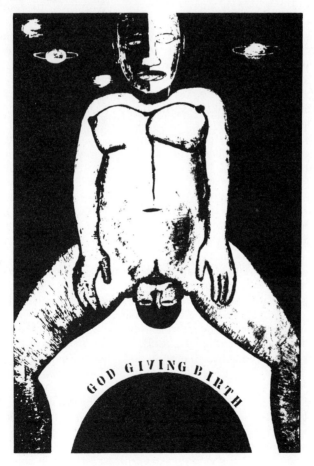

Monica Sjoo, *God Giving Birth*, 1973

Yet hundreds of artists continued to make figurative work in traditional materials outside the abstract or radical mainstream, disregarded by feminists and critics alike, since their politics seemed dubious and their art old fashioned. *Women's Images of Men* brought together many of these artists and focused their attention on the theme of the male sex. Much of the work was neither sophisticated formally nor theoretically yet, ironically, it succeeded where radical art had failed in capturing the attention and channelling the rage of the general public, both male and female.

The feminist slogan 'the personal is political' was proved correct. Individual perceptions of husbands, lovers and friends seen as vulnerable, weak, cruel or foolish punctured the masculine mystique. Although many were not committed to feminism, given the political climate, their collective contribution was read as a strong and confrontive feminist statement — not just the radical fringe, but a large body of women artists seemed to be on the march and to have taken up the brush against the patriarchy. And although much of the work was politically naive, the exhibition could, ironically, be said to have had greater political impact than all the theoretically sophisticated, 'alternative' manifestations put together.

This influence is still felt. Groups of women continue to meet and to organise. *Pandora's Box*, an exhibition which looks at misogynist mythology, is one such initiative currently touring the country. Individuals from the show such as Evelyn Williams, Eileen Cooper, Ana Maria Pacheco, Sue Coe, Jacqueline Morreau and Jo Brocklehurst have continued to exhibit. But more important than these individual successes are the changes in the general reception of women's work.

The ICA season not only gave confidence to individual artists, but encouraged dealers and exhibition organisers to promote women's work. When asked 'What more does a young writer need than pencil and paper?' the Russian author Vladimir Voinovich replied 'a publisher and a reader as well. To develop you must appear in print, get readers' reactions, their support, the approval and criticism of older writers. Without that a young writer usually loses the sense that somebody needs his work, he goes deaf, feels stifled, grows embittered and may never realise his talent.'[6]

We have always had good women students, but in the past they have largely fizzled out through lack of the kind of reaction and support that Voinovich describes as essential.[7] *Women's Images of Men* demonstrated, beyond doubt, that a large and interested audience existed for women's art and, as a result of that knowledge, there has been a remarkable outburst of activity with

Eileen Cooper, *Second Skin*, oil on canvas 1981 55″ x 31″

women refusing to be stamped on or to fade. Lisa Milroy's rapid rise to attention would have been unthinkable five years ago, especially given her subject matter — items of household use or of dress that would no doubt have been denounced as 'feminine' or 'domestic'. Amanda Faulkner's confrontive women would doubtlessly have provoked anger rather than delight. Therese Oulton's ambitious and elegiac landscapes would probably have passed unnoticed or even gone unmade. Then there are young sculptors like Yoko Terauchi, Alison Wilding, Judith Cowan, Hilary Cartmel, Helen Chadwick or Shirazeh Houshiary many of whom have shown abroad as well as exhibiting regularly in this country.

Most important of all, women artists no longer have either to ape their male colleagues or produce pretty little 'feminine' things. They are free to assert their independent voices — to be quiet or loud, aggressive or introspective, feminist or apolitical — to explore the full range of personal expression or political commitment without being considered insipid weaklings or hysterical harridans.

Amanda Faulkner, *Little Witches*, pastel and charcoal on paper 101,5cms x 76.2cms 1984

Shirazeh Houshiary

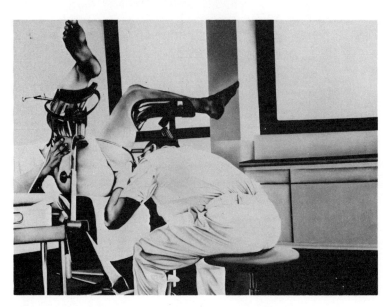

Maina-Miriam Munsky, *Colposcopy*, oil on canvas 1972

Footnotes

1) A phrase used to describe *Women's Images of Men* by Waldemar Januszczak in *The Guardian,* 6 October, 1980.

2) *Narrative Painting* was selected by Timothy Hyman for the Arnolfini Gallery in Bristol where it was shown from September to October 1979. It then travelled to the ICA, London, Stoke-on-Trent and Edinburgh. A catalogue was published by the Arnolfini.

3) *Berlin a Critical View: Ugly Realism,* curated by the author with Eckhart Gillen, compared the biting political satire of Berlin art from the 1920s (Grosz, Dix, Beckmann and Heartfield) with that of the 1970s (Grutzke, Petrick, Vogelgesang and Nothhelfers). The exhibition was shown at the ICA from November 1978 to January 1979 and a copiously illustrated book of essays about the artists and their relationship to the politics of the 1920s and 1970s was produced, edited by Gillen and Kent.

4) Alexis Hunter quoted by Sarah Kent in the catalogue of the *Hayward Annual 1978,* Arts Council of Great Britain, 1978, p.39.

5) Monica Sjoo in *The World As We See It,* CCIC, 16 Agincourt Rd, London NW3, 1977, p.3.

6) Vladimir Voinovich, *The Story of Socialist Realism* in *The Listener,* 30 August 1984, p.17

7) During the 1970s women artists made enormous efforts to establish a viable context for the viewing and serious discussion of their work by opening galleries, staging exhibitions and publishing magazines. For a full account of these initiatives see Margaret Harrison, 'Notes on Feminist Art in Britain, 1970-77' *Studio International* Vol 193, No 987, 1977.

Lighting a Candle
Jacqueline Morreau & Catherine Elwes

'It is better to light a candle than to curse the darkness'
Eleanor Roosevelt

Part one Organising the Exhibitions

The Gold of the Incas

'What's bringing in all those people, the gold of the Incas?' demanded a friend as we watched the crowds pouring into the Institute of Contemporary Arts in London. *Women's Images of Men* opened in October 1980 in a blaze of publicity. On average a thousand people a day came to see the work, breaking attendance records at the ICA as well as at each venue in the subsequent tour.[2] *About Time*, the second part of our exhibition, with its video, performance, slide tapes and installations, was no less successful in attracting large audiences.

At last something to look at — this refrain echoed around a collection of works that ranged from anecdotal directness to complex investigations into the conflicts implied by the theme. Men were seen as friends, lovers, dependants, opponents, familiar symbols of patriarchal power or as sexual prey. Whatever the artist's views, they were expressed in the language of figuration and were therefore accessible to anyone visiting the gallery.

This wave of enthusiasm for representational art after the modernist doldrums of the seventies was the result of two observations that dominated our discussions in the late seventies.[3]

First, we realised that although we knew a great deal about men's attitudes towards women, having seen, heard and read them all our lives, we knew astonishingly little about women's attitudes towards men (as opposed to those attributed to them). Our second point was that a substantial group of women artists were using figuration and narrative to explore their ideas in highly personal ways; they were neither represented by the feminist avant-garde which like the male mainstream rejected figuration or by the more directly feminist artists. It became clear that a theme show by women artists on the 'hidden' subject of men was a good way to combine our two main concerns. When we advertised

for artists to send work which addressed itself to the question 'How do you see men?', the response demonstrated that we had struck gold.

Women's Images of Men and *About Time* were built on the work of many women, beginning in the early seventies with the reappropriation of a common artistic language, figuration and narrative. Since a basic tenet of feminism was that the personal is political, narrative languages were the inevitable choice of feminist art. The new work was strongly autobiographical, much of it describing economic dependency, a sense of displacement, limited choices, violence and lack of value given to 'women's work'. Individual statements were linked to, and spoke for, the experiences of many other women. What had been hidden, private and nameless, now found a voice as the subject of art.

Women reclaimed their bodies both as experience and as image. Motherhood, menstruation and the menopause were seen in their positive aspects as well as their mysterious and threatening ones. (Monica Sjoo, Catherine Elwes, Judith Higginbottom). The familiar image of femininity that demanded make-up, high heels and long fingernails was exposed as a social construct. (Alexis Hunter, Roberta Graham and Annie Wright). *Feministo*, an entertaining and thought provoking exhibition at the ICA in 1978 of 'home-made', small-scale works exchanged by post demonstrated the problems housebound women artists faced, torn between the needs of their families and the demands of their work (Kate Walker, Monica Ross, Patricia Kitson).

Artist-initiated exhibitions increased the awareness of women's political work. Gertrude Elias showed political work by women in *The World As We See It* in London in 1975 (Monica Sjoo, Hilda Bernstein, Jacqueline Morreau, Liz Moore). At the Women's Arts Alliance gallery in London under the direction of Linda Mallet and Jenni Norris, exhibitions such as *Off The Fence* (1977), *Women's Images of Women* (1977) and *Not The Object* (1978) demonstrated how group shows could establish the gender of the artist and bring out the political implications of her authorship.

The Women's Arts Alliance provided a supportive environment in which to develop our ideas. The next step was to test them on a wider public. The Alliance was a specifically feminist space, which tended to limit its audiences to those sympathetic to its politics, and its gallery was too small for comprehensive shows. Encouraged by the success of the 1978 Hayward Annual, whose five woman selection group had reversed the usual male-female ratio by showing the work of more women artists than men,[4] we began to think about showing in a major space.

The final impetus came from Nina Jennings, one of the women who staged a protest when Allen Jones' fetishistic female

furniture was displayed at the ICA in 1978. Besides objecting to the work, she pointed out that the ICA seemed remarkably reluctant to show women artists. If they were prepared to exhibit one man's view of women, she asked, would they like to see how women perceive their traditional oppressors? 'Certainly, if it's good enough', came the answer. The next day, Nina presented us with the challenge. We responded with enthusiasm, clarifying the aims of the show as follows:

— to show the comments of a diverse group of women on men and the patriarchy.
— to demonstrate the quality, originality, and excellence of as many women artists as possible.
— to emphasize the power of imagery in the work of figurative artists.
— to reach a public beyond, but including, the women's art movement and the regular gallery visitors.
— to place women artists in touch with each other and create a dialogue between them.
— to encourage women to address wider social issues.

The idea of women picturing men prompted a great deal of discussion. We realised that the exhibition marked a radical departure from existing feminist art.

9 Joyce Agee, *Installing 'Women's Images of Men'*, photograph, 1980

The Viewer Viewed

In the late seventies British Feminism was concerned with the redefinition of feminity as well as the reform of institutional discrimination. This involved extracting women from male culture and male company long enough to discover what feminine experience might be without that omnipresent patriarchal frame of reference. Many feminists began relating their experiences to that of other women. In some cases men faded from their lives, their art and their politics. These more radical feminists considered any attention to, or contact with, the opposite sex to be counter-productive, almost counter-revolutionary. With this thinking, an exhibition of images of men would qualify as wasted energy.

We did not agree. Far from thinking that our male subject matter would reinforce traditional male power over women, we felt that we would be reversing a centuries-old relationship between artist and model. The viewer viewed through the eyes of his traditional sitter confronts us with the inequality of that original relationship. Film theory has argued the impossibility of appropriating the gaze, establishing female authorship, within conventional cinematic language. The same might be said of a painting which represents men in a stylistic tradition of their own making. But we believed that in the context of a feminist exhibition, even a conventional portrait would project a woman's point of view and her apparently arbitrary choice of formal devices would take on new significance.

For most of us there was nothing unusual about working with male subjects; they were central to the work of artists such as Elisabeth Frink, Mandy Havers and Jo Brocklehurst. But judging by the alarm the prospect of our show generated among men, a large scale exhibition revealing women's perceptions of masculinity was personally threatening and potentially subversive. We were soon accused of wanting to 'objectify' men. How could we justify reducing a man to a sex object? Were we not duplicating the oppressive stereotyping that we criticised men for applying to women? We answered that men are defined by considerably more than their sexuality. To isolate some aspects of their sexual behaviour does little to conceal their role as the leaders of society, the creators of culture. It is much easier to reduce woman to her heterosexual function. Twenty centuries of social and cultural convention have paved the way.

Planning the Season, Selecting the Shows

We now realised that the shows would be highly contentious. Art

critics, particularly men, were unlikely to ignore them. If we wanted to draw attention to figurative art by women, this theme could not fail. After Caroline Tisdall wrote about our project in *The Guardian*,[6] a flood of submissions arrived for a show that, as yet, had no assured venue. When later Sandy Nairne was appointed visual arts director at the ICA he was confronted with two proposals for feminist exhibitions, ours and *Issues*, a show planned by Lucy Lippard of socially committed artists from Europe and America.

With what some saw as foolhardy enthusiasm, he scheduled both of them for the autumn.

The two exhibitions turned into three when it became obvious that images of men was an unsuitable theme for women performance artists. For *About Time* we asked for work that indicated the artists' awareness of women's experience within patriarchy. Catherine Elwes enlisted the help of Rose Garrard, and together with Sandy Nairne they put together *About Time — Video, Performance and Installation by 21 Artists*, the first appearance of a show of time-based art in a major art institution. At the same time, the artist Claire Smith was planning an exhibition of more abstract work at the ACME gallery. Through *Eight Artists: Women* she hoped to demonstrate 'that women's art, both of students and more mature artists has tendencies, often objectives, that are rarely found in men's work.'[2] A season of women's films, talks and events were taking shape, London was unwittingly about to host the country's first festival of women's art; it would even include a *salon des refusées* at the Bakehouse Gallery.

When we began the difficult task of selecting work for the exhibition, we had hundreds of submissions to consider. We invited the art historian Lisa Tickner to join us because of her particular knowledge of feminist issues in art.

We looked for work that was relevant to the theme of the show, offered a strong personal statement, and made skilful and imaginative use of figurative languages. *Women's Images of Men* included painting, sculpture, soft sculpture, prints, ceramics and photography by twenty-nine artists. *About Time* showed 21 artists and covered all time based activities, with film as a separate but simultaneous programme.

Burning Questions:
Feminist elites? Women's Ghettos? Collaborating with the system?

In selecting the shows, we made certain value judgements. Some people suggested that we were creating a feminist elite in place of existing male hierarchies; others claimed that a show in a 'male'

17

art gallery would inevitably compromise and distort women's work. These views were based on experience from the previous decade, when feminists had examined existing art institutions and found overt and covert discrimination operating, just as it had done throughout the history of art[6]. Art colleges, funding bodies, journals, galleries and museums were all implicated. A perfect example was the Arts Council's exclusion of women from its shortlist for major awards just as *Women's Images of Men* opened. Art institutions were seen to be responsible for defining the nature and limits of such concepts as creativity, professionalism, innovation, good and important. Each term was found to encapsulate traditionally male attributes and activities; each word became a term of exclusion, the exclusion of women. As a result many women argued that a small slice of the rotten pie[7] was not worth having. Alternative art values, art venues, and audiences were sought on both sides of the Atlantic.

Although we were aware of this, we also saw the danger of reinforcing the male mainstream by setting up feminist ghettos. The existence of a few women's galleries was unlikely to shift male dominance of the art establishment which provided the major link between artists and the general public. Why not use a mainstream gallery for our own purposes? We felt that the interest the shows would generate in artists, critics, curators and the public would make it impossible for the art establishment to take credit for the events. The variety of work we planned to show and the wide range of events, would thwart any attempt to define and fix a category called 'women's art'. Many critics tried, but they could not agree on a definition. Their conflicting reviews brought still more people into the ICA and so allowed the work to speak for itself.

Savages Entering The Arena: The Critics View

'An aura of sensationalism, of penises for penises' sake, undermines the savagery with which some of the exhibitors have entered the arena'. Waldemar Januszczak, *The Guardian*. October 3 1980.

'*Women's Images of Men*' had a political angle, a human angle and eye-catching images and every writer, male or female, wanted to offer an opinion as to whether it succeeded, failed, was true or false to life or downright dangerous. Writers sympathetic to feminism generated interest in the shows although they tended to focus on individual artists rather than discuss wider issues and the cooperative nature of the organisation got lost. But of all the views, it was probably Waldemar Januszczak's reaction which was responsible for the greatest boost to attendance fi-

gures. Having accused us of gratuitous genital exposure and vengeful aggression, he conceded a few moments of 'accurate insights'. Evidence of male violence, male emotional dependency and male absurdity induced a bout of hysterical defensiveness in this critic whose parting shot was aimed at Helen Cherry's cartoons: 'lulled by the conscious femininity of her drawings, you don't immediately realise that she too is blaming you for absolutely everything'[8].

All the critics accepted the show's two fundamental points: that women are under-represented in the art world and bring a different social experience to art. Beyond that agreement there were as many reactions as there were writers. The subjective nature of criticism was manifest in every article. Critics seemed to have seen vastly different exhibitions. Some saw savagery where others claimed the artists had distanced themselves from their subjects. Some described the artists as sympathetic companions to their men, while others were seen to be taking revenge.

10 Joyce Agee, *The Critic, Paul Barker*, photograph, 1980

As long as the artists showed compassion, sympathy and tenderness towards their subject they were praised, for these qualities were seen as a reflection of their femininity. It was when they displayed 'unfeminine' qualities that the critics — female as well as male — found it hard to cope. Humour, for example, took everyone by surprise, and was viewed as decidedly unfeminine. The presence of the penis disturbed some critics who tended to exaggerate the number and, fixated on its biological function, misunderstood its use as a symbol of male power.

Marina Vaizey was not alone in seeing a 'forest of penises' although relatively few works displayed the offending parts and none gave them more than their natural proportions would allow. (It has been suggested that censorship of the male genitals reflects the disproportionate significance that culture ascribes to them. In revealing the penis without correspondingly inflating the male body to phallic proportions, the object becomes plainly unequal to its patriarchal task.)

When critics were determined to deride the work they burlesqued the 'man-hating' aspects of the show, or selected one or two 'good' works with which to condemn the rest. Sometimes the work was dismissed as eclectic, thereby implying a lack of originality. (A male artist works from tradition, a woman plagiarizes.) Some of them emphasised benign qualities such as compassion and denied the more angry statements — perhaps those which conflicted with the critic's self-image. Others criticised the show because it was figurative and therefore retrogressive. Some, suspicious of the show's success, claimed that art which attracted so many people was popular art not high art. If they really wanted to trivialize the exhibition, they ignored the unusual phenomenon of women being publicly acknowledged as the makers of art, and concentrated instead on audience reactions.

Video and performance art were, at the time, poorly reviewed in the art press and only made the national papers when the nudity or violence involved could be sensationalised and the Arts Council accused of wasting public money. Without a catchy title or anti-social behaviour *About Time* attracted little critical attention. If live work does not get reviewed, it has effectively not happened, and so it was left to the artists to ensure their place in the contemporary history of art by producing a ten day diary of the event.[9]

The most important fact that no amount of verbal abuse or critical silence could conceal was that more people were looking at women's art in 1980 than at any other time in British history. This remains one of the greatest achievements of the exhibitions.

After the event

An upsurge of feminist energy among women artists can be attributed to our shows. Groups have formed, events and exhibitions have taken place and a younger generation is now building on what we achieved.

Although there has been a tendency for publicly-funded galleries in London to say that women's art has been 'done', those outside London and commercial galleries have increased the number of women whose work they show. Overall, there is a greater acceptance that women have something unique to contribute which they do with skill and imagination.

As for ourselves, the ICA shows gave us renewed confidence and a sense of achievement. By forming a group we were able to break out of our isolation and through the shows reach a new constituency of women to which we could now say that we belonged.

In forming that constituency we helped establish the visual arts as an important arena for the exploration and communication of feminism. Like Brecht we feel that the function of art is 'to stimulate, through entertainment, the wits, the social conscience and the moral sensibilities of ordinary men and women.'[10] If this is politics by seduction, then we stand guilty and unrepentant.

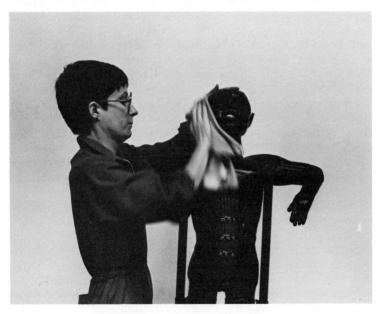

11 Joyce Agee, *Mandy Havers Polishing 'Icarus'*, photograph, 1980

Part Two Locating the Shows Within the Feminist Debate

'Around 1970, the women's movement was one of the most dynamic progressive and creative areas of activity in Britain. Women's culture, in the broadest sense was suddenly alive and kicking. Women artists responded in a number of ways and many of the themes explored by them were only later taken up in male mainstream art activities.'

Margaret Harrison, 1977

To understand fully the impact of *Women's Images of Men* and *About Time* within feminism, it is necessary to know something of the specific artistic and political context in which they appeared and the history of ideas from which they grew.

The feminist art debate began in 1971 when Linda Nochlin asked why there had been no great women artists.[11] Until then, this fundamental question had been answered only in terms of 'natural' female inferiority. Nochlin now proposed institutional discrimination as a major constraint. She also pointed out that historically, art reflected the white western male viewpoint, unconsciously accepted as *the* viewpoint of the art historian. Women were unlikely to identify with such a tradition and art historians did not regard any alternative perspective as art. Women's art had always been given a place in art history but as Rozsika Parker and Griselda Pollock pointed out, its 'feminine' qualities have been cited to reinforce the 'masculine' achievements of old and new masters.[12]

In the seventies, historians like Linda Nochlin, Ann Sutherland Harris, Gillian Perry and Nora Lufts rediscovered many female artists previously 'hidden from history', women who were often more successful in their own lifetime than the male artists whose work is known to us today. The question of their greatness was raised. Many feminists regarded this term as irrelevant since it referred to a set of artistic values that were created by and for men. A debate then developed over the difference — if any — between art made by men and art made by women. In America Lucy Lippard saw the answer in terms of content: 'However, the overwhelming fact remains that a woman's experience in this society — social and biological — is simply not like that of a man. If art comes from inside, and it must, then the art of men and women must be different too. And if this factor does not show up in women's work, only repression can be to blame.'[13]

In Britain, many feminists saw the problem in terms of form,

arguing that since art languages had carried male meanings for so long, they could not express the ideas and perceptions of the other 'race' in society.

This is where British and American ideas diverged. Lucy Lippard suggests that American women artists were able to use representation and narrative because of a highly visible and local women's art movement which contextualised their work. English artists and historians tended to organise themselves in collectives of like-minded individuals and operate on the fringes of the art establishment.[14] Without a sympathetic context for women's art and vocal spokeswomen, English artists dared not risk direct depictions of such subjects as female sexuality for fear they would be mistaken for traditional pornography. This fear of being misunderstood drove many feminists away from the minefield of representation and fostered the growth of a more theoretical approach.

Borrowing the tools of structuralism, feminists exposed patriarchal hierarchies concealed within verbal, visual, and cinematic language. These hidden codes positioned femininity as the negative value against which masculinity establishes its cultural primacy. The apparent content of a picture and the story-line of a film or other time-based work was seen as a seductive smokescreen to the true patriarchal meaning inscribed in the form. These feminists believed that even feminist content could not over-ride the message of the medium, and that any attempt to do so must result in distortion of the artist's intentions. 'Language', it was said, 'speaks us'. The task of feminist art, they felt, was to peel back the layers in traditional representation and expose the roots of oppression embedded in the very terms we use to describe ourselves. The contaminated words and pictures of everyday life were abandoned in favour of academic analyses. What we were being offered was deconstruction as art. This art often took the form of photographic or diagrammatic images captioned by academic texts, a format which was typical of much socialist art at the time. A copious theoretical literature grew up around these works reinforcing the new ascendancy of words over pictures. The traditional conflict between theory and practice was temporarily solved now that theory was practice.

The difficulties this presented for artists who did not have degrees in psychology, linguistics or political science are evident. But even if we were prepared to abandon the tools of our trades could we still use our subjective experiences, the personal in the political, as a source material? Apparently not. The deconstructive doctrine regarded femininity as a rigidly pre-set experience, as subject to patriarchal conditioning as language itself. In theory, we should no longer trust our own feelings (a familiar message

for women living under patriarchy). Feminists using their own observations and life experience now appeared to be operating on shaky ground. With both the form and the content of their work discredited, it is not surprising that figurative and narrative artists gave up on the feminist avant-garde and retreated to their studios.

Although deconstructive feminist art provided invaluable insights into the less visible workings of patriarchy it failed to offer a scheme for the radical reconstruction of artistic language.[15] Its concern with deconstruction rather than reconstruction ran parallel to formalist and conceptual attacks on artistic language which denied visual art the right to say anything beyond the indisputable reality of surface, medium or stated concept and put the artist into a strait-jacket. The fact that the artist was a human being existing within a network of personal and social relationships was scarcely in evidence. Under a deconstructive feminism, this denial of the artist took the form of an attack on individualism which, it was claimed, contaminated autobiographical work by women.

Art lost that essential presence which declares an interest on the part of its creator and invites the viewer to take an equal interest in the work. Visitors to galleries were more often harangued or bored by art than offered the opportunity of identification with and consideration of another's perceptions.

Women's Images of Men and *About Time* reintroduced the possibility of the one-to-one exchanges that early feminists had so valued. The accessibility of figurative work and the immediacy of live work opened up channels of communication between the artist and the individuals who saw and entered into the work. By re-affirming the value of her own perception in a language she shared with her audience, an artist implied the unique value of each woman she addressed.

Repercussions

The exhibitions made a huge impact on the British art scene. It can be claimed that *Women's Images of Men* accelerated the adoption of New Image as the new avant-garde.

In the 1980s most galleries were still showing abstract and conceptual art. New Image and American Pattern painting had made brief appearances but the British art scene plumped for caution. When thousands of people flocked to see *Women's Images of Men,* galleries realised the time had come to open the figurative floodgates.

New Image painting took from women's art a characteristic for which it has been condemned — eclecticism, previously known as

plagiarism. But where women re-work old styles and traditional craft skills to project their ideas within a feminist framework, New Image indulges in aimless history-hopping or plunders popular culture for no particular purpose.

Basically, the men missed the point. When New Image artists attempt to deal with personal issues they generally replace analysis with aggression. With the exception of some gay artists whose involvement with sexual politics includes a radical analysis of the personal, men do not establish links between their personal experience and that of other men. Rather they make heroic their experience in the tradition of the lone suffering artist. The failure of the New Image artists to say anything new confirms that women artists working with figuration and narrative are the true innovators of the 1980s.

Having seen the error of his ways, Waldemar Januszczak declared that 'It was at the ICA and ACME that art began to prepare itself for the future when personal politics and aesthetics must somehow coexist. It promises to be a fascinating struggle in which women will play the major roles'.[16]

Footnotes

1) The opinions expressed in this article are those of the authors and do not necessarily reflect the views of the other organisers and exhibitors.
2) The venues were: The Arnolfini Gallery, Bristol; South Hill Park, Bracknell, Berkshire; The Bluecoat Gallery, Liverpool; the University of Wales, Aberystwyth; The Third Eye Gallery, Glasgow, Scotland; and the Project Art Centre, Dublin Ireland.
3) The organising group consisted of Joyce Agee, Catherine Elwes, Jacqueline Morreau, and Pat Whiteread, but discussions included a number of other women, most notably Nina Jennings, Anne Wallace, Zoe deRopp Weinman and Judith Kazantzis, who made invaluable contributions to the project.
4) Hayward Annual 1978 was selected by Liliane Lijn, Tess Jaray, Rita Donagh and Gillian Wise Ciobotaru.
5) *The Guardian,* 23 June 1978.

6) When accused of ignoring women artists, many art administrators claimed that women with any talent would already be known to the art world. However, it became clear that women who were not art-school educated, foreign women, older women and those from the provinces were being discriminated against.

7) Lucy Lippard's term for the art gallery/museum/journal/nexus.

8) Waldemar Januszczak, *Guardian*, 3 October 1980.

9) *'About Time' A Ten Day Diary*, 'Primary Sources', Christmas 1980.

10) Berthold Brecht, *Tales from the Calendar*, London 1947.

11) Linda Nochlin, *'Why Have There Been No Great Women Artists?'* in *Art & Sexual Politics*, T.B. Hess and E.C. Baker, eds., New York, 1973.

12) Rozsika Parker & Griselda Pollock, *Old Mistresses: Women Art & Ideology*, London 1982.

13) Lucy Lippard, *From the Center*, U.S.A. 1976.

14) This attempt to undermine the formation of feminist hierarchies was not successful, and led to an expectation that women artists should remain relatively anonymous. The no-star system was in danger of reinforcing a male monopoly of the art world while making it very difficult for women artists to make a living.

15) 'The process of deconstructing the ideological personal of the woman artist is in danger of being carried so far as to eliminate all elements which may serve for a radical reconstruction... If theory pre-exists the realization of the work, there is a danger of limiting, closing and over-defining the potential boundaries of the work, thereby rendering it redundant to the individual artist and limiting its use for potential audience'. From a statement made at the ICA conference, 'Aspects of Women's Art', November 1980 by Monica Petzel, Catherine Elwes, *et al.* For the full text see FAN number 5, London 1980.

16) *The Guardian*, 30 December 1980.

Themes from the Exhibition
Sarah Kent and Jacqueline Morreau

Art historians, such as Ann Sutherland Harris and Linda Noch-lin, who have recently researched the history of women artists[1], have reluctantly pointed out that women's work has not generally been distinct from that of their male colleagues but has con-formed, in style and subject matter, to the period in which it was made. Seldom, and then only by stealth, did women allow their opinions to emerge.

However, by 1980 there were many women speaking in their own voices, but few had turned their attention to the theme of men and the patriarchy, and it was because of the diversity and freshness of responses to the question 'How do you see men?', that the exhibition *Women's Images of Men* broke new ground.

The abuse of patriarchal power was a central issue. The artists did not identify with the oppressors, nor did they indulge in voyeuristic portrayals of their victim's suffering. On the contrary, both victim and oppressor tended to be viewed as twin aspects of the same game (fig.12). Wit and irony were frequently used to cut men down to human size. *The corridors of power* were seen to be lined with excruciatingly bored and boring bureaucrats (figs 13, 52), the tyrant was portrayed as a naked and screaming baby (fig.50) and the hero in his bath as a vulnerable child (fig.35). Besides being *victims of one another*, men were seen as bullies humiliating or colonising women (figs 21, 74, 77, 91, 92), and as exploiters despoiling the planet (figs 27, 31, 33, 79).

Man as poseur pretending to have power that is not his was a frequent theme (figs 25, 36, 37, 51, 52). But, as Rozsika Parker points out in her article 'Images of Men' (p.42), the theme of *weak, crippled and dependent men* repeatedly surfaced and was in-tegral to many other ideas. *The hidden patriarchal voice or presence* is difficult to depict. In Jane Lewis's *Theatre* and *Wounded Figure* (figs 28, 40) one imagines an oppressor waiting behind the cur-tain to inflict further damage on the mutilated girl. Barbara

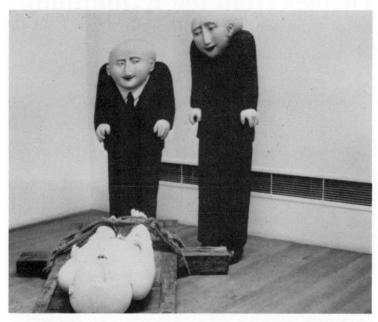

12 Ana Maria Pacheco, *Some Exercise of Power*, wood, 1980, 360″ × 360″

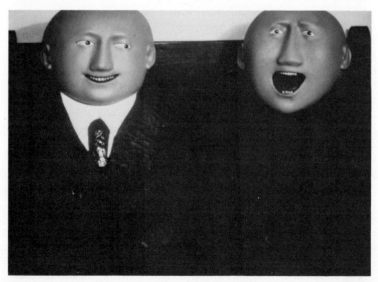

13 Ana Maria Pacheco, *Untitled*, wood, 1977, 90″ × 80″ × 40″ (now destroyed)

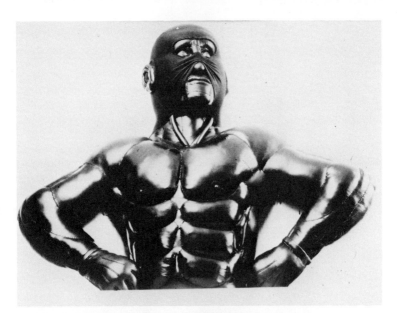

14 Mandy Havers, *Hooded Wrestler*, leather, 1976

Loftus paints girls in idyllic settings that become menacing when one notices the voyeur hidden in the bushes. Mayotte Magnus shows the martyrdom of *the heroic artist* to be self-inflicted (figs 29, 30). Glenys Barton's *Foetal Cushion* (fig.32) points out the unique contribution of the male to life itself.

Male genitalia as symbols of power did not feature as often as one might expect. Jenni Wittman's deliberate misuse of the symbol in *Untitled* (fig. 49), based on a young man with an erect penis and an amputated leg — a displaced castration — aroused substantial controversy. Mouse Katz parodied men's economic advantage by giving her *Landlord* cash-register genitals (fig.23). More frequently, though, the penis was shown simply as part of the male anatomy.

The man as object of desire seldom appeared without irony (figs 24, 35, 40 and the frontispiece). The artists were not in the mood to glamorize their subject. In fact, as Sarah Kent points out in her chapter on 'The Erotic Male Nude' (p.73), for a straightforward celebration of masculine beauty we have to look mainly to the work of men themselves. Objectification is a predatory act which requires a reversal of power that, as yet, seldom exists between the sexes.

Footnote

1) Ann Sutherland Harris and Linda Nochlin, *Women Artists 1550-1950*, New York 1976.

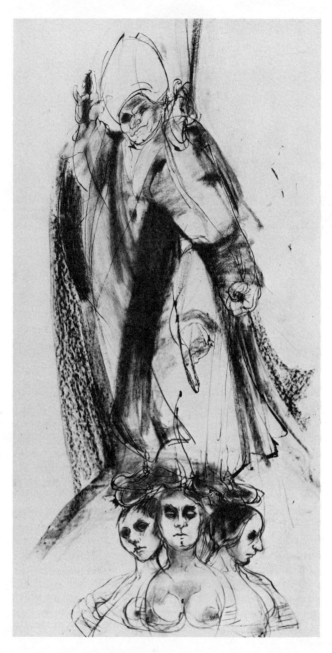

15 Jacqueline Morreau, *Pope John-Paul II*, Study for *'The Children's Crusade'*, ink and charcoal, 1980, 36″ × 20″

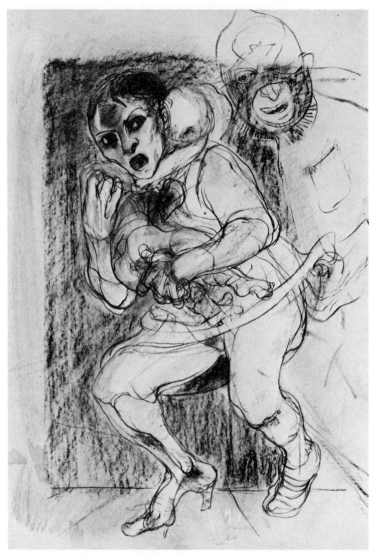

16 Jacqueline Morreau, *Study* for *'The Massacre of the Innocents'*, charcoal, 1980, 30″ × 24″

17 Marisa Rueda, *Man with Hands*, ceramic and wood, 1977, 24″ × 44″ × 91″

18 Marisa Rueda, *Gagged Mouth*, ceramic, 1976, 30″

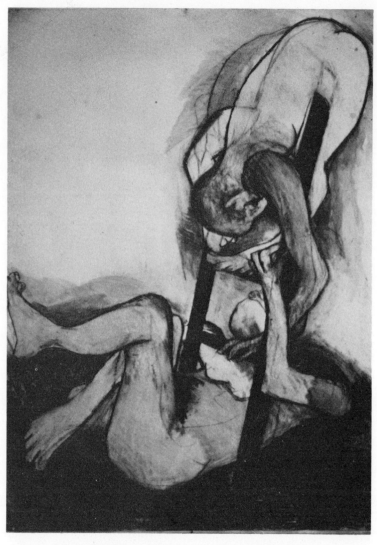

19 Eileen Cooper, *Ladder,* charcoal, 1979, 30″ × 25″

20 Glenys Barton, *Untitled*, bone china, 8″ × 14″

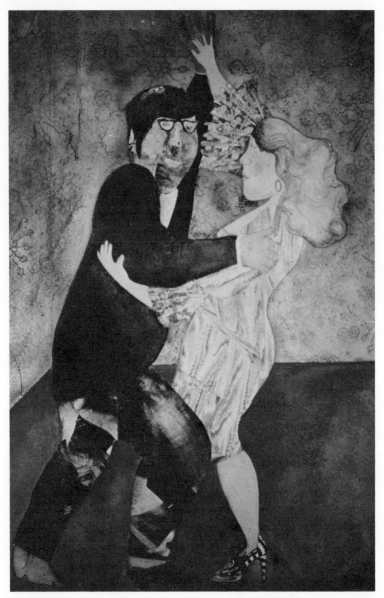

21 Elena Samperi, *Tango*, mixed media, 1976, 30″ × 20″

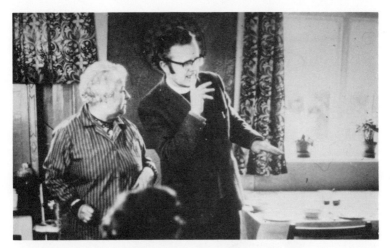

22 Sally Greenhill, *Vicar*, photograph, 1978

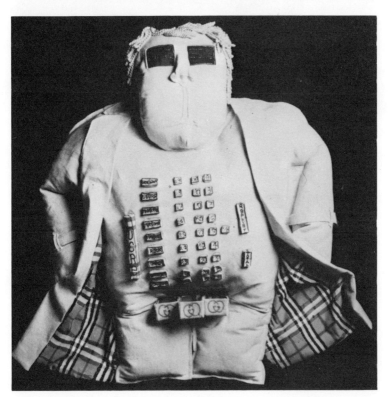

23 Mouse Katz, *Landlord*, fabric, 1980

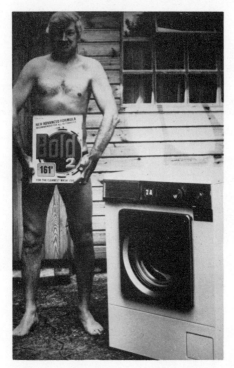

24 Lill-Ann Chepstow-Lusty, *Bold*, photograph, 1978

25 Christine Voge, *Arms Salesman*, photograph, 1980

26 Sue Coe, *In the Jungle of the Cities*, mixed media, 1978, 28″ × 40″

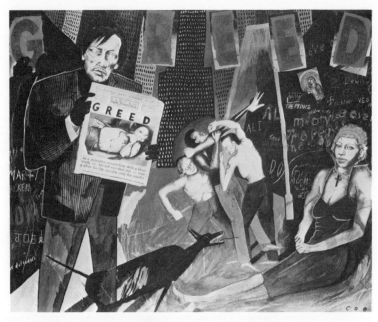

27 Sue Coe, *Greed*, mixed media, 1979, 31″ × 23″

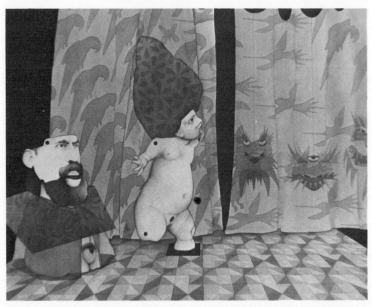

28 Jane Lewis, *Theatre*, watercolour, 1979

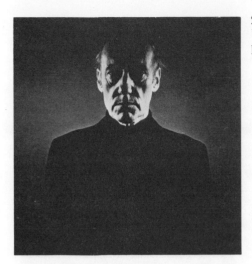

29 Mayotte Magnus,
William Burroughs,
photograph, 1973

30 Mayotte Magnus,
Francis Bacon,
photograph, 1973

41

31 Pat Whiteread,
Rigor Mortis, two photographs from Pollution Piece B, 1981

42

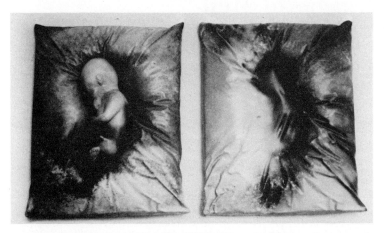

32 Glenys Barton, *Foetal Cushion*, china, 1980

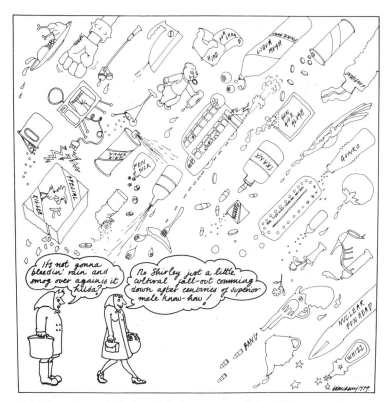

33 Helen Cherry, *Nuclear Fall-Out*, cartoon, ink, 1978

Images of Men
Rozsika Parker [1]

How it pleased me to guide your slow, feeble steps
To feel your arm clinging tightly to mine...
Leaning on your strength, with my hand in yours.

These lines which the nineteenth century writer George Sand
addressed to her lover conjure up a curious, highly contradictory
picture of the man. He is incapacitated, hardly able to shuffle
along, and yet he is a source of strength supporting George Sand.
Obviously the poem is not to be taken literally, but it does indicate
how women's writing about men (like men's writing about
women) reveals women's fantasies and desires, fears and de-
fences, rather than providing a concrete picture of the man they
purport to describe.

Relationships between men and women are unequal and
fraught with antagonism. It is (perhaps) inevitable that women's
images of men in art as much as in literature should be about the
effects of differences of power between the sexes; about the fear
and hatred it can generate, and about the desire to reveal, chal-
lenge, transform or destroy the imbalance. Take George Sand:
she can only allow herself to lean on her lover once he is, so to
speak, invalided out of battle, and relying on her to guide his
'feeble steps'. I am not suggesting that we all want to reduce men
to helpless invalids (though some of us may want just that) but
that through art women express the fantasies and desires engen-
dered in us by a sexist society.

The recurrence of 'invalided men' in women's art has always
interested me, and when I saw *Women's Images of Men* I was struck
by the way this theme emerged amongst others. The exhibition
said as much, if not more about women's response to a male
dominated world than would an exhibition of women's images of
themselves, and marked an important development in feminist
art which had long concentrated on images of women intended to
challenge current definitions of women. Innovative and exciting
work had been done, but frequently efforts to give new meanings

44

to women had been viewed through entirely traditional spectacles. For example, feminist photographs and paintings of our genitals have often been received not as the intended celebration of women's autonomous sexuality but simply as titillation, or even as obscenity. Men's bodies have never stood simply for sex, rather they have represented a wide spectrum of emotion and experience, from defeat to victory, from suffering to strength. Take a look at Kenneth Clark's book *The Nude* and you'll find naked men in chapters on 'Energy', 'Pathos' and 'Apollo', while for women look under 'Venus I', 'Venus II', and 'Ecstasy'. So when we use men's bodies to reveal our perspective on society there is perhaps a greater chance that we will be heard — and understood.

Moreover, to take men as the objects of our fantasies and the subject of our art is to shift power relations within art. Since the nineteenth century women's bodies have provided the raw material for acres of canvases and tons of sculptures. The exhibition also demotes men from standing unproblematically for mankind; presented through women's eyes men can no longer be Man.

Looking at the work I was reminded of a friend's exasperated remark that 'all men are either bullies or cripples'; on reflection she added, 'and all bullies are basically cripples'. Such phrases hold their own tyranny: the use of a physical metaphor — cripple — to signify an emotional lack reflects back on people who actually have physical disabilities. But a symptom of sexism is that it produces generalizations. Men divide us into madonnas and whores while women explain, excuse and shrug off the indignities they suffer at the hands of men by characterizing them as helpless little boys. Given the sexual division of labour which produces domestically incompetent men it is, in one sense, an accurate description. But the prevalence of 'invalided' men in women's art since the seventeenth century is no simple reflection of reality, but women's response to the unequal power relations between the sexes.

Male critics detecting this tendency amongst women to blind, maim, sicken and render their male subjects unconscious, have to a man cried, 'castration fantasies'. It is, of course, infinitely more complex than that, for the crippled man is only a constituent of women's art — we did not invent him. The male body has for centuries represented pathos with the crucified Christ as the archetypal crippled man. Women have merely employed the image to make meanings of their own, and incapacitated men have meant different things in different women's art at different historical periods.

In the seventeenth century, for example, when violent women biblical figures were a dominant subject of European art, the theme was adopted with alacrity by countless women embroider-

ers. They stitched cream-coloured satin with Jael hammering the tent peg through Sisera's temples, and in delicate white work embroidery they depicted Judith decapitating Holofernes. By the end of the eighteenth century, however, neoclassicism and romanticism ushered in images of women weeping at tombs, and in fiction vigils at sick beds began. Mary Wollstonecraft parodied the genre in her novel *Mary*, whose heroine gloried in the 'luxury of wretchedness' as she nursed her Henry.

The nineteenth century was the heyday for male invalids. *Jane Eyre's* blinded Mr Rochester was the tip of an iceberg. Within fiction the male invalid answered a number of needs. He gave women an excuse to abandon feminine passivity and reticence and to take action: 'Every shadow of womanly shame vanished before the threatening shadow of death' (*Olive* by Dinah M. Craik). And he allowed the heroine to experience her unacceptable feelings of sexual desire as maternal pity: 'He was trembling heavily, and his breath had visibly shortened. He looked very ill. Her heart leaped with a deep maternal yearning... flight would be either coquetry or cruelty; and of both she was incapable' (*Avis* by Elizabeth Phelps).

Pity was also a very useful emotion; it enabled the heroine to subscribe to the Christian virtue 'love thine enemy'. In May Sinclair's novel, *The Helpmate,* a marriage bitterly disintegrates until the man is entirely paralysed. Then the woman stands beside his bed and realises 'His body was once more dear and sacred to her as in her bridal hour'.

And however much a woman may be tied to the sickbed, male invalids are so gratifyingly grateful for attention: 'Beth used to wonder at the young man's uncomplaining fortitude, his gentleness, gratitude, and unselfish concern about her fatigue' (*The Beth Book* by Sarah Grand). The sick man clearly takes on the virtues associated with women. But not only does an invalided hero allow for the differences and divisions between the sexes to be emotionally and intellectually transcended, physical differences also in some way dissolve: 'There was beauty in his pale, wasted features. There was an earnestness, and a sort of sweetness' (*Shirley* by Charlotte Bronte). 'His whole face was softened and spiritualized, as is often the case with strong men, whom a long illness has brought low' (*Olive* by Dinah M. Craik). Soft, sweet, spiritualized, who do these sick men resemble, if not women? In order for men to appear desirable they have to resemble *the* objects of beauty and desire in our society — women.

Moreover, once a man is desperately ill, it suggests that he can empathize with women's sufferings, that understanding can exist between the two sexes who sometimes seem like different species. In Charlotte Bronte's *Shirley* two of the major protagonists be-

come deathly ill before there can be a meeting of minds. Then Caroline enters Robert's sick room and says, 'I understand your feelings: I experienced something like it. I too have been ill.'

Lying behind all the varied images of the male invalid is the desire to level off the power imbalance. Elizabeth Phelps in *Avis* gives these words to her male lead: 'He felt, that, had he come to her again in the power of his manhood, he might have gone as he came. It was his physical ruin and helplessness which appealed to the strength in her.' While in the *Tenant of Wildfell Hall* Anne Bronte's Mr Huntingford bitterly resents the power reversal he observes: 'Oh, this is sweet revenge!' cried he, when I had been doing all I could to make him comfortable...'And you can enjoy it with such a quiet consciousness too, because it's all in the way of duty'.'

Twentieth century medicine has changed not only the types but also the meanings of illness in our society. For twentieth century artists and novelists illness takes a different form. We find impotent heroes who suffer breakdowns, often destroyed and laid low by their own blind insensitivity: 'How gripped by fear he was, how possessed by pain and sexual energies gone haywire' (*Torchsong* by Anne Roiphe).

Women's Images of Men contained a fair variety of 'invalided men'; blind men, men with amputated limbs, tortured bodies, male bodies literally muscle bound by masculinity, passive men asleep or unconscious, men dependent on the props of machismo to provide the semblance of strength. Deborah Law's double image of a couple with the woman on the man's knee (fig.34) reminded me of traditional images of suffering men.

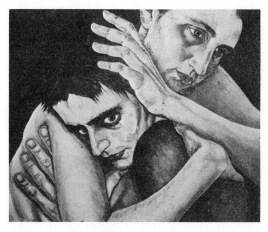

34 Deborah Law, *Untitled*, detail, tempera, 1972

Although the woman is in the powerless position, held like a little girl upon the man's knee, he is the pale and fearful member of the couple. She cradles him. Yet her expression is entirely tragic as she gazes over the top of his head. She is the Seer, the Mother, the Pieta — the Virgin Mary holding the dead body of her son.

Traditional power relations are tenacious — casting the man as the invalid almost inevitably transforms the woman into his mother. Another artist, Elena Samperi, reveals what an ambivalent, oppressive role it is to be the feeder of 'invalided' men. She depicts a solid, stalwart madonna figure, her face hideously contorted as she breastfeeds a particularly nasty city gent, the size of a baby (fig.50).

Other artists avoid showing where the 'invalided' man puts the woman in terms of power relations by absenting women from the image. By keeping women out of the picture they present weak, vulnerable men without placing women in the maternal, protective role. Instead they place men in the positions usually occupied by women in art — naked and on display. Helen White photographs a man in his bath, limp, vulnerable, eyes closed, with rubber alligators ranged round the tim of the tub (fig.35). Anya Teixeria shows a man half stripped, out cold on a pub floor in a litter of beer cans. Then there's the photograph of a naked man prone on a Persian carpet in a shaft of light. But male bodies refuse to be turned into passive, available nudes. These photographs suggest irresistibly that the man is caught between actions; the drunk will come to, the man in the bath will dry himself.

Artists who work with traditional images of men, subverting them or providing a fresh perspective upon them, manage to convey their meanings more forcibly than those who attempt role reversals. And artists who use the techniques of surrealism and expressionism are particularly successful.

Several women present highly symbolic images of men with no eyes. (Cries of 'castration' again.) Mr Rochester walks once more. Some provide their men with blank spectacles, others just close their eyes, or bury their faces in beer mugs. Scores of meanings could be attributed to these images. For example, the man with the extinguished eyes can no longer evaluate, dominate and control women with his gaze. But equally the image suggests that although men do observe women constantly they do not *see* us, do not perceive who we really are. It could be argued that the construction of masculinity — the process that turns boy babies into men with the characteristics valued by our culture — does 'blind' men.

Perhaps it's stretching my argument to place works like Mandy Havers' rigid leather bodies (fig.38) or Jo Brocklehurst's

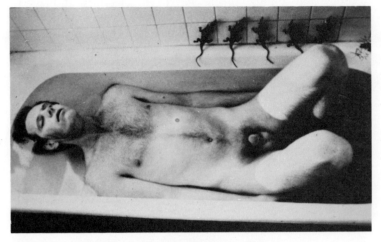

35 Helen White, *Man in Bath*, photograph, 1979

machismo bully boy in the 'invalided' men category, but I believe
that is where they belong. They suggest that machismo is skin
deep — an ugly defence mechanism against fear and weakness.
Lill Ann Chepstow-Lusty, for example, exhibits a photograph of
a city gent looking arrogant and unconcerned, but beneath his
bowler he is entirely naked, clad only in a copy of the *Times*,
a brolly and a huge phallic tie. Jo Brocklehurst displays two
types of power posturing — the cowboy, all bulging biceps and
black stetson (fig.36), and the immaculate young man propped
up by his well cut green suit and pink shirt (fig.37). Mandy
Havers' sewn stuffed leather figures give concrete form to the
expression 'muscle bound' (fig.38).

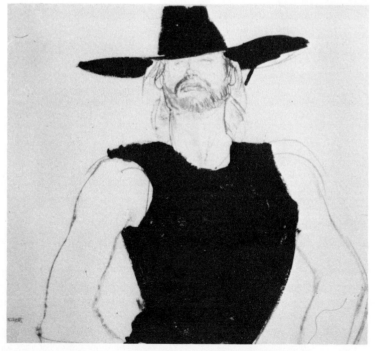

36 Jo Brocklehurst, *Don, The Urban Cowboy I*, ink and chalk, 1978

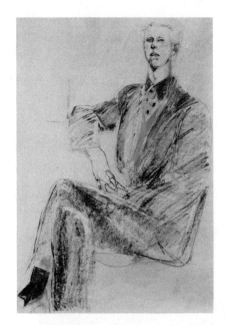

37 Jo Brocklehurst, *The Man in the Green Suit*, pastel, 1978

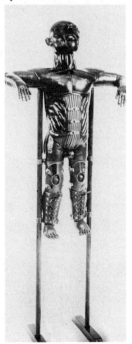

38 Mandy Havers, *Icarus*, sewn leather, 1979

Some artists hint that it is possible to transcend differences and divisions — or, at least, that the effort should be made. They emphasize that both men and women are damaged by a sexist society. Jackie Morreau draws the two sexes locked together inside an apple (fig.39). Jane Lewis provides a surreal representation of the oedipal movement when, according to Freudian theory, castration fears erupt and the child takes his or her place in society as a sexed being; two truncated doll-like male and female figures stand beneath a flight of steps, both with blood-stained genitals (fig.40).

Only one artist, Philippa Beale, seems to deal directly with love and desire for a man. She displayed suggestive, sensitive close-ups of parts of her lover's body (fig.41). A tendency to isolate bits

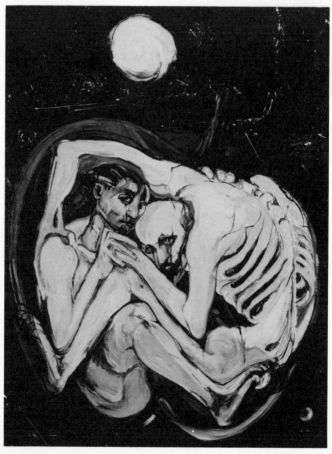

39 Jacqueline Morreau, *Within the Apple II*, oil on board, 1983

of man's body rather than recreating the desired body as a whole is quite common in women's writing and painting. For example in Mary Gordon's novel *Final Payments* the heroine fragments her lover so completely in her fantasies that she '... had difficulty remembering who he was. Not that I had forgotten him; I had thought of him in those days with a constancy it embarrassed me to acknowledge... I had thought of his hands and his walk... and his eyes, and his back... I had thought of having those arms around me...' More manageable in pieces?

Virginia Woolf commented that men need women to reflect themselves back to themselves twice as large as they are. *Women's Images of Men* shows women's determination to reflect men no larger than life.

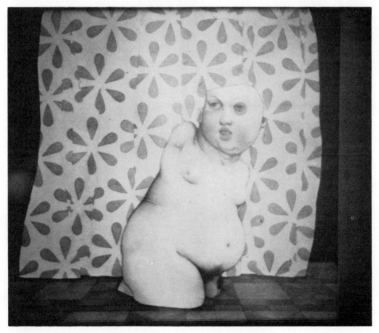

40 Jane Lewis, *Wounded Figure*, watercolour, 1978

41 Philippa Beale, *The Rough and the Smooth*, six photo silk-screens, 1979, 48″ × 36″

Footnote

1) Reprinted from *Spare Rib* no. 99, October 1980.

Looking Back
Sarah Kent

'For years men looked at women. Now women are looking back at men.'

Arnold Schwarzenegger[1]

The Stare

When asked as a boy what was his favourite pastime, Max Ernst always replied 'Looking'.

As a child I used to examine the people sitting opposite me on the bus or tube, fascinated by the slant of an eye, the twitch of a mouth, a curl of hair around an ear or the wrinkles of a neck scrunched up tightly by a collar. I would indulge in concentrated and leisurely perusal, lost in the marvels of these visual minutiae. 'Don't stare' my grandmother would hiss in a stage whisper, meanwhile offering placatory smiles and apologies to the injured party who was by this time writhing in embarrassed discomfort.

My brother and I used to play the game of outstaring each other, nose to nose. Anyone who has indulged in this game will have experienced the oppressive power of an opponent's steady gaze. My brother always won these encounters — age and gender were on his side. In her book *Body Politics* Nancy Henley reminds us that 'staring is used to assert dominance, to establish, to maintain, and to regain it'.[2] Little wonder, then, that in our culture staring is seen as a male prerogative. Men are free to watch women and to pass judgement. 'That's a nice pair, darling' may ring out in a public place while the woman in question is meant to lower her eyes in embarrassment — not to return the look or the 'compliment', for as Adrienne Rich has pointed out 'women are perceived not as sovereign beings but as prey'.[3]

A woman who looks openly at men is seen as brazen if she is flirtatious, or confrontive and threatening — even castrating — if she is cold. This division into male viewer/female spectacle is so deeply entrenched as a social norm that in *Ways of Seeing* John Berger asserts that 'men act and women appear. Men look at women. Women watch themselves being looked at. This determines not only most relations between men and women but also the relation of women to themselves.'[4]

42 Edouard Manet, *Olympia*, oil on canvas, 1863, 51″ × 73¼″

The same conventions govern *images* of women and the relationship between image and viewer, so that the pin-up's smile to camera is understood as an invitation while the 'artistic nude' avoids eye contact so that sexual desire can be sublimated into aesthetic appreciation. When in his painting *Olympia* (fig.42) Manet purposely jumbled the codes, the results were dramatic. At its first showing in the Academy of 1865 the picture had to be protected by uniformed guards from a public outraged by its lewd indecency. By making the model return the observer's gaze with a challenging stare, Manet had reversed the power relations between viewer and viewed. 'She looks not so much at you as through you,' explains Liam Hudson in *Bodies of Knowledge*, 'weighing you up... To Victorian men, vouchsafed the privilege of looking at images of naked women non-reciprocally, as connoisseurs, this grouping of Manet's must have seemed very threatening indeed.'[5] Her cool appraisal undermined male sovereignty — she caught them with their pants down, as it were, and made them feel foolish and guilty. But it was she who was labelled 'impure', 'bestial', 'an animal Vestal' and a whore. In witnessing their lust she was implicated in their sexual imaginings and their guilt could, therefore, be displaced onto her.

One challenges these conventions in art and life at one's peril. For they are not merely annoyances to be circumvented with care and sensitivity, nor just an example of one individual imposing authority or asserting dominance over another in a person to

person encounter. Underlying these trivial social limitations are more profound restrictions on looking and enquiry — ones that, by and large, have prevented women from engaging in serious investigation and research. Exploration has been a male prerogative, enabling men to control learning and knowledge and to monopolise the business of analysis and judgement. Consequently when a man speaks his voice carries the authority of information available to his sex, making his observations appear valid, objective and reasonable. When a woman speaks her observations, based on inward looking — until recently the only direction available to the enquiring female mind — are characterised as subjective and emotional, rooted in feeling rather than fact, and for that very reason are overlooked, dismissed or disparaged. As Dale Spender argues in *Man Made Language,* 'One of the major protests against women's meanings is on the grounds that they are false and biased. Classified as the 'subjective' (and emotional) knowledge of women and polarised against the 'objective' knowledge of men, there exists in patriarchal order a ready-made format for dismissing feminist meanings.'[6]

A woman who refuses to avert her eyes in the social or academic worlds and insists on speaking out risks ridicule or violence even today. Her observations will not be welcomed as a broadening of the debate, they will be met as a challenge to masculine authority and an impertinent break with the silence originally imposed on women by St. Paul and frequently invoked since then. 'Let the woman learn in silence with all subjection', he wrote. 'I suffer not a woman to teach, nor usurp authority over the man, but to be in silence.'[7]

Women Artists

If looking functions as a paradigm of other forms of enquiry, it is not surprising that women artists, whose whole enterprise is based on visual analysis, are seen as particularly threatening. The women who exhibited paintings, sculptures, photographs and prints at London's Institute of Contemporary Arts, during the autumn of 1980, were greeted with derision and abuse. *Women's Images of Men* caused outrage because it reversed normal power relations. Not only had the women usurped the observer's role, but they had turned men into models. The shock of being exposed to view and made vulnerable sparked off extreme reactions in many male viewers. Expressed in the work was a remarkably broad range of feeling — from sadness and irony to curiosity, humour, affection and tenderness. Gay Clifford writing in the *Times Literary Supplement* was surprised, for instance, 'given how much women artists have to be angry about in the operation of

the largely male-dominated art establishment' that there was in evidence 'so little vengefulness or paying back.'[8] But male critics saw with different eyes and were almost unanimous in their condemnation of the 'hysterical overkill'[9] and 'shrill scream of pain and frustration'[10] that they discovered. Twenty male nudes were included amongst ninety eight works; only two of them drew particular attention to the genitals. Yet where Gay Clifford found images 'full of pathos and vulnerability', Edward Phelps was abused by the many 'full-frontal assaults', Marina Vaizey encountered 'a veritable forest of penises',[11] and Waldemar Januszczak found it hard to stomach the 'aura of sensationalism' created by so many 'penises for penises' sake'.[12]

Were the male reviewers being prudish about the sight of the naked male body? Apparently not — for showing at the Marlborough Galleries at the same time were R.B. Kitaj's drawings and pastels including explicitly detailed images of vaginas, penises and copulating couples. Yet his work raised neither a hackle nor an eyebrow. On the contrary, his 'full sensual response' was much appreciated and his ability to derive 'artistic satisfaction from the way the parts of a woman relate to her, and his, whole design'[13] was recognised and applauded. The 'overwrought ladies' at the ICA, on the other hand, were pilloried for thinking of 'nothing but the male's sex organs'.[14] 'If the sight of a lot of badly drawn penises turns her and the 'feminist movement' on then I pity her' wrote one irate correspondent to me at *Time Out* magazine.[15]

Appreciation of women as part of a 'grand design' on the one hand, grossly indelicate lust on the other. Delightfully risqué sensuality in one exhibition, offensive and castrating aggression in the other — or 'pathos and vulnerability' when a woman was making the judgement. Such extraordinary discrepancies of response make it clear that what is good for the gander is not good enough from the goose.

Artist and Model

It is not the sight of the male member that causes outrage, but the sex of the artist who proffers the image. There seems to be something inherently indecent about a woman exhibiting pictures of the male nude.

Since the right to look is equated with sexual dominance, the relationship between artist and model — based as it is on visual intimacy — is assumed to include physical intimacy as well. Introducing her book *The Artist's Model* Frances Borzello observes that 'To admit to writing a book about artists' models is to set off an avalanche of interest. "Didn't Rossetti marry his model?" "Didn't

Augustus John sleep with all of his?" — I became fascinated by the way that, contrary to the facts that were emerging, the majority of model anecdotes shared a common obsession — sex — and a common assumption — that models are female.'[16]

Making an image is seen, then, as an act of sexual possession — 'I paint with my prick'[17] boasted Renoir — and as a precursor to actual intercourse. Picasso's tender etchings of the artist's studio in the Vollard suite epitomise this notion of the artist-model relationship. He shows the sculptor joining his model during the break. Luxuriating in each other's arms, the naked lovers rest from their exertions to admire the artwork emerging from their intimacy. But after the rest their apparent equality will disappear. He will continue working while she remains 'in the picture'. Her role is to inspire him with her beauty and generously given sexuality. (fig.43)

In offering an image of her to the world he boasts his sexual and artistic prowess, invites the viewer to share his admiration of her beauty and, by proxy, to enjoy his intimacy with her. 'She flaunts her body', writes Liam Hudson, 'he flaunts the fact that he has privileged access to it.'[18] Between male artist and viewer a complex interaction takes place focused on the nudity of the female model. Intimacy is created through sexual rivalry — perhaps a sublimated form of homosexuality — in which the model appears to be the subject of the conversation when she is, in

43 Pablo Picasso, *Sculptor and Reclining Model at Window Viewing a Sculptured Torso*, etching, 1933, 7⅝" × 10½" © DACS, 1990

fact, only a form of currency in a male centred exchange. Liam Hudson argues that her nudity is a device 'for affirming the masculinity of men in a male world' and in this respect, 'her nakedness is not a function of her sexuality but of the sexuality of those who have access to the picture'.[19]

The same principle is at work in the traditional Hollywood film where the 'heroine' is the instigator of the action — the goal or prize to be won in a successful outcome. As catalyst, she spurs the hero on to his splendid deeds, but it is *his* achievements that the film follows and applauds. As Budd Boetticher put it 'What counts is what the heroine provokes, or rather what she represents. She is the one, or rather the love or fear she inspires in the hero, or else the concern he feels for her, who makes him act the way he does. In herself the woman has not the slightest importance.'[20] When a woman artist exhibits a male nude she completely disrupts these traditional interactions. She will seem to be flaunting her immorality, while inviting the viewer to join in her intimacy with the model — in our culture an obscene idea. Not surprisingly, the artists in *Women's Images of Men* were labelled by critics as 'neurotic', 'overwrought' and sexually obsessed. 'The women I have known' boasted Terence Mullaly in the *Daily Telegraph,* 'would certainly not fit into the company of these so-called ladies (who) can think of nothing but the male's sex organ.'[21]

Since the viewer is traditionally assumed to be male, it is worth considering what opportunities the male model offers him for reverie. As the site of a sublimated homosexual encounter, the male nude may be too explicit and therefore too threatening to encourage fantasy. 'Man is reluctant', argues Laura Mulvey, 'to gaze on his exhibitionist like.'[22] Even Renoir — who, according to the myth, liked a nude before breakfast and painted so many sexually ripe nudes, resplendent in the abundance and sensuality of their flesh — is said to have been too embarrassed to work from a male model. The man who painted 'with his prick' could not countenance the appearance of a rival one.

One can only guess at the fears and anxieties that were stirred in him. Margaret Walters reported that men 'felt they had been brought up at a distance from their own bodies' and consequently 'it just never really occurred to them to think of the male body as something you look at'.[23] But it is not as simple as that. As already suggested, the sex of the artist is an essential element in the reception of an image and the audience's ability to identify with it or its author.

David Hockney's drawings of the nude Peter and Mo (fig.44) and his more explicitly homosexual series of *Two Boys Aged 23 and 24* in bed together have rightly been praised for their tenderness.

44 David Hockney, *Mo Asleep*, etching and aquatint, 1971, 89 × 72 cms

While even Mario Dubsky's sexually aggressive drawings *Admission* and *Submission* in which a young man offers his anus for sexual intercourse, have not met with the same censure as the nudes in *Women's Images of Men*.

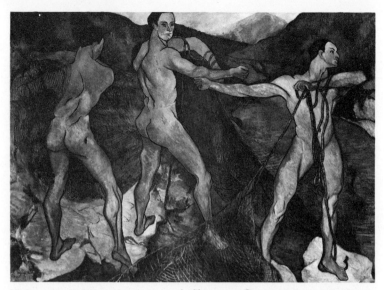

45 Suzanne Valadon, *Les lanceurs de filets*, 1914 © ADAGP, Paris and DACS, London 1990

If the male viewer finds the passivity of Dubsky's models un-nerving, he still has the option of identifying with the artist — the dominant male. But if the artist is a woman, he is likely to identify, however unwillingly, with the model — the passive rather than the active participant — and so to feel his authority and sexual integrity threatened. A common response is to reassert domi-nance through a scathing attack on the author of the discomfort — the female artist. Women have, accordingly, learned to share many experiences privately and secretly, out of earshot of the male. If they intend, like men, to speak of sexual pleasure publicly through the medium of the male nude they must learn to do so without discomfort, embarrassment, guilt or a sense of disloyalty to their men, and to make images that speak without ambivalence, ambiguity or self-consciousness.

With a few notable exceptions like Suzanne Valadon and Alice Neel, the male nude is a subject that women have turned to only during the last twenty years — a minute length of time when compared with the illustrious history of its female counterpart. It will take women time to explore and create images appropriate to their own needs and desires, and an enormous deadweight of prudery must first be overcome. The difficulty of the terrain is two-fold: first the lack of a tradition of erotic male nudes created for women from which to borrow or against which to react and, secondly, the absence of a body of knowledge or an art form

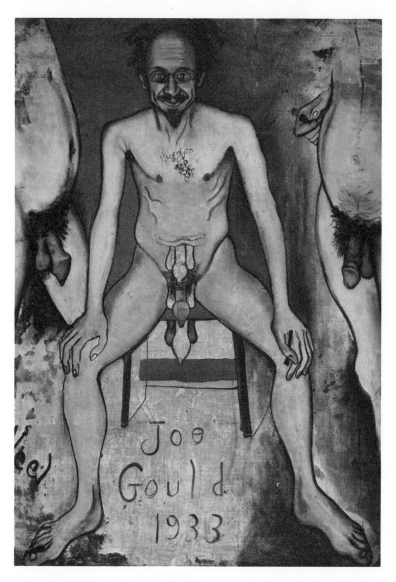

46 Alice Neel, *Joe Gould*, 1933

which recognises and describes female sexuality as a potent in-
itiating force, rather than merely as a response to masculine de-
sire. The sexual drive necessary to instigate a body of erotic art
must first be acknowledged before it can be harnessed without
appearing deviant, obscene, evil or insane.

The question for the woman artist is not, therefore, simply a matter of reversing roles so that she can ape the man, borrowing masculine attitudes and the images which give them expression. She must grope towards a language that will bring her own feelings into consciousness.

Appropriate imagery

'It is not just a question of being as competent (as men), it is also a question of being authentic' insists Shulamith Firestone in *The Dialectic of Sex*.[24]

Many women's images of the male nude sit unhappily on canvas or paper, somehow lacking in conviction or authority. 'We think back through our mothers if we are women', argues Virginia Woolf, 'masterpieces are not single and solitary births; they are the outcome of many years of thinking in common, of thinking by the body of the people, so that the experience of the mass (of women) is behind the single voice.'[25]

The artist suffers from her lack of tradition and from the absence of aesthetic codes through which to articulate her thoughts and feelings. 'Maybe', observes the American painter Judy Chicago, 'the existing forms of art for the ideas men have had are inadequate for the ideas women have'.[26]

Ideas cannot live outside the visual or verbal framework of a language that can encapsulate them and give them substance. Without it they remain vague, incoherent, and at the margins of consciousness — we do not even dream in abstractions. The absence of a suitable form makes clarity of thought inconceivable.

The masculine voice is always heard, as it were, in the background providing the norm against which any new utterance is measured. Women's contributions, therefore, frequently appear incorrect, deviant or flawed, because their interests and goals differ from the male tradition.

The female voice still holds little authority or authenticity. When David's portrait of *Mademoiselle Charlotte du Val d'Ognes* (fig.47) in the Metropolitan Museum, New York, turned out to be by Constance Marie Charpentier, a painting that had been 'a perfect picture, unforgettable' was suddenly discovered by Professor Sterling of the museum to have cunningly concealed flaws. 'Its poetry, literary rather than plastic, its very evident charms, and its cleverly concealed weaknesses, its ensemble made up from a thousand subtle artifices, all seemed to reveal the feminine spirit.'[27]

This revelation of the worm at the core of Eve's apple — the innate 'weakness' of the female contribution and spirit, was made only ten years ago. And the poison of this belief still infects both

47 Constance Marie Charpentier, *Mademoiselle Charlotte du Val d'Ognes*, oil on canvas, c.1801, 63½" × 50⅝"

artist and viewer, influencing perceptions, judgements and actions.

A civil tongue

Women are brought up to eavesdrop on a culture which includes them only in terms of their relationships to men and describes them largely from the masculine viewpoint. 'The circle of men whose writing and talk was significant to each other', writes Dorothy Smith, 'extends backwards in time as far as our records reach. What men were doing was relevant to men, was written by men about men for men'.[28] Women listened in, as much as they were allowed, to this cacophony of self-importance. Men, on the

other hand, have had little experience of listening to women either individually or collectively. Phyllis Chesler found that it was often impossible for women to speak when men were present and 'very rarely do men listen silently to a group of women talking.'[29]

Why then did the male critics pay so much attention to the collective female voice of *Women's Images of Men* when the other exhibitions and events in the same season were practically ignored? Snatching the brush or chisel and turning the lens onto the male of the species seems to have caused panic amongst those who found themselves the subject of scrutiny. What did they fear from women breaking their silence?

Women know too much about men. We watch them grow from infancy, to adolescence and adulthood. We see them at their most vulnerable and inadequate. The woman behind the great man has information that could seriously damage his public image. She has acted as nurse, psychoanalyst, adviser, lover and confidante, repaired his bruised ego, rebuilt his lost confidence and restored his pride. She has probably rehearsed his speeches, written his manuscripts and corrected his spelling as well as chosen his clothes, cut his hair, cooked his meals and ironed his shirts. Her role has been to help construct and maintain his public or professional persona. She continues her support publicly, acting as public relations officer — charming his boss, ingratiating herself with his clients and subtly singing his praises. But in order to succeed, this constant labour of affirmation must be discrete, invisible, so that credit will accrue to the man in question and not be disseminated amongst those who have also contributed. Not a word must be breathed about his doubts and anxieties, nightmares and cold sweats, sexual or emotional problems, poor spelling and sentence structure. 'Muteness and invisibility are not incidental by-products of female labour', Marion Glastonbury explains in *Holding the Pens*, 'they are what women are paid for, part of the service, the pre-requisites of privacy, ease and confidentiality for men. For women, economical survival within marriage, in domestic service, in prostitution and in all analogous occupations, depends on keeping a civil tongue in your head and divulging nothing to outsiders.'[30]

Revelations

As women begin to gain the confidence of psychic and economic independence, and to take up the brush, pen or camera on their own behalf, they can no longer be trusted to keep counsel. As they learn to articulate their versions of reality more forcefully and with less hesitation, it becomes more difficult to dismiss these as

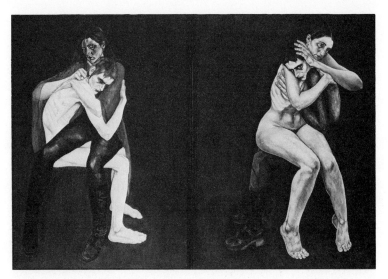

48 Deborah Law, *Untitled*, tempera on board, 1972

foolish or aberrant. *Women's Images of Men* was accused of 'scratching and biting'[31] savagery because it contained some observations that men would prefer to have suppressed. Deborah Law's painting of a cuddling couple (fig.48) shows, for instance, a young man vulnerable, afraid and utterly dependant on the strength and maturity of his partner. Although she sits on his lap in the 'feminine' position, apparently supported by him, he clings to her in the terror of a child just woken from a nightmare. His vulnerable and scrawny body seeks out the protection of her more solid proportions, while hiding in her arms from the pressures of the external world. Her face expresses the concern of a caring and responsible adult, his the numbing pain of fear.

Elena Samperi's *Madonna* (fig.50) depicts the adult male as a parasitic infant biting the succulent breast that feeds him. Emotionally and physically dependant, he returns her nurturing with spiteful cruelty. Having nothing else to offer — his minute genitals are of little use for her needs — he diverts attention from his own inadequacy by terrorising her with demands.

Jo Brocklehurst's drawings make a mockery of the macho posturing with which men impress each other. *Don*, for instance, has thrust his sagging flesh into a skimpy vest and tight trousers (fig. 51). Grinning under the broad brim of his cowboy hat, he seems unaware of the discrepancy between his unhealthy, middle-aged body and the rakish muscularity of the image he projects.

These and other pieces hold an unwelcome mirror up to the male ego, deflating it with gentle or savage humour, but Jenni

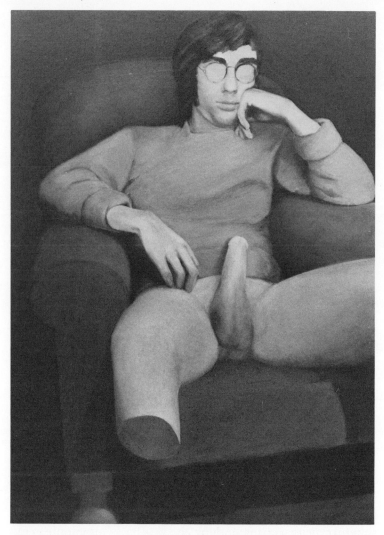

49 Jenni Wittman, *Untitled*, oil on board, 1978

Wittman's painting of a young man offers a more overt challenge
(fig.49). He is well endowed with an erect penis, but his right leg
has been severed below the knee and his eyes obliterated behind
their glasses. Blinding and amputation are recognised as symbols
of castration, but the power of her image comes from its ambigui-
ty and the cool dispassion with which she portrays this violence. Is
the young man the victim of the artist's aggressive fantasies or is
he merely subject to his own castration anxieties? Is the danger

real or only imagined?

The aggression in Jenni Wittman's painting can be denounced as 'penis envy'. According to Freud, every girl must come to terms with her secondary status as exemplified by her lack of a penis — the symbol of masculine authority, the focus of masculine pride, and, therefore, an obvious focus for female resentment and aggression. Admiration for the penis as well as for what it represents is learned with difficulty as this conversation between two naked four-year-olds illustrates:

Girl: What's that?
Boy: It's my dicky.
Girl: Doesn't it get in the way?
Boy: Yes. And it hurts if it gets hit. I have to look after it a lot.
Girl: Can't you tuck it up somewhere?
Boy: No, I've tried, but there's nowhere for it to go.
Girl: Doesn't seem much good to me.
Boy: My mother says I can help make babies with it.
Girl: (inspecting): I think your mother is having you on... I don't think it will work.[32]

The little boy is clearly unsure of the value of his genitals, while their vulnerability makes them a constant nuisance.

Margaret Walters has pointed out that whereas male artists are happy to distort the female body and genitals, they tend to treat their own organs tenderly, protectively and with respect. Even Picasso who 'wrenches the female nude and sex organ into the most startling and disturbing shapes'[33], who is happy in pictures to dismember, disfigure, rape or even murder the female, treats the penis with loving care, affection or amused indulgence.

But a woman may not show the same respect. On the contrary she may display a lack of reverence for an organ which she experiences as wilful and inconsistent — making demands while not guaranteeing satisfaction. For although characterised in pornography and popular fiction as a powerful weapon or tool that can hurt or rape — in slushy novels the heroine murmurs 'Don't hurt me' as she sinks into her lover's arms — in real life the penis often fails to make its presence adequately felt. Most men, at one time or another, have suffered fears of sexual inadequacy and the actual embarrassment of premature ejaculation — and do not want to be reminded of these tortures. As a concept, 'penis envy' tells us more about male castration anxieties and fears of sexual incompetence than it does about women's sexual identity.

Joan Wakelin's photograph of a footballer whose shorts inadvertently show his genitals (fig.53) is anarchically funny because it deflates phallic mythology by revealing too much as being too little — but it is a joke which men may not enjoy.

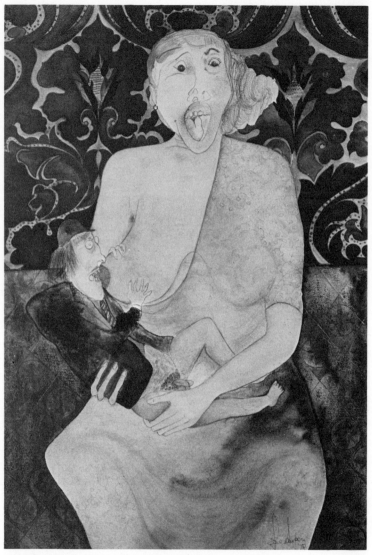

50 Elena Samperi, *Madonna*, 1979

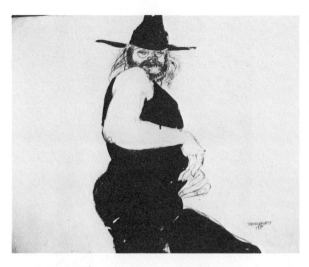

51 Jo Brocklehurst, *Don, The Urban Cowboy II*, ink and pastel, 1978

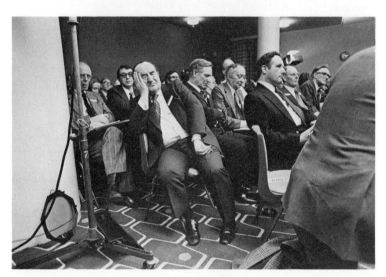

52 Sally Greenhill, *Participants in 'The Great Debate'*, photograph

Sally Greenhill's *Participants in the Great Debate* (fig.52) takes a quizzical look at the masculine world of business. Peeping in through the doors of a conference, we discover the privileged participants to be snoozing in boredom. Stripped of its glamour and self-importance, the male world seems less desirable — is this really the life that women covet, the photograph seems to ask?

71

53 Joan Wakelin, *Footballer of the Year*, photograph, 1978

The Phallic Mystique

This points to a fundamental problem in depicting the penis. For as a symbol of masculine power, authority and potency within the patriarchy the phallus has to carry an enormous burden of significance. That bulge in the trousers on which the hero's sexual identity depends and on which pop stars, like Elvis, focused their fans' attention to such good effect, cannot withstand exposure to view.

Phyllis Chesler has observed that 'since the penis is the proof of male existence, the proof of male power, it is too important and too vulnerable an organ to be exposed publicly especially to women.'[34] Male and female viewer alike may respond with embarrassment or dismay at its diminutive size. Women may feel cheated, as if the terrorist who has held them hostage and threatened them with the pistol in his pocket, turns out to be armed only with a finger!

Even the most beautiful male body, then, contains an inherent and perplexing contradiction. The penis, symbol of masculine virility, a source of sexual pleasure and focus of male pride, is also the most vulnerable piece of human flesh. Those few inches that

should epitomise male strength and potency need more protection than any other part of the male or female anatomy. The sight of the limp penis sparks off the anxiety and ambivalence that men feel about their own sexuality — hence the defensive hostility evident in the reactions of male critics to the nudes in *Women's Images of Men*.

Only in the last twenty years or so have women looked back unflinchingly to explore the male nude as the locus of sexual desire and fantasy and as an expression of positive and negative feelings towards men. In this respect *Women's Images of Men* can be described as an introduction to the topic and its enormously complex potential. As women speak out more often and more openly men will be forced to acknowledge their right to a voice and will learn to feel less threatened by their observations.

The American artist Martha Wilson described art as an 'identity-making process.'[35] Through their own efforts in making, looking at and responding to images, women will establish clearer definitions of their own identities, will locate their own desires and learn to give them expression and will eventually act fearlessly as 'sovereign beings' with the ability and the right to look wherever they choose and to comment as they please.

Footnotes

1) Quoted by Margaret Walters in *The Nude Male*, London 1978 p. 295.
2) Nancy Henley, *Body Politics*, New Jersey 1977, p. 166.
3) Adrienne Rich, *On Lies, Secrets and Silence*, London, p. 241.
4) John Berger, *Ways of Seeing*, London 1972, p. 47.
5) Liam Hudson, *Bodies of Knowledge*, London pp. 104, 106.
6) Dale Spender, *Man Made Language*, London 1982, p. 61.
7) Quoted by Ben Maddow *Nude in a Social Landscape* in Constance Sullivan *Nude Photographs 1850-1980*, New York, p. 184.
8) 10 October 1980.
9) Edward Phelps, *Bath West Evening Chronicle*, 25 November 1980.
10) Phillip Midgley, *Times Educational Supplement*, 10 October 1980.

11) Marina Vaizey, *Sunday Times*, 19 October 1980.
12) *Guardian*, 6 October 1980.
13) John Russell Taylor, *The Times*, 14 October 1980.
14) Terence Mullaly, *Daily Telegraph*, 15 October 1980.
15) David Michaels, *Time Out*, 31 October 1980.
16) Frances Borzello, *The Artist's Model*, London 1982, p. 7.
17) Walters, p. 315.
18) Hudson, p. 133.
19) Hudson, p. 116.
20) Laura Mulvey, 'Visual Pleasure and Narrative Cinema' in *Screen*, Autumn 1975 (Vol 16 no 3), p. 11.
21) 15 October 1980.
22) Mulvey, p. 12.
23) Margaret Walters interviewed in *Lip*, Australia 1980, p. 81.
24) Shulamith Firestone, *The Dialectic of Sex*, London 1979, p. 149.
25) Virginia Woolf, *A Room of One's Own*, London 1929, pp. 63, 72.
26) Quoted by Lucy Lippard in *From the Center*, New York 1976 p. 6.
27) Quoted by Germaine Greer in *The Obstacle Race*, London 1979, p. 142.
28) Spender, p. 77.
29) Spender, p. 42.
30) Spender, p. 226.
31) *The Guardian*, 6 October 1980.
32) Spender, p. 181.
33) Walters, p. 220.
34) Phyllis Chesler, *About Men*, London 1978, p. 218.
35) Lippard, p. 106.

The Erotic Male Nude
Sarah Kent

'In essence, the domain of eroticism is the domain of violence, of violation.. What does physical eroticism signify if not a violation of the very being of its practitioners? — a violation bordering on death, bordering on murder?'

Georges Bataille[1]

'An image of an erotic object is a negation of the object's essential character or humanity.. The model thus becomes a token of nature, an objectified artifice that allows the viewer to handle her mentally and to fantasize about her; the human becomes a mannequin, a doll.'

Robert Sobieszek[2]

Georges Bataille's and Robert Sobieszek's analysis of erotic images sums up those aspects of masculine sexuality so repugnant to many women. The debasement of women into passive objects of desire, whether actual or imagined, is felt as an assault on human dignity.

It's easy to agree with this sentiment, and if you are female, also to enjoy a shared sense of outrage, reinforced by the conviction that women are less bestial than their exploiters. But Sobieszek continues his argument with the comment that 'there is no reason to suspect that the same process does not occur if the sexual roles are reversed.'

When I first read that sentence it made little impact — my mind somehow glided over it. Since I could not accept his first statement, either emotionally or intellectually, the fact that its corollary followed logically seemed of little importance. But I didn't forget it. It had evidently been stored away in some mental recess and in writing this essay it obstinately resurfaced. As I reflected more deeply, it began to flesh out and become convincing, until finally I had to accept its truth.

This was not a conclusion arrived at glibly. To admit to sexual responses and interests despised in the opposite sex is difficult, especially as one wants to respect oneself and be loved by others. 'Any 'vision' of the world', writes Morse Peckham in his book *Art and Pornography*, 'is dictated by interests inseparable, ultimately, from the interests of self approval.'[3]

While violent or sadistic sexual fantasies are tolerated in men and channelled into socially accepted outlets such as blue films and videos and pornography in general, there is no comparable recognition of sexual aggression in women. Phyllis Chesler argues that 'while lesbianism may be tabooed, female sexual aggression towards men is even more tabooed. Here I'm not talking about the men who pay prostitutes to whip or humiliate them. I'm talking about what women want, and about the dominant sexual mores within the family.'[4]

In fact, there is precious little acceptance of female sexuality besides a passive acquiescence to masculine demand. There are no words comparable to 'potent' or 'virile' to decribe the sexuality of women and, although gone are the days when 'ladies don't move' and women are now expected to be active in bed, love making is, nevertheless, still described in terms of what the male does to the female. 'All the vulgar linguistic emphasis', writes Germaine Greer, 'is placed upon the poking element, fucking, screwing, rooting, shagging are all acts performed upon the passive female: the names for the penis are all tool names. The only genuine intersexual words we have are the obsolete swive and the ambiguous ball.'[5]

As a result female sexual activity is still so invisible that in their book *Sex and Gender* which examines the very issue of the social construction of sex roles, Archer and Lloyd can write that 'women are sexually *receptive* throughout most of their adult lives'[6] (my italics).

Things that are nameless because their existence has not been acknowledged can neither be recognised nor properly considered. 'Whatever', argues Adrienne Rich, 'is unnamed, undepicted in images, whatever is omitted from biography, censored in letters, whatever is misnamed as something else, made difficult-to-come-by, whatever is buried in the memory by the collapse of meaning under an inadequate or lying language — this will become, not merely unspoken, but unspeakable.'[7] Her words clarify the way women's sexuality remains unspoken and unspeakable and, by and large, unthinkable — lying formless in the mind or being channelled inappropriately into images created as projections of male sexual fantasy. But are there no opportunities for women to explore their sexuality by means, for instance, of fantasy? Morse Peckham argues that both art and pornography offer the opportunity to discover one's reactions to a range of socially unacceptable situations without fear of opprobrium, since 'one is required only to meditate and contemplate and let those reponses occur that will occur... — because of art's irresponsibility — it is... admirably suited for material which is disturbing, forbidden or confusing' while 'a glance at pornography shows... one of its most

important functions: self-reinforcement of genital response to sexual role cues.'[8]

This appears promising terrotiry, offering women the opportunity safely to explore thoughts and feelings that transgress accepted norms of behaviour. Yet in an entire book devoted to the topic of sexual role playing and pornography, Peckham refers to women only twice, stating that 'Freudianism has made many people miserable, particularly women, because they feel they ought to be more interested in genital activity than they are' and advising that 'if a man can persuade his wife to free herself of her inhibitions — to achieve a certain cultural transcendence — and train her to fellate him, then both have a new source of sexual pleasure'.[9]

His assumption is that women derive satisfaction from servicing their partners and although he discusses at length the function of pornography and erotic art for men, he, not surprisingly, finds it unnecessary to do so for women, nor to ask why there is no pornography aimed specifically at them. From his book, one can only conclude that woman's sexual identity is so feeble and her capacity for erotic fantasy so weak, that neither provides any material for discussion. For him, too, assertive female sexuality remains unthinkable and unspeakable.

Homo-erotica in Art History

The history books are peopled with erotic male nudes made by men for each other. Women are used to living vicariously — viewing their culture voyeuristically and translating its material, as best they can, to serve their own needs. What potential, then, do these nudes offer the female viewer to explore her erotic fantasies? Many are intentionally seductive and evidently display homosexual proclivities. Michelangelo's *Dying Slave* (c.1514) (fig.54) languishes in an ecstatic swoon, his singlet rolled up like a modern-day pin-up to reveal a well developed torso as though to invite sexual intimacy. Carvaggio's *John the Baptist* (c.1595) (fig.56) is more openly lascivious. The adolescent boy smiles invitingly to the viewer. Naked on a fur rug, he embraces a curly horned ram — surely a pun about unbridled sexuality as well as being the saint's traditional companion?

A favourite theme for the indulgence of sado-masochistic fantasies was the martyrdom of St. Sebastian. Many of these young saints appear to expel a sigh of exquisite pain as the arrows pierce their exposed and vulnerable flesh. Mattia Preti's *Sebastian* (c.1657) (fig.55) sits tied to the branch of a knobby tree that thrusts urgently into the picture space at the angle of an erection. He gazes up breath held, lips parted in expectation, his skin as

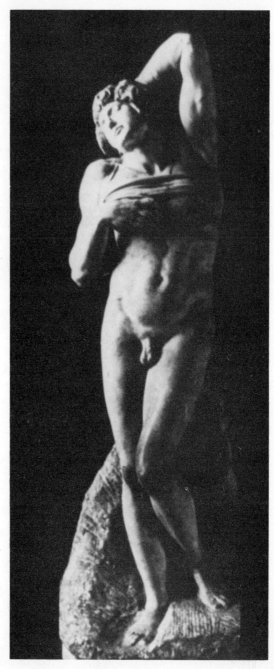

54 Michelangelo, *Dying Slave*, marble, 1514, 84⅝″

55 Mattia Preti, *St Sebastian*,
1657, 238 × 167 cms

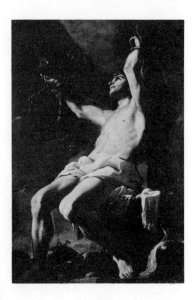

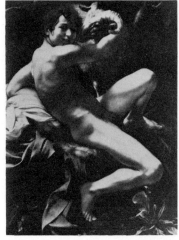

56 Caravaggio, *St. John the Baptist*, c. 1595

yet unblemished, awaiting penetration, while a judicious fold in
his loin cloth hints at sexual arousal.

The rape of the young Ganymede, carried off by Zeus dis-
guised as an eagle, has provided a popular homosexual theme.
Damiano Mazza's sixteenth century *Ganymede* (fig.57) lies along
the eagle's back offering his rounded buttocks to view, like
Boucher's *Miss O'Murphy* would some two hundred years later,
his soft skin contrasted with the coarse feathers of the emblem of
patriarchal authority, so that spanking as well as buggery are
suggested as appropriate fantasy responses.

57 Damiano Mazza, *Ganymede*, C 16

Although I enjoy the overt manner in which these images are encoded with sexual cues, they hold no erotic interest for me. Their message is too specific and their audience too clearly stipulated. The young men's girlish faces and adolescent bodies hold little promise, while their passivity discourages the idea of a positive response. Nor do I warm to more active and muscular examples of the male nude such as Rubens' *Hercules Victorious over Discord* (1615-22) (fig.58) and Pollaiuolo's *Hercules Slaying the Hydra* (c.1460), their dominance and virility exaggerated by their lion cloaks, bulging muscles and enormous phallic clubs. Their physical strength and energy seem oppressively bullying and insistent — offering no potential except acquiescence. The brilliance and authority of their self-presentation seems too complete, too reflexive. Their overbearing presence crushes all imaginative fantasy so that one's function as a female viewer is only to admire and be conquered.

Both these passive nudes and macho males limit one's fantasies to a specified range of known reactions. As opposite sides of a similar sexual encounter — the active and passive, the dominant and submissive partners of a familiar scenario — they block mental exploration of alternative and more equal interactions. As an exultation of power and its uses, they offer women only negative identification.

58 Peter Paul Rubens *Hercules Victorious Over Discord*, red chalk with touches of black, 1615-22, 47.5 × 32 cms

But there exists a host of less overtly sexual nudes, which exude a non-specific sensuality that, instead of directing one's thoughts, allow a wide range of imagined responses. Bellini's *Dead Christ mourned by the Virgin and St.John* (c.1465) is astonishing for the freedom with which a mother's love is given erotic physical expression in a lip to lip embrace, hand clutching hand, while the vertical body of Christ is steadied by the gentle pressure of St. John's hand on his belly. The mature form of Michelangelo's *Awakening Slave* (1520-3) is imprisoned in the block of stone and, therefore, at the mercy of any sexual advances, while his profoundly incestuous *Pieta* (fig.59) of 1500 in St. Peter's, Rome, depicts Christ's mother as a lover rather than a parent. As the young woman looks down on the slender body lying supine on her lap, her expression is closer to admiration than to sorrow, while there is no escaping the fact that, as she savours his beauty, her downcast eyes gaze directly at his genitals.

I could enthuse about Rubens' body of Christ in his Antwerp *Descent from the Cross* (c.1610) or his drawing of *Venus lamenting the dead Adonis* (c.1612)(fig.60), an unusual work in which the woman takes an active role, bending over the drooping body as she lifts it in her arms. Since both figures are practically naked the sexual overtones are strong, especially as the cupid pulls away Adonis' loincloth to peep at his genitals. Most seductive of all are fragments of classical Greek sculpture such as the copy of Polyclitus' *Doryphoros* (c.450 B.C.) and the second century B.C. *Torso of a Satyr*, both now in the Uffizi.

What these paintings and sculptures have in common is the depiction of a dead body, a body imprisoned, or a headless torso — in Freudian terms a part-object, rather than a whole being. In them the will has been suspended and the personality frozen so that the body is at one's disposal. As Robbe-Grillet wrote of the erotic female nude, they are 'frozen in a pose which is not the model at all, but the image born in the imagination.'[10]

I am not discussing necrophilia, dominance, acquiescence or slavery, but a firm and independent will that lies dormant so that, to change the sexes of Sobieszek's comment, 'the model thus becomes a token of nature, an objectified artifice that allows the viewer to handle him mentally and to fantasize about him; the human becomes a mannequin, a doll', an *object* onto which one can project one's own erotic fantasies, rather than have them dictated by the author of the image.

The absence of a will or personality are key factors in imagined erotic pleasure. One's eye or hand is then free to wander over every detail of form and texture without self-consciousness, embarrassment or fear of ridicule. And from these details one can construct a personality — the angle of a shoulder or hip, the

59 Michelangelo, *Pieta* (St Peter's Rome), marble, 1497-1500

60 Peter Paul Rubens, *Venus Lamenting Over the Dead Adonis*, pen, brown ink, brown wash, 1612, 21.6 × 15.2 cms

thickness of a neck or the smoothness of skin can suggest attributes like strength, assertiveness or sensitivity and from these signals one can deduce characteristics such as courage, determination, intelligence and so on. One's mind is free to construct the being one would wish for, without danger of disappointment. For this reason Michelangelo's headless study for Adam has far more erotic potential than the finished painting on the Sistine Ceiling — although in the final work his musculature has been simplified to become clearer and more elegant — because one does not have to consider his foolish and doleful expression, but can construct the personality one pleases.

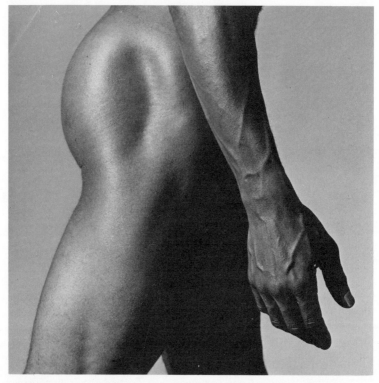

61 Robert Mapplethorpe, *Untitled*, black and white photograph

The Continuing Tradition

The tradition of the homo-erotic nude is still continuing, and is now even more frank about its erotic function. Robert Mapplethorpe's photographs are a brilliant contemporary example of the presentation of the male nude as erotic spectacle and site of homosexual fantasy. Their firm limbs, lustrous skin, well defined musculature and large penises exemplify the 'body as erection' — every inch the epitome of virile strength and staying power. Mostly black, they exude sexuality — confidently, subtly and with no trace of anxiety or hysteria — to become emblems also of a racial myth.

Carefully posed and beautifully poised in the isolation of the studio, the body is frozen into present time like a piece of sculpture, to embody potency held in stasis so that it cannot be squandered, and to personify youth that will not age, virility that will never fail and, more immediately, an erection that will not fade. They offer the idyll of guaranteed satisfaction and availability.

But while Mapplethorpe's nudes have a powerful physical and sexual presence, they are at the same time anonymous. *Untitled* (1980) for instance, not only has no name, but his identity is hidden by a bag over his head, that eliminates his personality from consciousness and emphasises the vertical thrust of his statuesque body. The clarity of the image meanwhile allows us to explore at leisure every detail of surface, form and texture. In his health and beauty he exemplifies 'the sane body, the working body, free, sovereign, poised, whose proportion, equilibrium and ease are such that it dominates the landscape and commands itself at each moment.'[11]

Other photographs frame segments of the body into self-contained body parts that seem arrogant in their perfection. A muscular thigh and buttock encapsulate virility and strength. This time the penis is hidden, but the veins of the arm and hand suggest the pumping of blood for action and erection. In its ability to initiate or respond to touch, the hand 'personalises' the body fragment, emphasising that it belongs to a warmly sentient being who can reciprocate one's caresses. (fig.61)

Other images are openly confrontive. *Patrice* (1977) (fig 62) stands like a cowboy, legs firmly astride, hand ready for the draw. From his studded belt hangs not a gun holster, but a crocheted cod-piece amply filled by his genitals. His penis hangs limply like some exotic fruit, but its potential for strong action is implied by the firm muscles of his thigh whose form it echoes. The visual pun of the penis as gun seems to parody the chant of the basic training drill: 'This is my rifle, this is my gun (cock). This is for killing, this is for fun',[12] while offering the excitement of mock confronta-

tion. Sex with an anonymous stranger — Patrice's body is cut off from the waist up — is savoured as a dangerous encounter, an adventure that might end in death.

When Mapplethorpe does include the head, the model looks directly to camera, coolly, assertively and without hesitancy, fixing you with his eyes, drawing you in hypnotically with his gaze, until your will seems to melt into his. The model becomes the embodiment of masculine pride and one's fantasy response is the swoon of a Hollywood heroine melting into his arms and succumbing to his will in an extraordinary reversal of normal viewer/model relationships.

His nudes are objects of desire, but such is their strength and beauty that their integrity as independent beings is also retained as an exhilarating combination of coercion and availability of threat and promise. Despite their homo-eroticism, or perhaps because of it, Mapplethorpe's nudes are essentially traditional — confirming rather than questioning the myth of masculine virility. The present-day equivalents of Ruben's *Hercules*, they are examples of perfect manhood. And their enormous attraction lies in the utopian promise that the myth is not illfounded — the perfectly potent male specimen can be found here on earth.

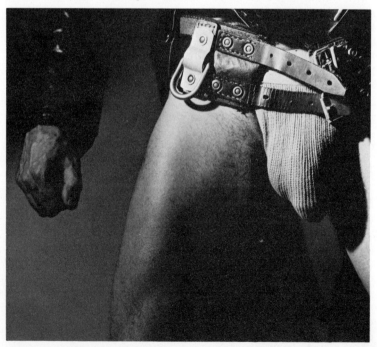

62 Robert Mapplethorpe, *Patrice*, black and white photograph, 1977

Playmales

Even from my very partial account it becomes clear that the museums, galleries and art history books are filled with male nudes to which women can respond with erotic pleasure and through which they can explore sexual options, even though the images were intended for masculine eyes and express homo-erotic desires. This has certain advantages for the female viewer who is eavesdropping on a man-to-man communication. Her presence is neither expected nor taken into consideration — it is irrelevant to the construction of the image and the message it contains. She can, therefore, indulge her voyeurism unselfconsciously like a fly on the wall, while her sexual interest is confirmed through identification with the author of the image. My pleasure in the male body coincides with Robert Mapplethorpe's and his frankness enables me to overcome my embarrassment. Mapplethorpe has borrowed heavily from the conventions of pornography in his work: 'virtually the only means currently available' says Morse Peckham, 'for showing what interests may be engaged in playing the sexual role, and presenting those interests in the form of exemplary verbal and nonverbal mediating signs of role factors ... it provides the individual with an opportunity to make an inventory of factors in the sexual role and modes of genital activity so that he may discover what really appeals to him.'[13] But as Peckham implies by his silence on the subject, there are few images of the male nude created specifically for women. Those that do exist, such as the pin-ups in magazines like *Playgirl*, although ostensibly designed to mirror and stimulate female fantasy, seem absurd, embarrassing or even insulting rather than erotic. Why is it that playmales and other pin-ups fail to offer women the pleasure of erotic fantasy when homo-erotic nudes like Mapplethorpe's are rich in imaginative potential?

The answer lies, I think, in power relations between the sexes and between viewer and viewed. Once a female observer is envisaged, her presence becomes a conscious element in the encoding of the image. The tensions, ambiguities and contradictions apparent in the male pin-up reflect a conflict of interests that is fundamental to this new interaction. The male model apparently puts himself at the disposal of the female viewer, while actually attempting to maintain a position of sexual dominance. And whereas the female pin-up and homo-erotic nude tend to be acquiescent or submissive — little more than a screen onto which men can project their fantasies — playmales try to assert their independence and to control the observer's responses.

This is achieved in a number of ways, both in the images and accompanying texts. Full names are given plus details of the man's professional status and career ambitions to establish him as

an active person in the real world beyond the image, while emphasis is placed on the unimportance of women.

Keith Bordes, for example, one of *Playgirls'* naked cowboys, characterises himself as 'a hardworking ranch hand who loves thrills. When he takes time off from his busy schedule, he likes travel and beautiful women.'[14] The woman looking at his naked body as he sits smoking in the outback can, therefore, be in no doubt that she is low on his list of priorities — a thrill to be savoured after work if she is beautiful enough.

'Bartender Dennis Cadena says his favourite aspect of surfing is the scenery: 'You get a great view of all the beautiful women on the beach.'[15] And so the viewer, in the privileged position of scrutinising his image on the printed page, is reminded that, in the real world, men do the looking and call the tune.

The point is also emphasised in the accompanying articles. 'Right now all over the country men are hunkered down talking amongst themselves ... about the score they've managed to run up thus far in their lives... his number of cars, houses, dollars, seductions, college degrees and whatever else can be counted .. Such talk occurs in bars, gymnasiums, on ships, in hunting lodges — anywhere, in fact, where women are not present... I think the reason for this lies in the fact that very, very few men have women as friends... As a buddy told me recently, 'I don't want women as friends. It's impossible. Women are for fucking.'[16]

Ostensibly designed for women's pleasure, *Playgirl* actually stresses their exclusion from the world of men and situates them negatively as admirers of masculine achievement and sexual potency. Control is established not just by captions and texts but is built into the images themselves. At stake is the whole construction of masculine and feminine identities in our society and our consequent perception of ourselves and each other. Research into sexual stereotyping in Britain and the States reveals the following adjectives to be considered desirable characteristics for women: yielding, considerate, needing approval, compassionate and sensitive to others' needs. Men on the other hand, should be independent, aggressive, assertive, dominant, self sufficient, interested in sex and seeing themselves running the show.[17]

In this light, the issue for the male model becomes how to strip off for a woman while apparently retaining those qualities which construct his sexual identity and constitute his personal dignity. Bearing in mind Morse Peckham's observation that 'Any 'vision' of the world is dictated by interests inseparable, ultimately, from the interests of self approval', the question for the female viewer is how to assert her dominance over the male by looking at and coolly appraising his nude body, without transgressing the boundaries of acceptable female behaviour even in her own

mind. For 'Not only are men expected to assume authority, but they are expected to exercise it with skill. Similarly the submission of women is expected to be well practised and successful.'[18]

Embarrassment and confusion are inevitable responses to a situation in which conflicting interests of self-approval and erotic curiosity compete — an immediate reaction on opening a copy of *Playgirl* is acute embarrassment followed rapidly by the hope that no one is looking.

Negotiation of the model's role is equally subtle if he is to hold onto any vestiges of masculine authority. He has problems of self-presentation similar to those of the male stripper. Should he adopt a bullying, submissive, aloof or sycophantic manner? Should he appear pliant or assertive? With no existing codes or appropriate precedents he is at a loss: 'the number of significantly different body attitudes capable of being maintained steadily is probably of the order of one thousand' writes Gordon Hewes. Selection from these possibilities is governed by convention, differing from one culture to another. 'Many cultures maintain careful distinctions in posture on the basis of sex, and there are others which emphasise age and status considerations in the manner of sitting and standing. Postural conformity is enforced as a rule by the same methods as conformity to other social rules of etiquette — by ridicule.'[19] This explains why so many male pin-ups *do* appear ridiculous and their body language foolish.

As discussed in *Looking Back*, the right to look is normally a male prerogative used 'to assert dominance, to establish, to maintain and to regain it.'[20] The transaction between male pin-up and female viewer is, then, a reversal of normal power relations between the sexes. In an attempt to retain dominance, the model is often set back in space as an assertion of 'otherness' and non-availability while affirming his indifference to the viewer's stare by looking past or through her, or gazing upwards as though lost in thought — contemplating spiritual or worldly goals and achievements — unaware of her presence. The viewer then becomes doubly deviant since she has not only usurped the masculine right to look, but is spying on someone's private moments.

But the greatest irony of all is that onus is put not on the model to please, but on the viewer to pin down the pin-up. Whereas the female pin-up massages the male ego by apparently servicing every whim, the male nude plays on female insecurities. Will she be the one who is sexy, pretty or clever enough to attract his attention and catch him, where others have failed?

States of Undress

Contrary to popular mythology, clothing plays a more crucial role

for men than for women. Traditionally, women strive for beauty, their dress being designed to enhance their physical appeal, so that whether naked or clothed, their bodies convey a similar set of cultural messages. But as Virginia Woolf recognised, men's dress serves a more important function. It reinforces dignity and indicates position within the social hierarchy. 'Now you dress in violet,' she writes in *Three Guineas*, 'a jewelled crucifix swings on your breast; now your shoulders are covered with lace; now furred with ermine; now slung with many linked chains set with precious stones ... every button, rosette and stripe seems to have some symbolical meaning. Some have the right to wear plain buttons only; other rosettes; some may wear a single stripe; others three, four, five or six. And each curl or stripe is sewn on at precisely the right distance apart; it may be one inch for one man and a quarter for another.'[21]

It is not an easy task, then, to denude the male without seeming to expel him from the ranks of the civilised and powerful and demote him to the level of savages and animals. Female nudity, on the other hand, is seen as more 'natural' not because female nudes are more prevalent but, as the anthropologists Penelope Brown and L.J. Jordanova point out, because 'woman's body and its functions, being more involved than man's in species life,' places her closer to nature. 'Man's physiology, by contrast, leaves him relatively free to take up the projects of culture, thereby creating artificially, whereas women create naturally... Women are thus somewhere outside culture; they are part of the nature which is to be controlled by culture.'[22] The female nude can seem so natural that writing about Picasso's nudes, John Berger could comment 'one scarcely feels that she is posing... She is there... her function is to be. She is nature and sex. She is life.'[23]

One could not envisage a comparable description of a male nude unless he were black. Richard Dyer has pointed out that black men are often photographed freely naked 'in the wild' with hints of jungle savagery and animal sexuality, or promiscuity, flavouring the image. They too are 'outside culture'.

A number of ways exist for offsetting the vulnerability and 'savagery' of nakedness. The male nude has often been given the 'dress' of symbolic significance. He has represented courage and virtue (Hercules), reason and justice (Apollo), Christian piety (St. Sebastian) and the soul ascending to Heaven (Ganymede), as well as military might and civic pride. This overlay of moral, political or religious significance acts like a cultural mantle that veils nudity, while allowing erotic potential to shine subliminally through.

Now this kind of overlay no longer seems appropriate, other forms of 'dress' have been devised. Sporting references are useful. The model can be seen swimming, surfing, working out in the

gym or horse riding nude, while associated attributes of health, strength, fitness and leisure add to his desirability and to his apparent independence from the photo-session. Doing his own thing, he can seem preoccupied and his nudity can appear to have a purpose.

Hi-tech toys can link the male with cultural achievement. The presence of fast cars, motor bikes and speed boats imply cultural sophistication and have phallic connotations plus implications of speed, power, wealth and leisure — all 'positive' attributes that accrue to the man depicted. Phallic accoutrements perform another important function. The viewer may have sight of the model's genitals, often a shock and the cause of acute embarrassment since that little piece of pendulous flesh, the symbol of masculine power and authority, cannot possibly sustain the phallic myth of superhuman virility. The exposed penis seems horribly vulnerable rather than resplendent with confidence and pride — it is illegal to show an erection.

To avoid the awkward discrepancy between fact and fancy, reality and myth, the male nude often hides his penis while implying virility by means of displacement. Rubens' *Hercules* is armed with a knobbly club so enormous that it reaches to the ground, while the aggressors in his *Rape of the Daughters of Leucippus* arrive on shining steeds, armour glinting, cloaks flying and swarthy limbs rippling with firm muscle. Their hardness and strength is contrasted with the pearly pink fleshiness of their naked victims who fall back under the assault. The men defy gravity, wrestling, struggling and triumphing upwards, while the women swoon in a deadweight of languid passivity. All the details of the picture are used to sustain the concept of masculine power and dominion over female helplessness.

In the absence of a female to master, the contemporary male pin-up has to rely on his own phallic power to impress. Surrounded by props such as motorbikes, horses and guns, attention is drawn away from the flaccid penis to other parts of the body, preferably transforming the whole image into a metaphor of erection much as the composition of Rubens' painting strains with upward surges of energy. Muscles are hardened to produce what Tony Benn describes as 'that solid feeling of becoming hard all over, the body as erection.'[24] exemplified so convincingly by Mapplethorpe's nudes. But it is a difficult task to achieve that level of conviction and calm sexual authority. 'Hence,' writes Richard Dyer, 'the excessive, even hysterical quality of so much male imagery. The clenched fists, the bulging muscles, the hardened jaws, the proliferation of phallic symbols — they are all straining after what can hardly ever be achieved, the embodiment of the phallic mystique.'[25]

As he is presently constructed, the male pin-up is an unhappy creation, riddled with contradictions and anxieties. He is also based on a total misunderstanding of female erotic fantasy, assuming that what she wants in real life — a fulfilling relationship with a loving partner — is what she wants in her dreams. But, unpalatable as it may be to many men and women, I would argue that erotic fantasy works in much the same way for both sexes.

There is just one rider that needs to be added. If I imagine visiting a male prostitute, what checks my pleasure even in this projected encounter is his personality. Given my conditioning as described by Archer and Lloyd, to be yielding, considerate, sensitive to other's needs, and approval-seeking, I cannot, even in my thoughts, ignore the character, feelings and judgements even of an imagined sexual partner, as a man evidently can. Since I am unable to cancel out his personality, I am obliged to pay attention to it and here lies the problem. When I look at the playmales offered in the pages of *Playgirl*, I recognise that self-conscious exertion to achieve a macho image, which I find laughable; I read the model's faces which I find arrogant, smug or stupid, and I know with certainty that I would want no contact with any of them.

Since I cannot ignore the model's personality, in order for me to act selfishly and without fear of ridicule or censure, his personhood must be eliminated. He must be transformed into an object that does not make judgements, has no independent desires and whose life beyond the present moment is held in abeyance. Only then can I freely concentrate on my own responses and allow my fantasies full flight.

But this is exactly what playmales fail to offer. By denying female sexuality beyond the passive and receptive, they reaffirm traditional power relations between the sexes and insist on the status quo. In doing so they serve the interests not of their audience, but of the teams of people — mostly males — who create them.

Opportunities are denied for exploring alternative interactions or imagining 'deviant' sexual options. They fail in the very area which pornography is designed to service — the exploration of a range of socially unacceptable possibilities, which would allow women to discover where their sexual interests actually lay. But this would also be highly subversive since it would encourage them to identify their sexual proclivities beyond the parameters of masculine requirements and projections. It would mean acknowledging women as fully sexed adults and offering them sexual autonomy — an idea perhaps still too threatening not only for men, but also for many women.

Female Erotica

Is the male pin-up *necessarily* unsatisfactory, then? The answer is, of course, no. Women are beginning to make images of the male nude for themselves, without looking over their shoulders for masculine approval. Lill-Ann Chepstow-Lusty's *Lovable Nuts*, featured as the book's frontispiece is, for instance, a humorous experiment in role reversal. A packet of KP nuts is tucked into the trunks of a smooth skinned young man who looks directly to the camera with none of the edgy self-consciousness or studied indifference of the playmales. The softness and neutrality of his face, half hidden in shadow, offers no resistance. The firm flesh of his fine body is made available without conflict, tension or anxiety on either side of the interaction.

His personality has not been eliminated, but neutralised or made ambiguous. Standing close to camera, he offers his body for our scrutiny and pleasure, yet he is not submissive. There is confidence in his bearing and posture. The image is extremely subtly tuned — his presence is neutral enough not to block the free play of sexual fantasy yet strong enough to support transference and make it seem feasible, desirable and appropriate.

Attempts by other women to create male pin-ups indicate that this balance is not easily achieved. Carole Latimer is determined to 'put Apollo back on his pedestal' as a beautiful and romantic creature. Her carefully posed photographs (fig.63) are of well built young men, naked except for small, togo-like pieces of cloth draped across their genitals. They relax into the limbo of the studio with no props except a phallic candle, lit as though in homage to their beauty. They look to camera, alert yet passive, awaiting her pleasure.

In her attempt to humanise and soften the male — to destroy aggressive phallocentrism in favour of a more diffuse sensuality — she has given them gentle expressions and nonassertive poses and photographed them with soft lighting and focus. While the crispness of Chepstow-Lusty's photograph gives an added frisson to the encounter, the softness of Latimer's images weakens sexual tension. These men seem docile and submissive, like pets — she has not only neutralised their phallic power, but has castrated them altogether.

Roberta Juzefa's *Aura* lies outstretched on a Persian rug, his body bathed in a shaft of light that pours in through the window and shines around his body in a golden glow. Light seems to radiate from his flesh like an aura, implying that he is 'too hot to handle', while the coy drama of his pose and the unusually long penis held delicately down by one hand, encourage one to read the photograph as a parody.

63 Carole Latimer, *Untitled*, black and white photograph, 1981

64 Elisabeth Frink, *Man and Horse II*, lithograph, 1971

As explained in *Looking Back*, reversing power relations between men and women within the artist/model encounter is a proposition fraught with complexity for both participants. Not surprisingly, women have found it difficult to make convincing images of the male nude. Sylvia Sleigh's painting of *Philip Golub Reclining* (1971) (fig.65) is an interesting work because it exemplifies some of the problems inherent in this role reversal. The painting is riddled with contradictions and paradoxes. Both artist and model are in a transitional state — ridding themselves of old patterns of behaviour while not yet having achieved satisfactory new interactions. Martha Wilson's observations that 'art-making is an identity-making process'[26] seems especially pertinent to an understanding of this picture.

Golub's slender body, long hair and fine features appear 'feminine' while his languid pose, bracelet and apparently narcissistic involvement with his own reflection also encourage a feminine reading of his personality. He seems, in fact, to epitomise John Berger's description of the 'surveyed female' as one who 'turns herself into an object of vision: a sight'.[27] But there is something unsettling about his pictorial presence, something in the relationship between artist, model and viewer which is forced and uncomfortable.

The artist can be seen in the mirror working on her canvas and concentrating on her model. She is the active, the 'masculine' presence, yet she wears the role unhappily like a borrowed coat. Nor can her small figure, set back in the space of the room, counterbalance Golub's large head, placed in front of the mirror and reflected life-size.

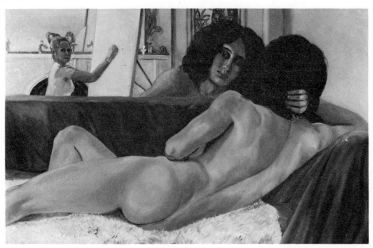

65 Sylvia Sleigh, *Philip Golub Reclining*, oil on canvas, 1971, 42″ × 60″

Her assertive stance seems self-conscious, even forced. As she paints she also poses for her self-portrait — watching herself at work, as it were. In this respect she is still trapped inside the feminine position as delineated further by Berger. 'A woman must continually watch herself... whilst she is walking across a room or whilst she is weeping at the death of her father, she can scarcely avoid envisaging herself walking and weeping... She has to survey everything she is and everything she does because how she appears to others, and ultimately how she appears to men, is of crucial importance for what is normally thought of as the success of her life.'[28]

Looking again at Sylvia Sleigh's painting, the absurd thought comes to mind that the artist is posing for her model as well as for herself and us. He seems to be watching her attentively in the mirror and measuring her progress. For in spite of the intensity of her concentration, it is his presence which asserts itself the more strongly. In spite of his passivity, Sylvia Sleigh has not managed to neutralise her model's calmly assertive stare. One's eyes are drawn past his supine body to the reflection of his face and his clear eyes — until embarrassed by his look one turns away. Like Manet's scandalous *Olympia* the model shames the viewer into guilty self-consciousness of her voyeurism.

Macho Males

Instead of 'gentling' the male as Sylvia Sleigh has done, the American sculptress Nancy Grossman explores the traditional notions of masculinity, portraying men as victims of a constricting self-image that inhibits growth. Her full-size *Male figure*, for instance, (fig.66) is restrained by straps and buckles that bind his arms above his head.

His head and whole body are covered in a shining skin of black leather which, with its zips, buckles, studs, straps and laces, resembles restrictive sado-masochistic clothing, while fitting so tightly over the muscle-bound body that it could be his own skin. Zips slant across eyes, mouth, cheeks and arms like tribal markings or scar tissue recently formed over vicious knife wounds or whip lashes, preventing the communication of his pain. He cannot speak, hear or see.

Whether he is the metaphoric victim of a macho self-image that inhibits intelligent or humane interaction or an actual prisoner is not clear. For whatever reason, the firm flesh of his well-developed body is entirely at our disposal, while the sado-masochistic overtones of the work bring a frisson to one's speculations encouraging sadistic thoughts that might normally horrify the viewer. In this respect Nancy Grossman's sculpture acts as a

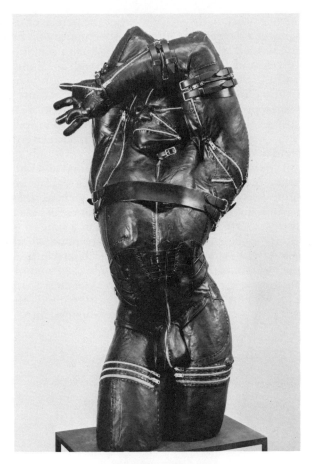

66 Nancy Grossman, *Male Figure*, leather over carved wood, 68″

trigger releasing aggressive fantasies that would otherwise prob-
ably lie dormant, especially bearing in mind Phyllis Chesler's
observation that 'female sexual aggression or sadism towards
men is even more tabooed (than lesbianism)'.[29]

The disgust felt by many men and women for the bullying,
authoritarian and inhumane aspects of masculinity are tempered
in Grossman's sculptures by a sexuality that confuses one's re-
sponses and frustrates easy moralising. Their importance lies in
providing an opportunity calmly to examine the attraction and
repulsion of the fascist persona, its stylish accoutrements, impecc-
able self-presentation and the enslavement of its active and pas-
sive protagonists to power.

'The psychic insulation of artistic behaviour', writes Morse

Peckham, 'may work in three ways: either the perceiver uses it to permit himself a degree and intensity of response that he could not permit himself when faced with such situations in life; or he uses it to respond to disturbing material with a calmness and objectivity he could not summon in life situations; or he uses it to practise the culturally appropriate response... because of the peculiar social protection often characteristic of artistic behaviour and the psychic insulation... because of art's irresponsibility — it is, as we have seen, admirably suited for material which is disturbing, forbidden or confusing.'[30] Her *Male Figure* is only one of a number of victims that appear in drawings bound and fettered in tight leather, whose helplessness encourages sadistic readings and responses. Nancy Grossman's heads, such as *R.O.* 1968 are claustrophobically hooded in leather that covers everything but their noses, effectively trapping them in a state of sensory deprivation — unable to communicate or respond to stimulus. These heads, (fig.67) of which she has made about a hundred, are more ambiguous than the standing figures. In their smooth leather sheaths they become extremely phallic. 'The most erotic thing is the brain — there's no eroticism without the mind', the artist explains.[31] Sexuality and the intellect are combined into a potent

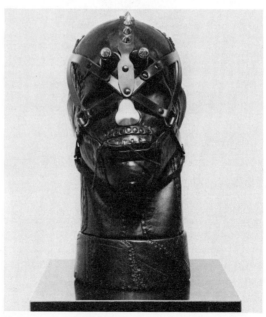

67 Nancy Grossman, *Head Sculpture*, leather over carved wood, 1969-70, life size

phallic force — the head has become the locus of sexual aggression. In some drawings a powerful gun is strapped onto the face like a muzzle, forcing the wearer to look through its sites. His perceptions are so controlled that he can only think and act murderously.

Yet the constriction of the leather hood and the consequent malfunctioning of the sensors turns these heads into metaphors, not of virility and sexual drive, but of frustrated desire — one head is attached to a leash so that the man can be lead like a dog and forced to perform to order. Grossman's drawings and sculptures offer a frightening glimpse of a world in which sexuality and aggression are inextricably linked, where communication is irrevocably blocked and frustration rules.

Mandy Havers also fashions her figures in leather, stitching it tightly over padding to describe the contours of muscles, ligaments and flesh. Gloves, hoods, straps, buckles and zips also create ambiguous readings between clothing and flesh, but her *Hooded Wrestler* (1976) (fig.14) and *Black Man* (1981) (fig.68) seem to be enslaved by the ethos of the body beautiful and the toughness of spirit that matches it rather than by an external, restraining skin.

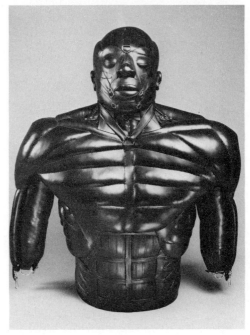

68 Mandy Havers, *Black Man*, leather and mixed media, 1981, 68 × 80 × 40 cms

They are muscle-bound body builders trapped by the exaggerated development of their biceps, triceps and other brawn. Whereas her *Wrestler*, arms akimbo, eyes flashing and lips set in a firm line, is a parody of strutting machismo — ridiculous in his brutish self-importance, her *Black Man* has more personal dignity. His padded shoulders suggest the gear of an American footballer, while his closed eyes imply introspection and restraint as if one could peel away the layers one might uncover a more receptive personality. The desire to 'undress' him is heightened by the

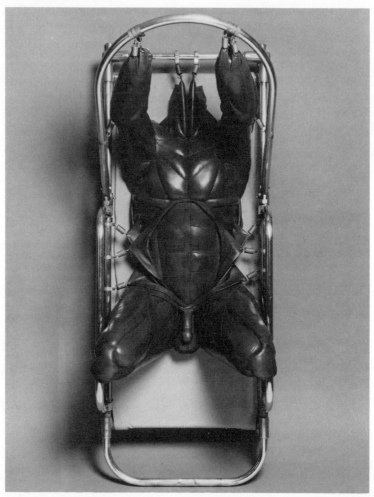

69 Mandy Havers, *Framed Figure*, leather and mixed media, 1980, life size

erotic beauty of the shining leather and firm body, strongly re-
miniscent of Mapplethorpe's sculptural nudes.

The outer skin of her *Framed Figure* (1980) (fig.69) has already
been pulled back. He is a headless torso pegged out on a metal
frame. The air of orthopaedic exactitude suggests that this hand-
some body is the victim not of seduction but of institutionalised
violence — perhaps of human vivisection awaiting the surgeon's
blade. His plight is made more poignant by the muscular perfec-
tion of his body, while a disturbing aspect of the sculpture is the
eroticism of the victim's vulnerability — his firm thighs and trun-
cated knees thrusting phallically forward on either side of perfectly
formed genitals, his body accessible to the caresses of mind or
hand. Mandy Havers has literally pinned down the male in order
to be able to scrutinise him at leisure and to enjoy him as sexual
and aesthetic spectacle.

One of the earliest emblems of phallic potency to be made by a
woman is Elisabeth Frink's *Torso* of 1958 (fig.70). All that remains
of this badly mutilated body are thighs and a torso lying on its
side, yet the limbs are firm and muscular and the fine body resem-
bles the trunk of a tree — compact and resilient. In spite of his
deformity, the overwhelming sensation is not one of impotent
defeat but of virile strength, the castration subliminally implied
by amputation being countered by the large genital mound at the
centre of the composition and the phallic shape of the overall
work. Here is a powerful masculine sex object — passive yet po-
tent — comparable in its sexual intensity to Michelangelo's *Dying
Captive*.

70 Elisabeth Frink, *Torso*, bronze, 1958, 13" × 39"

In her essay, Rozsika Parker comments on the number of artists and writers who have maimed their heroes in order to gain access to the male through his vulnerability. Frink's torso clearly comes into this category, especially as her other sculptures focus on the destructive and dangerous aspects of the masculine character. Nancy Grossman and Mandy Havers' work incapsulates overtly aggressive impulses towards the male. Seeing him both as dangerous and endangered by his own militancy, they turn the violence back on itself and encourage fantasies of vengeful sadism.

Few women have shared Robert Mapplethorpe's unbridled enthusiasm for masculine strength and his perception of it not as a threat, but as an embodiment of the Renaissance idea of 'virtu'. Latimer, Sleigh, Juzefa and even Chepstow-Lusty temper love and admiration with irony, ridicule, or a desire to soften the male to the point of castration. Women have, by and large, portrayed men either as beasts that need restraining, or at the other extreme, as placid castrati. Is it possible, then, to 'gentle' and sensualise the male without 'castrating' him?

Gentle Men

My own photographs (fig.71) are tender glimpses of a body well known and much loved — an expression of affection and closeness, not of the distancing necessary for the free play of erotic fantasy. The body is neither invested with lustful potency nor shameful impotence. The genitals are seen not as symbols of dominance nor as evidence of vulnerability, but more matter of factly as a known source of intimacy and pleasure. He offers his nudity to camera calmly and without anxiety, confident that he is loved and accepted. One senses the mutual respect and co-operation between subject and photographer — he has not been 'taken' but freely declares himself.

Elisabeth Frink's lithographs are exceptional in depicting the male with astonishing warmth and sensuality. Rarely has a woman's sexual interest been expressed with such relaxed eroticism. In six lithographs, *Man and Horse* (1971) (fig.64) are depicted in harmonious collaboration, Skin-tight trousers, boots and close-fitting helmet are subtly indicated, fitting so perfectly that the rider seems naked in his relaxed well-being. In three of the prints he sits astride the horse — no need for reins or saddle, since horse and rider are essentially one — while a doubling of the image suggests the rhythmic motion of their gallop. In remaining prints the two relax in sympathetic familiarity, leaning against each other with affection. The firm but mature body of the man is depicted with crisp lines and feathery strokes which lightly caress

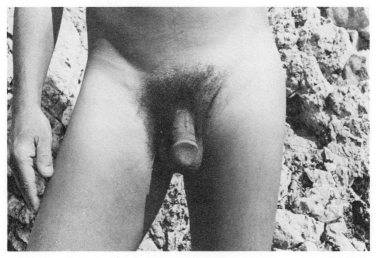

71 Sarah Kent, *Male Nude: California*, black and white photograph, 1982

72 Sarah Kent, *Male Nude: California*, black and white photograph,1982

the forms into being, while the image of the horse, created from dabs, washes and puddles of ink — wildness held delicately in check — is less clearly defined. These free creatures offer an idyllic view of unselfconscious sensuality tempered by care and affection — the symbol of a loving couple and of a man at peace with his animal sensuality.

Freudian psychoanalysis identifies the horse, especially for women, as a symbol of masculine sexuality. As psychologist Bruno Bettelheim observes 'by controlling the powerful animal she can come to feel that she is controlling the male or the sexually animalistic within herself.'[32] Elisabeth Frink's man and horse offer a vision of a utopian state of empathy between man and nature, man and himself, and between man and woman, in an interaction of mutual co-operation and respect that seems a long way off from present reality.

The exploration of women's erotic fantasies is, meanwhile, in its infancy. We have still to combat self-censorship and prudish resistance to a topic that is still not acceptable for discussion or display. It is essential that we should continue our enquiry, visually and verbally, to overcome ignorance of our own sexuality. Adrienne Rich has pointed out that 'ignorance of ourselves has been the key to our powerlessness... Without such knowledge women live and have lived without context, vulnerable to the projections of male fantasy, male prescriptions for us, estranged from our own experience.'[33] Only when women eschew masculine projections and replace them with their own descriptions and analyses, will female sexuality be recognised as an independent and constructive emotional and creative force.

Footnotes

1) Georges Bataille quoted by Robert Sobieszek in *Nude Photographs*, Constance Sullivan, ed., New York 1980, p. 171.
2) Sullivan, p. 171.
3) Morse Peckham, *Art and Pornography*, New York 1971, p. 89.

4) Phyllis Chesler, *About Men*, London 1978, p. 229.
5) Germaine Greer quoted by Dale Spender in *Man Made Language*, London 1980, p. 177.
6) John Archer and Barbara Lloyd, *Sex and Gender*, London 1982, p. 88.
7) Adrienne Rich, *On Lies, Secrets & Silence*, London 1980, p. 199.
8) Peckham, pp. 123 and 169.
9) Peckham, p. 161.
10) Alain Robbe-Grillet quoted by Robert Sobieszek p. 171.
11) A. Lingis quoted by Tony Benn in *Camerawork*, November 1982, p. 5.
12) Rich, p. 115.
13) Peckham, p. 186.
14) *Playgirl*, August 1982, p. 70.
15) *Playgirl*, July 1982, p. 68.
16) Harry Crews, 'Man Talk' in *Playgirl*, July 1982, p. 45.
17) Archer and Lloyd, p. 42, reporting on research carried out with university students by S.L. Benn and others.
18) Archer and Lloyd, p. 127.
19) Gordon Hewes in Ted Polhemus, *Social Aspects of the Human Body*, London 1978, pp. 81, 85.
20) Nancy Henley, *Body Politics*, New York 1977, p. 166.
21) Virginia Woolf, *Three Guineas*, London 1977, p. 23.
22) Penelope Brown and L.J. Jordanova, in *Women in Society*, London, p. 227.
23) John Berger, *The Success and Failure of Picasso*, London 1980, p. 186.
24) Benn, *Camerawork*, p. 5.
25) Richard Dyer in *Screen*, Sept/Oct 1982, p. 71.
26) Martha Wilson quoted by Lucy Lippard in *From the Center*, New York 1976, p. 106.
27) John Berger, *Ways of Seeing*, London 1972, p. 47.
28) Berger, p. 46.
29) Chesler, p. 229.
30) Peckham, p. 111.
31) Nancy Grossman in conversation with the author, January 1983.
32) Bruno Bettelheim, *The Uses of Enchantment*, London 1976, p. 50.
33) Rich, p. 240.

Vienna and London:
in conversation with Gertrude Elias
Sarah Kent & Jacqueline Morreau

Question: How would you describe your work as an artist?

Gertrude Elias: I'm not interested in working for an elite — having work hung in people's drawing rooms. I prefer to do things for publication, such as political cartoons. I work because I have a specific comment to make, a message for women's liberation or other causes that I support. I have made various series of wood and linocuts, each based on a theme. One series called *Intimacies*, of men and women in intimate situations, was produced, for example, after an infatuation which had shaken me to the bone. In my experience, man-woman relationships are very different from the way they are portrayed in the cinema. I always had to conquer the man I wanted. I showed the woman taking on the man, trying to understand him. She gives herself completely, in the nude, while he remains shrouded — clothed. She is open for the love affair, yet he doesn't respond. Women give much more in love, often to men about whom they know too little. Although I'm not a lesbian, I have learned far more from women. They are more generous in parting with their experience and knowledge — perhaps it was just my personal experience...

Q.: Isn't that a typically female reaction — to discount your own perceptions and imagine there's something odd about your own experiences? So much of our cultural input offers the male view, while being presented as though it were objective or somehow 'universal'.

G.E.: Exactly, those things that each woman regarded as her personal experience have now become, so to say, our common experience. At the time I made those prints — about thirty years ago — some of my friends thought they were the best things I had done, but the publishers refused to print them. They found them bitter and depressive and thought that no-one would understand or be able to identify with them. Impatient as young people are, I

destroyed many of the plates. But when I exhibited some of them recently in an exhibition which I had organised to mark International Women's Year, I was amazed at the way women responded — they became an instant success. If I were dead, they might even fetch good prices!

Q.: How do you relate to the feminist movement — it must have been interesting watching it grow?

G.E.: Well, before the war it was called the movement for equal rights and emancipation and was geared to women imitating men. During the 1920s you could see women wearing men's hats, collars, ties and so on. Today no women would dream of imitating a man in such a way. I think — and this is a very good thing — we have dethroned the man, theoretically at least, and we no longer want to imitate him.

Q.: What we want as women is still a crucial question. Do we simply want to displace men and have their power transferred to us, or do we want our perceptions accepted as part of world knowledge? Very few women have really thought about what femininity is and what they want to have known about women's experience.

G.E.: Perhaps in twenty years, as our ideas evolve and conditions change, our concept of femininity will have completely altered. When we think of masculinity, we need not think only of generals and hunters — we still accept the roles we were taught in children's books and women's magazines. I was brought up in a very different atmosphere — in the shade of a despotic, all devouring virago. My mother was a formidable creature. With her zest for adventure and talent for standing up for her rights, she ought to have been in charge of a travelling circus. But she wasn't trained for anything that could absorb her surplus energy except playing the piano until the window panes rattled and were covered with steam. As an only child, I soon understood what oppressive regimes mean to the defenceless. She frightened me to death and by the time I was five, I was determined never to ask her for anything no matter how much I wanted it, simply to avoid controversy. She had been carrying on a lesbian affair for many years until it broke down because of her intolerable possessiveness. For years she was hanging on the telephone trading jealous outbursts. That taught me a useful lesson, particularly for my marriage with Charles, that possessiveness and intolerance are incompatible with good relations.

Q.: Did your father know about the affair?

G.E.: Of course, but in Vienna everything was regarded as funny.

In reality it wasn't funny at all, though I didn't understand at the time what an eccentric home we had. You can't judge these things as a child. My father didn't take me seriously. He was an immensely popular man — a poor man's lawyer, a political animal — extremely erudite and witty. He couldn't be bothered with family trivia. Looking back, it seems to me that his sense of justice was confined to the law courts and to public affairs. At home he disliked being asked for legal aid. When I complained about my mother, he brushed it aside saying he didn't like 'informers'. Only when I had blood streaming down my nose did he go into action. A child's complaints about a cruel mother were never listened to because it offended conventional morality — only step-mothers and mothers-in-law can be depicted as cruel.

Q.: It sounds to me as though she was horribly frustrated. Do you think she had too much energy to be a housewife?

G.E.: Yes. I came to the conclusion, watching her, that women who have too much energy and are too masculine shouldn't have children. She nearly destroyed me. I was the only child, but she neglected me — I nearly drowned in the bath, for instance. Something terrible was always happening. She let the canaries starve to death in their cage and all the flowers in the house died. There was this grandiose, operatic figure totally unfit for domesticity — she was a horror to me and my greatest fear was that, one day, I might become like her. Her provocative self-assurance explains my self-destructiveness and timidity, which made me incapable of fighting when my work demanded it. I only overcame it years later when I started to fight for general issues and lost my ego in the big causes of our time.

Q.: She must have been very angry to let the canaries die — it's such a blatant rejection of the woman's traditional, succouring role.

G.E.: She regarded herself as a very modern woman. She was an excellent sportswoman — a tennis player, swimmer, skater, hiker and a good shot with a gun. Young people tend to think that fifty years ago women were entirely different from themselves, but we lived in a very open-minded society — it was not a restricted life for a woman.

Q.: What was it like for a woman student in Vienna before the war?

G.E.: Perfect — it was marvellous. I was the youngest student at the Austrian School for Applied Arts during the days when the Austrian Republic was perhaps the most progressive country in Europe, and although the economic crisis, sparked off by the

Wall Street crash of 1929, destabilised the entire capitalist world, we still enjoyed the political freedom and the richness of our culture made up for the lack of material things people nowadays take for granted.

It was also the period of women's emancipation. In the years which preceded Hitler's seizure of power in 1933 women made rapid strides forward and were gradually accepted as equals. The Nazis pushed women back totally after that. It was stipulated at the first meeting of the Nazi party — three years after the end of World War I that women should, under no circumstances, play any part in public life. That was because they had played an eminent role in the peace movement during the First World War. In 1915, a meeting was called in the Hague sponsored by the great American pacifist Jane Addams, the Dutch physician Dr. Aletta Jacobs, the British suffragette Emmeline Pethick Lawrence and the German socialist Lyda Gustava Heymann, as well as lesser known women from all over Europe, to end the war. When they went back to their own countries, many of them were persecuted and some were even imprisoned. In civilian life you can get into trouble for disturbing the peace, but those women got into trouble for disturbing the war! Nobody really understood why the Nazis pushed women back a hundred years. People said it was to combat unemployment, but in 1921 there was no unemployment. It was because they would have interfered with militarism and the Nazis were dedicated to a second world war — the plan of waging another war came instantly after World War I was over. Women's liberation was put down in all countries that came under Nazi occupation and it wasn't until the 1960s in the States that there was serious awakening of the women's movement.

Q.: So when you were a student, what was the attitude towards women?

G.E.: Neither at grammar school nor at art school did I ever feel like a second class citizen. I had the good luck that both my father and teachers took an interest in my development. There was a tendency for girls to go into the fashion classes, but I always wanted to be a book designer and I went into the printing class. At the age of nineteen I had already won two national prizes — one for newspaper cartoons and one for a poster. There's nothing I love more than the printed page. It is my aesthetic ideal and I earned my living like that for many years.

I left the art school with flying colours, yet what to do with my 'qualifications' was another problem. Not one of my colleagues could find a job; only one girl who had good connections at the top and knew how to ingratiate herself with men managed it. I had neither of these assets and Charles thought we should try our

luck in London, where according to my art mistress all the doors stood open to the artist!

Q.: What year was that?

G.E.: We left in February 1938, three weeks before the Nazis occupied Austria. It was the greatest luck we ever had and I can say for sure that, even if my work hasn't brought us much profit, it has certainly saved our lives.

It was in England, then, that I started my career. We took up lodgings in a tiny bed-sitter in a Bloomsbury slum to make the fourteen pounds that we brought with us last a bit longer. I was inarticulate and shy so Charles took on the arduous job of going round the publishers to solicit orders for illustrations and book jackets. His charm and good looks must have appealed to the men — it was a very exclusive profession and he brought home commissions from Bodley Head, Constable, Collins and so on. And without giving the matter much thought, I signed myself 'Elias'. It was only much later when they had to call me for discussions that they discovered that the artist was a women. 'With those magnificent features, we would never have taken your husband for anything but the artist himself,' they used to say, a bit ill at ease and puzzled.

Q.: Did you mind that?

G.E.: No. I had no great personal ambitions at that time. I was happy that it appeared and was successful. The fact that a woman would do this type of work appeared strange to them. Men in England at that time seemed to be scared of women. Nobody ever drew me into a conversation, nor was I invited out for a drink as Charles was. It taught me something that I often noticed later. The truer the fact, the less people will believe me. It's a terrible realisation and it explains the success of all the frauds and phoneys in the world.

Q.: When you were a student, were there any women artists that were important to you?

G.E.: No. My favourite artist was Franz Masereel, a Flemish Artist — a great woodcutter. When I came to England I wanted to exhibit his work as well as my own, but people didn't want to touch it. Cultural chauvinism was rampant and progressive German art was unknown here. It had to wait until Brecht was translated during the last decades. But times have changed. The political situation in England is growing harder, and the harsh graphics of the German school suit the present political climate very well.

Q.: Presumably when you worked to commission, there were res-

trictions on what you produced.

G.E.: Yes, but I got used to it. This type of work gave me immense pleasure and I kept it up intermittently even during the war when I worked in an aircraft factory on the lathes. For years and years I worked at five inches by eight and in black and white and two colours, and only in line. Everything I did was either published or sold, but during the fifties the craze for colour photography began to replace graphic artwork and orders began to slacken. I had to look for a permanent job in a studio to bridge the lean intervals between commissions. That was my first real encounter with male chauvinism. I deliberately applied for jobs sending specimens of my work but without using my Christian name. I was always invited for interviews, but when they saw me they were appalled, because I had applied for senior positions. In the end I found a job in an agency, but the idiocy of the work and of the studio hacks bored me stiff.

My fate was not an isolated case. It was the time when men were demobbed from the services and most women who had done essential work during the war were suddenly made redundant. Women fell ill with all sorts of psychosomatic symptoms which the doctors could find no explanation for. It was virtually an epidemic of the malaise which we now call frustration.

It was at that time that my series of *Doctors and Patients* came into being as a residue of a confrontation with the pundits of the medical profession. My 'ill health' was nothing but the cumulative effect of my struggle to keep alive and to carry on my work under the most intolerable conditions, from which I saw no way of extricating myself because I had no money. I felt paralysed and choked. I still lived at that time under the illusion that doctors, particularly psychoanalysts, were some sort of father figures with whom one could sort out one's problems when one had no other intelligent person to turn to.

I was appalled by their archaic views on women, and because my depression wasn't due to sexual frustration, they would only pontificate about my 'unwillingness to adjust to the feminine role.' The fee I had to pay for listening to that tripe had the effect of shock treatment — it cured me instantly! Suddenly it dawned on me that it was quite foolish to expect 'liberation' from a psychoanalyst, I realised that my problems were in fact all our problems, and that they were due to the unnatural and inhumane conditions which our system imposes on us, conditions which no human being alone can change. I can't look at my life as an artist in isolation from the political upheavals which have decimated my generation. Years were wasted through economic crisis, not to speak of the war and events which made survival a sheer miracle.

And unless my work sells I stop doing new things — which is very bad. One must have faith in going on.

Q: Do you find it difficult to sustain yourself?

G.E.: Very difficult. When you have no private income you are bound to do other jobs and your work suffers. Arthur Rubenstein said "When I don't play for a day, I notice it. When I don't play for a week my wife notices it. And when I don't play for two weeks, the audience notices it!' It's even more true for designers and painters.

Q.: Was getting married a difficult decision for you?

G.E.: No. I've been married since I was seventeen. We knew that we would have to elaborate our own golden rules and not follow the catechism strictly. Charles was a hero taking me on with nothing but a bunch of unpublished cartoons as my dowry and a lifetime of green lettuce and hard boiled eggs ahead of him. We promised not to destroy each other's freedom — not let monogamy degenerate into monotony. Charles needs young women who he can take to the opera and discuss with them the merits of the coloratura sopranos, whose voices drive me mad. I had to build soundproof walls between our rooms to avoid his music sessions. I, on the other hand, like endless political debates — I have to go to meetings and change the world! And I do like men. Charles does not:'Meet your men wherever you like,' he would say. 'In the meantime, I will listen to Elizabeth Schwarzkopf.'

I was extremely lucky that I didn't appeal to men who were ambitious, or wanted to be the master — no Citizen Kane ever wanted to marry me. Really I chose *him*. If you live with a man you admire too much, he may well paralyse you. I think it's better not to go for the big game. Men never do. They are terrified of forceful women and they are probably right — they must protect themselves. When I was still young and foolish, I dreamt of a friendship with a superman who would inspire me and carry me with him into the Pantheon of celebrities. Then one day, I thought I had found one and although I had no carnal desire, I complied, hoping that this would be the price for the great things to come. The best that can be said about the whole affair was that when it was over, I felt as though I was newly born. He had crushed me completely. Ever since then I have avoided 'giants' like the plague.

My father was the best friend I ever had. He was killed along with more than a thousand others in the bloody fascist coup that overthrew the Austrian republic. I missed him for many years and regretted that he couldn't witness my development since it owed so much to his early inspiration.

He made friends with people of all classes and colours and was particularly fond of intelligent women colleagues at the bar and political journalists. These were the *hetaerai*, or companions, whose company cultured men cherished in ancient Athens and in Renaissance Italy and later in Paris and Vienna. The horrible 'male only' clubs of England, which betray a complete insensitivity and mental sterility, would not have appealed to any men outside military circles. So although I have always been a fighter for emancipation and economic independence, I have never regarded men as women's enemies.

Q.: How did England seem to you after Vienna?

G.E.: At first I was appalled. It was the winter of 1938 and London was shrouded in fog. England was still frightfully puritanical. You wouldn't believe how depressingly respectable one had to be. One had nowhere to make love because landladies were the dictators of morality. I was warned by friends that my smile might be misinterpreted — I would walk along the street laughing. In Vienna when you wear a glum face people think something dreadful is brewing in your head.

Q.: That gaiety doesn't come out in your work does it?

G.E.: Clowns are often very sad people. But I see the funny side of things — when I was ill, for instance, the doctors appeared quite ludicrous to me.

Q.: In your prints they seem quite threatening and the women patients appear to be their victims.

G.E.: The doctors are not threatening, they are incongruous and lifeless although they deal with life. They are alienated from their patients who belong to another species — the sick. They have learned everything from their books except how to talk to the patient as an equal — nowhere is the class barrier more intolerable. They are deliberately astringent so as to prevent the patient from unburdening herself and taking up too much time.

Q.: Don't you think that doctors exemplify the way men behave towards women anyway — the situation is simply more exaggerated, because as a patient you are so powerless. You didn't have any children?

G.E.: No. I was never interested. It was one of the things that Charles and I always agreed on. Most women live with much too much on their shoulders. One has to differentiate between what one wants, what one needs desperately and what one cannot do without. British women impressed me instantly, especially your grand old ladies. English women are far more independent and

more courageous than their continental sisters, and they have a longer tradition of political struggle. After all England was an industrially developed country and women have worked and fought for their rights here for nearly 200 years. Then comes the British Library — I couldn't have done without it.

Q.: What about the men?

G.E.: Your menfolk? It doesn't surprise me how many young women hold onto their teddy bears even after they get married... Charles is very Austrian and fond of women in the great Romantic tradition of Schubert's music and songs. And women love him for it. It was Goethe who said that his genius owed much to the feminine in his makeup. He never denied how much he owed to the inspiration of women. What we now call 'male chauvinism' is nothing other than cavemanship brought into our age by puritanism and militarism. And it finds its culmination in the cults of virility and violence.

I was amused when I saw the English rendering of Schnitzler's *La Ronde* and the way in which the English actor talked down so harshly to the prostitute. A Viennese wouldn't talk to a prostitute like that — to his wife maybe, but not a prostitute!

Q.: Many feminists argue that wives are essentially prostitutes.

G.E.: Yes, but I think some wives suffer more than prostitutes — although I can never believe that the domineering husbands you read about really exist. The ones I know are mostly indifferent — their interests are all outside the home. They wouldn't bother to bully the family, because they simply aren't there enough.

Q.: You can also bully someone by neglect! Tell us about your other print series.

G.E.: After *The Doctors* I made a series on *Art and Money* showing my views on the art dealers and the sufferings of artists who have to wait for posthumous exhibitions before getting a good write-up. There is a dearth of art which examines real situations and deals with them in a satirical way. I made another series of linocuts about how men look at women and the way women woo VIPs at cocktail parties. When you're short, as I am, you can never catch anybody's eye... Men don't like to lower themselves when they talk to you. My mother didn't want to come down to me when I was a child — I don't remember that she ever knelt down. There is some arrogance in these tall people.

Q.: Are you economically independent? And do you think that's an important question?

G.E.: Yes. I think it is important. We've always shared our money. It's much easier to share a bed with someone, but one of the essential things about marriage is that you can share a bank account. It's not good to keep men — it's probably not good to keep women either. I think all people should be economically independent, so that they are not tied to people they don't love.

Q.: If you had a daughter, what advice would you give her?

G.E.: Work hard, study hard. Don't marry early — but I'm not against the institution of marriage, you must have something stable. There is nothing more important than security. Our society offers freedom but no security. First there must be security, then freedom. When you are ill, there's somebody to look after you — this is marriage. It's not a source of constant stimulation, but it's very, very difficult to find someone in life who will rejoice with you in the little bit of happiness that you have — it's the rarest thing.

Q.: What would you regard as success?

G.E.: To be able to sell your work and to get it published. At certain periods I regarded myself as eminently successful — I couldn't have gone further — my political cartoons, book jackets, everything, were published. Recognition is very important and you need somebody whose opinion you respect, otherwise you feel as though you are swimming in the open sea.

Q.: It's very hard to find intellectual stimulus, feedback and criticism, especially if you are not out in the world making daily contact with other people, as most men are.

G.E.: Women don't take each other seriously enough — you have to treat your colleagues with respect.

Q.: But professionalism is a very complex issue. Some Marxist feminists, for instance, are questioning whether women should take part in the masculine rat race at all.

G.E.: I have heard this idiotic theory. There are also certain fools who claim that everybody is an artist. This is perfectly ridiculous!

Q.: Is fame important?

G.E.: Persil is famous, or Omo — they're household names! But an artist can never be that famous. The trend of non-figurative art destroyed me. It wasn't individual destiny, it happened to a whole group of people. Even Felix Topolski, a marvellous artist, very gifted and extremely well received in the forties and fifties, drifted into the background. With the change of style all figurative work was suddenly out.

Q.: Would you describe youself as a feminist artist?

G.E.: I'm a woman — I fall in love with men. But if men discriminate against women, I get absolutely militant. I get very, very angry and my work has always expressed this anger. I think all work should be propagandist. Unless it has a message, it is unimportant.

73 Gertrude Elias, *Self Portrait*, lino-cut, 1948

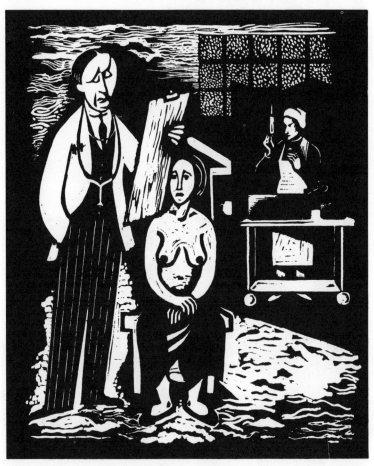

74 Gertrude Elias, *Hospital*, lino-cut, 1948

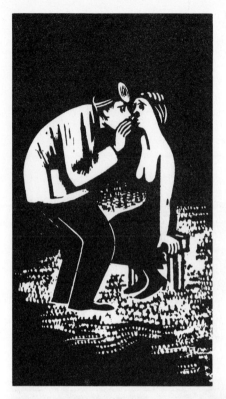

75 Gertrude Elias, *Student and Victim*, lino-cut, 1948

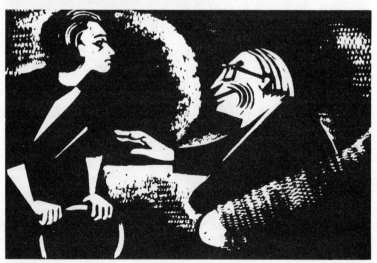

76 Gertrude Elias, *Ideological Class*, lino-cut, 1950

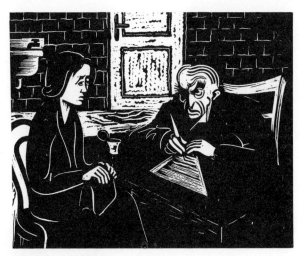

77 Gertrude Elias, *Keep on Taking the Tablets*, lino-cut, 1950

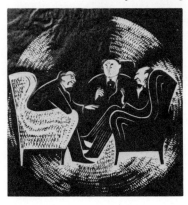

78 Gertrude Elias, *Medical Top-Men*, lino cut

79 Gertrude Elias, *It's Oil* from *Art and Money*, lino-cut, 1978.

Imagery
Jacqueline Morreau

A Dream

Once, a long time ago, I dreamed that I was standing at the edge of a canal: I felt deeply divided and heavily burdened. As I looked across the deep waters of the canal, I could make out emerging from a dark tunnel, the figures of the 'old masters' with whom I felt the deepest affinity. Rembrandt and Goya were there, as were Rubens and Delacroix; Beckmann stood slightly in front of the others. They were all looking at me, but communicated nothing. They were dead, and could not tell me how to get over to the other side. I felt they could not reveal to me any of the mysteries of how they had lived their lives, what made it possible for them to produce so much work, and how they, from their different backgrounds and lives, could have produced so much that was still meaningful to me. I had looked at their work and studied it. I had read whatever any of them had written, trying to wrest their secrets from them; but there they stood, remote, not communicating. Yet I had a feeling that they wished me well, although they could not help me. As they looked at me, I saw myself. I was two people inside my old and heavy overcoat: one was a harassed mother, carrying a baby; and one a resolute artist, also burdened by a great briefcase full of ... what? The housewife/mother had turned her head towards another opening in the same wall which housed the tunnel. This space, seen through a slightly open door, was empty. The artist was looking for an answer from the past, which was silent.

The next day I started to work on this dream, a rich parable to unravel, a gift from the Muse (fig.80). The Muse never gives her gifts freely. I had already been sacrificing to her by hard and constant work. I had been trying for years to find a way to make female meanings available through painting and drawing. This dream brought together many ideas I had been working through, both at home and in the studio.

120

80 Jacqueline Morreau, *Divided Self and Old Masters II*, oil on board, 1979, 27″ × 40″

The more I have worked on the theme of the divided self, the more meaning I have found in it. It was the starting point for all my work from then on, and led to my deep involvement with the women's movement when it began to emerge a few years later. Without the insight which that dream gave me, I would not have been so sure of the need to create a context in which women's work could be understood, and for women artists to gather together and speak out about their own journeys to find form for their meanings.

I believe that all human beings are linked to each other, and therefore are capable of understanding each other's symbols and works of art. Not that they always do, but they *can*. The artist is someone who out of her or his life, both conscious and inner, produces symbolic forms which can have meaning for others.

Art can be an artifact with meaning for many people. The more layered the meaning the more it fulfills its function. The artist succeeds in her or his intention when the emotional climate of the work can be recognized at first glance, and then draws the viewer in for closer inspection. Then the artist can use form, content, colour, tone and subject matter to communicate more intimately with the viewer.

Representation means that observed and imagined forms are transformed by the artist and presented, translated, onto the canvas or the page, where they stand for phenomena but cannot be mistaken for them.

We do not need recognizable imagery to communicate, but it is my contention that imagery — suggestions or *re*-presentations of objects from the real, lived world, and especially *re*-presentations of people—has the greatest power to communicate a multiplicity of meanings. Through them a resonance is felt from artist to viewer, and eventually from viewer to others.

Art is made by artists. Artists are people who have skill and training, and the intention to make artifacts which hold meaning for themselves and for others. The artist herself is the guinea pig. She is the one who makes the thousands of decisions that go into creating a work. She improves it constantly, re-evaluates, changes, stops. The work is the result of training in skills, and receptivity to form, colour and to degrees of animation, light and dark. The artist is the craftsperson who translates personal experience into material being.

But because a visual representation can hold many meanings, it may be read in ways that the artist did not intend. Groupings of work can overcome this. Exhibitions with clear aims can help focus on particular styles, periods or meanings, or on a single artist's life-long evolution. No work seen in isolation can succeed in directing the viewer's response so well as a body of work. In a similar way, gender-based groupings help clarify intention, encourage an accurate reading of work made from gender-based experience, and allow a wider range of responses. This was one of the reasons why I took part in organizing *Women's Images of Men,* which was explicit about the gender of the artist, the subject of the work, and the accessibility of its forms.

Women As Child Prodigies

Many women artists, and this includes myself, have a sense of inner ego-strength and identity which transcends gender. I believe that this derives from a dedication to, and identification with, their craft, vocation, *métier,* call it what you will, which predates their full awareness of sexual identity.

Read their statements: 'I was a prodigy', 'I was petted and praised for my work', 'I had a scholarship at thirteen'. All show a positive reinforcement of an already developed talent.

This sense of dedication to an art can come very early. For myself, I cannot even remember the beginning. There were generations of artists, and there were works by those artists in my family. The first pictures I saw, the first work I saw being made which seemed magical, were made by members of my family. This is the most comfortable milieu for the new member of the guild; although it is not the only one, it can be necessary, even crucial, for women in our culture.

For who can withstand the rejections, deliberate misinter-pretations, misattributions, refusals? Who can pick herself up and begin again and again, other than those women who have always been sure of their primary role as artists? Who can put up with the knowledge of how her less talented, less interesting male colleagues have usurped her ideas, have won public recognition, have gone ahead, while she was having babies, putting husbands through graduate school, working in menial jobs, caring for aged relations.

Because I am interested in form and emotional climate, one of my most important models has been Käthe Kollwitz who was also a 'prodigy'.

I was fortunate to come across her work early in my life. (I do think you find what you are looking for; I was certainly looking for her). We know how important it has been for women to be able to find female precedents for the work that they themselves are trying to do. Each generation differs though, as each indi-vidual differs, in how they feel about their ability as women to accomplish what they set out to do. And in this context a genera-tion is a very short period indeed — five years, at the most ten. Many women born in the thirties had much more confidence than those born during or just after the war, and those born in the fifties have, through the women's movement, regained and in-creased that self confidence.

The Thirties

I was born on the day of the first Wall Street crash. This meant that my first decade was spent surrounded by people who felt insecure, disappointed and disorientated. The American Dream had failed them.

At the same time refugees from Austria and Germany began to arrive. Their experiences were so horrifying, and the stories of those who could not get away were so much worse, that anything the adults may have felt about their own reduced expectations could be seen as trivial compared to the plight of these people.

The refugees had been richer, better educated and much more sophisticated than their American cousins; and yet none of that had helped them. Because of the stories they told (which they thought I did not understand), I had nightmares about children separated from parents, about parents being blackmailed with their children's lives as the price, and about quiet lives invaded and ruined: life was precarious and there was no shelter: 'The devil roams the world like a ravening lion seeking whom he may devour'. Seeking those who will collude with him in evil, and those whom he may devour as victims, or so it seemed to me.

So evil spread from the heart of one psychopath to my quiet home. And now that some of the women of my generation are writing of their experiences, I find these events shaped their own feelings about the world.

Whatever the climate, country or historical period, a child's discovery of the physical world seems to her or to him an intensely wonderful exploration. Like most children, I had experienced this Garden of Eden, but like Eve who once she had eaten the apple could see that good and evil existed, I could not return to innocence.

I left childhood with a vocation, a kinship with the natural world and this knowledge of good and evil.

81 Jacqueline Morreau, *Fleeing Woman*, charcoal, 1980, 30″ × 20″

Imagery in the Thirties and Forties

'The social conditions and institutions of democracy impart certain peculiar tendencies to all imitative arts, which it is easy to point out.. in a word, they put the Real in the place of the Ideal.'
Alexis de Tocqueville, 1840

The art and life of the thirties was realism. When material expectations shrink, people turn to each other. Realism in the thirties was based on an expression of that knowledge. It was not about nature, or still-life, or idealised forms. It was about people, specific people against the background of real events or particular landscapes which related to the human condition depicted in their work. It often contained implied or explicit social criticism.

Although American realists like Hopper, Bellows and Thomas Hart Benton were influential, their work was resisted by some younger artists such as Rothko, Pollock and Gottlieb who, when working as realist painters in the thirties, proclaimed their intention to work towards 'communal myth and primordial associations'.[1]

Others like Ben Shahn (who had worked with Diego Rivera) continued to address social and political issues. This split between the generalized statements of the abstract expressionists and the specific statements of political and realist painters continued until the late 1940's when the victory of abstraction overwhelmed the work of realist artists and eventually a whole new generation which included myself.

New techniques of colour reproduction also contributed to the decline of realist imagery. Much of the art of the thirties — graphics, photography and film — was in black and white, its strength stemming from the slight distancing from reality which it attains, or perhaps from its associations with newspapers and with film documentaries. The realists continued to limit their use of colour, frequently using only black and white with its considerable power to evoke emotion. But the age of inexpensive; glossy colour reproduction had arrived, and with it came the colour advertisement — so clean, so glossy, so real that reality was lost. The media image had arrived. A seductive, unthreatening world was put before an America ready to welcome its dream. In the early post-war USA, few wanted to be presented with the sombre images of realist art.

My education in imagery

During the war, I studied at Chouinard's Art Institute in Los Angeles whenever I was free from my ordinary school work, but

— and with consequences reaching just as far into my future — I became one of a group of teenaged displaced persons who wheeled around the streets of Los Angeles at night, finding a family in each other. Many were children of, or students of, European intellectuals, musicians and artists. Through them — my surrogate family — I became part of an exiled European world in which the need for excellence, intensity and self-sacrifice to one's craft was taken for granted.

While I was absorbing these attitudes from two generations of European exiles and learning about humanism from those who were victims of its failure, my older brother and his contemporaries were returning from the European theatre of war, loathing Europe and all it stood for. A flood of ex-GI's entered art schools and universities. We were to spend our college years with our older brothers.

In 1945, Herbert Jepson, an instructor at Chouinard's set up his own school and insisted I come to study with Rico Lebrun, his star teacher. He gave me a scholarship to make it possible. When I began at Jepson's I was sixteen. The school population was almost entirely male. Only two women worked with us for any period of time.[2] Everyone who was at art school at the end of the war remembers the excitement, but I remember the herd environment, the conformism to some masculine norm and (with appreciation) the very few men who were free of this desire to be one of the boys.

Rico Lebrun was a forceful and brilliant teacher who made his students understand forms in nature and how to re-invent them for their own expressive purposes. Only in recent years has his mark faded from my work, and I still find traces of his influence (fig.82). A whole school of expressionism could have grown up around him, but this was not to be. With the new confidence that victory brought to the American psyche, the past was to be swept away by a clean, new reference-free art.

In 1948, I discovered Max Beckmann. In his work I found ways of using not only form, but colour and the whole presence of the canvas to affect the viewer with complex metaphoric images. Although Beckmann rejected the term 'expressionism', and quarrelled with its proponents, he nevertheless shared its spirit. Like realism, Expressionism is often nourished by anger, an anger which in Beckmann's case fuelled his quest for 'tragic significance'.[3] Like Picasso, Lebrun and Käthe Kollwitz, Beckmann showed me how to suggest many layers of meaning in the depiction of specific events: 'To create a new mythology of present-day life; that is my meaning'.[4]

In the same year I discovered Beckmann, I saw for the first time Picasso's *Weeping Women*, and then, a year later, the *Guernica*

mural. These pictures expressed for me the death of human compassion, yet also implied its continutation. Through them I learned how forms could be exaggerated and transformed to make a point.

82 Rico Lebrun, *Figure With Bandaged Legs*, ink and wash, 1959, 30″ × 15¾″

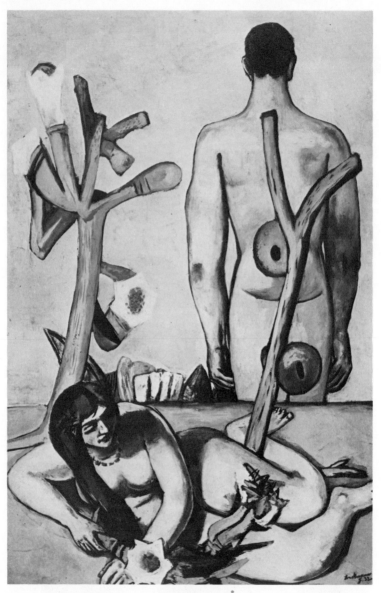

83 Max Beckmann, *Man and Woman*, oil on canvas, 1932, 68″ × 48″

84 Käthe Kollwitz, *untitled*, etching, circa, 1908

Even before I began to study with Lebrun, and before I disco-
vered Beckmann and Picasso, I had found in Käthe Kollwitz a
female precedent who used individualized forms and distinct
shapes to suggest hidden, darker meanings. "Occasionally my
parents said to me, 'After all, there are happy things in the world,
why do you only show the dark side?' I could not answer; the
joyous side simply did not appeal to me.'[5]

'There are always artists who will see the skull beneath the skin'[6] I happen to be one of them. Remembering the skull gives poignancy to the flesh which covers it. Why do I think this way? Was it hearing all those terrible stories from the Viennese relations, or being born in days of darkness and despair? I could no more have painted coloured stripes or photorealist views of Los Angeles than I could have painted girls with prefabricated hearts.[7]

Lebrun. Kollwitz, Beckmann, Picasso. Hardly the models for the new America!

By ignoring the European roots, Abstract Expressionism and Action Painting were presented as truly American products. When Clyfford Still brought these new artistic ideas to the West Coast, they were taken up eagerly by the returning soldier art students. Having lost up to five years of their lives, they saw no point in learning traditional skills when the direct approach to art awaited them. (How the big brothers laughed at their younger brothers and sisters who had worked so hard to learn the skills which were no longer needed!)

Suddenly, work which expressed a humanist outlook was taboo. It criticised society, and it was wrongly associated with the Socialist Realism of Communist countries, whose dry academicism was used to promote an ideal far removed from the realities sought by American realists.

America moved from her pre-war isolationism to her post-war attempt to clean up and Americanize the whole world; one day it would be safe for us to venture out; but in the meantime it was better to stay home and try to clear out the commies, fellow travellers and bleeding hearts. In the world of the visual arts, realism, imagery and expressionism, were on the black list.

The Death of Imagery

"Humanist ideas represent the conviction of the dignity of man, based on both the insistence on human values (rationality and freedom) and the acceptance of human limitations (fallibility and frailty); from the two postulates result — responsibility and tolerance"

Erwin Panofsky

In the thirties, and throughout the war years, these ideas and ideals were accepted as the groundwork for a democractic society, whether or not they were articulated in just that way.

After the war things changed, drastically. Humanist ideas were associated with the Left, and the Left with Europe. Europe, 'the old country' as immigrants called it, was the past. The future was

America.

Americans were now to expunge Europe and European ideas from the memory. The war against Communism was actually a war to eliminate those who did not reflect the new Republican image of America as clean, problem-solving and perfectable unto the elimination of dirt, disease, and even death. Anyone who held contrary views was soft, sick, European, tainted, black, Jew, or female. None of these could carry the meaning of the new America.

The witch hunts of the first half of the fifties were symbolic: they expressed fear not only of political dissent, but of all hidden meanings — fear of the 'skull beneath the skin'. They also expressed a fear of nature. The perfect new America would be entirely man-made. Nature would be subjugated and even the sun would become unnecessary as we would live underground or in glass domed cities, thanks to the miracles of science and technology. I cannot tell you why we had this vision of Utopia, but it is worth thinking about.[8] As Octavio Paz warned, 'A civilization denying death ends by denying life.'[9]

The subjugation of nature not only required the suppression of humanist ideals, but of those experiences and instincts based on our relationship with nature. Woman, with her associations with nature, was too dangerous to listen to. Her meanings were denied any validity in this scheme of things.[10]

But even as this ideal new America was being proclaimed, the realization that a man-made end of the world was a possibility slowly spread throughout the land. The fear and despair brought by this realization was too hard to face and imagery which sought to reveal emotion became — like humanism and nature — a threat to society, another menace to be suppressed.

In the world of the arts, expressive imagery disappeared from the gallery walls and many WPA murals were painted out. For some years, photography, and particularly photo-journalism, continued to express a compassionate picture of the human condition. For a while it provided a link with the ideas which painting no longer expressed, but eventually the magazines which supported this work went out of business or sank to sensationalism.

I had been too busy to notice how the art world had changed. But when I moved from Los Angeles to Berkeley in 1954 and people said in surprise 'Don't tell me you are still doing that!', I realized recognisable imagery was not longer wanted. Once in a while when I did get work into a show, it might be noticed and someone would write about the strange re-appearance of this kind of thing and occasionally regret its general absence. I felt like a dinosaur. I was only 24.

Thoroughly disillusioned with the art world, I enrolled in a

course in medical illustration, a profession in which my skills would at least be useful. Throughout the next decade I tried to continue to work and to keep hold of ideas which I had begun to develop. I worked at all kinds of jobs, married, raised children, and learned etching and lithography in order better to express my personal and political ideas. I did not abandon imagery, even though there was little feed-back. But there were moments of despair.

Rebirth of Imagery

Neither an individual nor a culture can despair forever. The years went by and we had not been blown up; new forces began, bit by bit, to break up the ice-pack of emotions frozen by fear.

The end of the sixties saw the start of a re-awakening for women, inspired partly by the illusory liberation of the sixties and partly by the new model of political action offered by black protest within the civil rights movement![11] It was at this time that women realised that their comon cause was with other women, and that they had to re-examine society and its patriarchal values if they were to understand how to combat the destructive forces at large in the world.

In the sixties I was sending my children's baby teeth to a laboratory monitoring nuclear fall-out to be tested for strontium 90. I was involved with mounting an exhibition on the after effects of the Hiroshima and Nagasaki bombings. I made a series of etchings, *Victims,* about the new horror of napalmed children and their helpless mothers. In one of them a bewildered soldier looks on, turning the image into a *Trio of Victims* (fig.85).

In protest against the Vietnam war, Women for Peace was formed. Women were coming together, first in the cause of the blacks, then in the cause of their sons both black and white, and then in compassion for a civilian population being slaughtered even more brutally than Guernica had been bombed.

What had hard-edged abstraction to do with all these realities, unless it represented the measurement-based psychopathology of modern society? What were the reprocessed images of pop art and photo realism except the most superficial reflections of the most superficial aspects of a society which delighted in its own image? Compared to these developments, abstract expressionism seemed positively rich.

By the late sixties when my youngest child started school, I was at last able to work regularly and practically full time. My husband, who throughout the years had helped me to carve out working time, now helped me find a work space of my own. I have never been able to work at home. The problem of identity is too

85 Jacqueline Morreau, *Trio of Victims*, etching, 1965, 10″ × 8″

86 Jacqueline Morreau, *'Silence Gives Consent'*, 1981, oil on board, 78″ × 33″

87 Jacqueline Morreau, *Persephone*, triptych, oil on board, 1983, 78″ × 33″ each

basic. When I am working I am not the 'I my little dog knows'.[10]

Now deep-frozen ideas began to thaw. Metaphor-made-visible became an important element in my work. Blind heroes, deaf fathers, conception as death were all subjects for me. I began to find out how gender affected not only subject matter, but also the ways I viewed the work of the 'old masters' whose work I loved best. I began to make work where woman was the subject and actor. It was at this point that I had the dream I described at the start of this article. This dream clarified for me the need for a clear consciousness of gender-based perceptions for the makers and viewers of art.

In 1972 my husband and I moved to England. These moves are difficult for women and for the children, and difficult for artists who come without an identity to a new artistic climate.

In 1976, I began to teach a drawing class at the Women's Arts Alliance where the discussions, the exhibitions and friendships provided the stimulus so crucial to the development of ideas.

88 Jacqueline Morreau, *She Who Spins*, oil on canvas, 1983, 39" × 40"

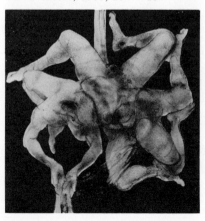

89 Jacqueline Morreau, *If Mary Came to Greenham...*, oil on board, 1983, 78" × 33"

My Work in the Seventies and Eighties

The shared ideals, experiences and difficulties released new energy to make new work.

The theme of the divided self was one I continued to explore. I see it as the pull between the longing to be united with the other and the necessity for apartness that creativity demands. In each of these pictures the woman is seen as a Siamese-twin, each part of her performing a desired task, but torn apart by the opposing demands these tasks make on her.

I also use metaphor in the triptych, *The Children's Crusade* which was inspired by the return of fundamentalist religions, by limited wars, and by the numbing effect of seeing all this on television. In the central panel, patriarchs stand on women's heads while women are born endlessly from each other's wombs. In the right hand panel, *Massacre of the Innocents*, women ancient and modern are patiently supporting the patriarchal structures which lead to their own subjugation. On the left, in *Silence Gives Consent,* I represented on a cinema screen my version of the traditional *pieta* in which the mother cradles her raped and murdered daughter. The audience is satiated with such images and turns away, bored. (fig.86)

After reversing the *pieta* image, I began to re-invent other traditional imagery. I postulated a goddess in whom we all believed, and began to go deeper into the meaning of persistent themes in the history of cultures.

Through the Persephone myth (fig.87). I explored the closeness of mother and daughter, which I saw as a powerful affirmation for women, and our ambivalence towards men and our own fertility. Persephone eats the seed of Hades, god of the underworld. The mating is necessary though accomplished by rape and abduction. He imprisons her; she plans her escape. A second triptych describes the dangerous journey Demeter takes to recover her daughter. When she arrives in the underworld, she finds that Persephone is now mistress of her own domain, united with her husband Hades. She can only be reunited with her mother when she herself becomes a mother. The myth of the three fates lent itself to exploration of the idea of a mother goddess. The woman/spider (fig.88) spins the fabric of life out of her own body. I returned to a more political theme in *If Mary Came to Greenham...* (fig.89), a tribute to the women of the peace camp. Much fiction has speculated on the effect of the return of Christ into modern society. In this picture the goddess Mary returns and is immediately arrested along with the other demonstrators. I try to make my work as many-layered as possibly without losing its power to evoke an immediate response in the viewer.

Today and Tomorrow

Meaningful imagery has returned — and women have played a major part in bringing it back. But can it, and the values it represents, survive? The forces in the world which suppressed it in the past are still with us. Will a better understanding of how art is marketed increase our ability to circumvent that gallery/magazine/museum nexus which Lucy Lippard has described in *From the Center*?

Art styles or movements — which style is in and which is out are orchestrated to make the maximum profit out of artists' work as quickly as possible. Just about everyone, including the artist, has colluded in this fiction of successive movements in art. Artists generally have one way of working which comes out of personal history, physical being, education and vision; one movement does not drive out the other. What is called the *zeitgeist* is in reality money.

No one wants to deny artists that moment in the spotlight which gives them confidence, money, and the feed-back which helps them develop. How can an artist achieve it without becoming a pawn of the dealers and the art market.

In England the Arts Council network of galleries helps independent artists, who do not necessarily have a saleable product, to find a public. The Council has its faults, but until recently a male artist could hope to make his way into the private sector after exposure in its galleries. Even women have made small inroads into the Council's gallery scene particularly outside London.

In the present political climate, this may change. Money is tight and nowadays the arts are expected to pay their way. Despite the Council's claim in *Glory of the Garden* that it supports the contemporary arts, galleries, grants and networks disappear daily. The rate of attrition amongst artists, particularly women, will be enormous, and the loss of work cannot be calculated. Even the auction houses may suffer.[11]

Women artists have shown the way out of this dead end. By putting on shows, opening their studios to the public, forming lobbies and joining pressure groups, they have organised their own interventions into the art world. The days of the lonely genius ushering in a new style of painting, to be replaced within a few years by another, may be over. The new era of common cause with other artists, and the new pluralism of styles, owes much to the women's movement

Footnotes

1) Dore Ashton, 'The San Francisco School' in *Evergreen Review*, vol.1, no.2, 1957.

2) Men were the main beneficiaries of the two periods when the United States Government subsidised art and art education. The first was the Work Projects Administration — especially important because, besides financial help, it provided public commissions and group projects which helped alleviate the sense of isolation from which many artists suffer. The second was the G.I. Bill which subsidised further education for ex-service personnel and by its very nature gave men an advantage.

3) Stephan Lackner, *Max Beckmann*, New York 1977.

4) Stephan Lackner, *Max Beckmann: Memories of a Friendship*, Miami 1969.

5) Hans Kollwitz, ed., *Diaries and Letters, Kathe Kollwitz*, Chicago 1955.

6) T.S. Eliot, *Whispers of Immortality*, 1920.

7) Hans Richter, *Dreams that Money Can Buy*, film, 1946.

8) Charles Jencks, *Architecture 2000*, New York 1971, discusses this further.

9) Seldon Rodman, *The Insiders*, Louisiana 1960.

10) Gertrude Stein, *What are Masterpieces?*, Los Angeles 1940.

11) When I proposed to an art dealer that auction houses should pay a tax that would go into supporting living artists, he could not even begin to see that there was a connection between the two worlds.

Anthropology into Art:
Susan Hiller interviewed by
Sarah Kent & Jacqueline Morreau [1]

This talk by Susan Hiller was given in Australia in the summer of 1982. Following it is a discussion with the editors. She begins by explaining why she left anthropology.

I was working then in the United States. We were told that as social scientists our work existed outside the real world that is, it was value-free, it was objective and it was meant to exemplify pure academic research.

Well, the Vietnam war showed everybody in the social sciences, at least in the United States, that this wasn't so, because anthropology data was being used by government agencies to subvert village life in South-East Asia.

So these anthropologists quickly were brought to realise that there was nothing that couldn't be used. That was one reason why I left anthropology.

And although I didn't have a clearly articulated notion of this at the time, it was apparent to me that there was something odd about the position of women within the practice of anthropology. There was also something odd about the kind of information about women in other societies that was being fed back into our society. In anthropology men and women are trained to go out into the field and gather information but they have traditionally gathered information only from the male speakers of the tribe for all the reasons that we understand. The men have always spoken about the women of their tribal groups, so the information about women that is being filtered back into the social sciences tends to reinforce the usual patriarchal views of women. Now the odd thing about that is that many of the first and second generation, at least of American anthropologists, were women, Margaret Mead, Ruth Benedict, but they had not in any way been able to alter the discipline. That was deeply disturbing to me, but I couldn't quite put my finger on where the problem was.

Social or cultural anthropology pivots around the notion of the

'participant observer'. This is a schizoid kind of notion. It means that someone from a dominant society goes out to observe the culture of another society and adopts, for a short time, the formal role of being a participant within that society, but all the time is chalking up information which he or she then takes out of the original society back into their own, and uses it to build their professional career.

In the early seventies there was a lot of radical anthropology that tried to correct these positions, but particularly as far as women is concerned, it's not something simple to deal with.

So I left anthropology and decided to become, not an artist — it's a word I didn't like and still don't — but a painter. One of the reasons I was able to make that transition was that I had studied at an American University, and they don't produce specialists. I had taken a minor in art with some painting and drawing courses. So I started off learning to paint, and had some exhibitions, but at the same time I was doing other things which I didn't think of as art, and it took a number of years for me to say *I don't care what it's called, that's what I'm going to do,* and it turned out to be an approach to art practice that takes some of the methods and/or attitudes toward art of anthropology, and uses them to deal with cultural artifacts from our own society.

I made the decision when I left anthropology that I never wanted to be an observer again. I didn't believe there was anything called 'objective truth', and I didn't want to be anything but a participant — I didn't want to stand outside; and I didn't want to denigrate the interest of the things in my own world, ordinary things, things that are not considered very important, things like postcards, broken things, cultural discards.

Over the years I've evolved an approach to these materials which looks at what you might call the unconscious side of our own cultural production.

An early piece of mine was called *Dedicated to the Unknown Artist.* I used postcards that I found in Britain, postcards of the sea, that had the caption *Rough Sea.* I found the first one when I went to Weston-super-Mare. I went there because of the name and the postcard had this tempestuous ocean crashing against little houses and it was titled *Rough Sea.* Then a few weeks later I was in Brighton, and found this card that said *Rough Sea, Brighton,* and I realized that if there were two that implied the existence of a set. After that, for about three years, these cards found me everywhere, I literally couldn't get away from them, and I had a lot of fun sorting through them, playing with them, classifying them, comparing the images, looking very closely at these miniature art things. Then I decided to make a piece of work based on that experience.

In order to do this work I decided I would take the stance of curator for this body of little pictures, and as curator one of my jobs would be to produce a catalogue.

I produced a small book which is the catalogue for this museum exhibition of tiny seascapes. The book is a summary of some of the themes of the images: lots of times the buildings in the background have been painted by hand, the same wave with different buildings, or in places where the sea is never rough — seaside towns that are famous for their calm seas — someone will have airbrushed in a big wave; and then a lot of them have frames, and the notion of framing is included in the postcard idea; then there are quite a few that come from paintings. This was very curious to me. They contradicted a lot of the ideas I had about paintings, about let's say, sensibility, original response to scenery etc, because the painted images all conform to a set of strict conventions so that one locale looks exactly like another. But in the *photographs,* because they go through several stages of photography, re-photography, etc, images from the same negative can be radically different.

I did an installation in which I played visually with the cards to bring out some of these things and, because the initial fascination for me had been in the mysterious redundancy or doubling of two languages, a visual and a verbal, descriptive language, I also used words to make complex tabulations which query notions of photography versus painting and so on.

The piece also has a great deal to do with Britain as an island. Someone once said to me that only a foreigner could have done this piece, and I realized that my position gave me a privileged access to some insights that the British themselves didn't have into their own tradition of landscape art.

What's interesting to me about this piece is that in those days I still wasn't able to be explicit about what the real content of the work was. I hoped people would see it for themselves, as I had seen it. It was the sexuality, the symbolic significance of the imagery that created a most obsessive perpetuation over the years in the making of these postcards. In the tabulations I included comments by the people who had sent the postcards, only in so far as the comments referred to the picture on the other side, and that was what really gave me the clue. On one level they showed the power of art to structure people's experience, because they would often say 'Dear Mum, the sea today is *just* like you see in this picture.' The other thing is the incredible excitement that the British seem to feel about waves — there were a lot of comments like 'Dear Mum, what an exciting day! The sea has tossed us about, we've been wet...' They just went on and on, a most bizarre thing. Then I began thinking about nature/culture, male/female

gender attribution etc, but I still was not being explicit.

Years later I made a work called *Ten Months,* a piece in ten units. I was pregnant in 1977-8, quite late in my life, and I took photographs of myself and kept a journal, but at that point I didn't have any intention of making it into a piece of work. I was just trying to keep a record of the internal and external changes. I was interested as someone who was already a mature artist, and aware of the metaphors of creativity that come out of pregnancy. Afterwards it became clear to me that I had to make a piece of work. It wasn't until some time after my child was born that I found out several things. The average pregnancy is 280 days, which is not nine and bit months, but ten lunar months, and in France old women still call the months of pregnancy the *lunes,* so this is still current in folk knowledge.

Like many other things concerned with the female body it has a natural rhythm which is not clearly stated by the solar calendar. That gave me a principle of organisation. That was when it became possible for me to make a piece of work out of it. I had been taking full figure photographs, and thinking of the moonscape, landscape analogy. I made a decision just to use the section of the body you couldn't talk about, the pregnant part, a tiny little section of the 35mm negative, thus all the graininess. Having made that decision, to excerpt a part of the body, I then knew what to do with the journal I'd been keeping — a huge plastic carrier bag full of scraps of paper — so I selected out bits from each month that seemed particularly relevant. When it came to organising it on a wall there were certain things which dictated my choices, because I wanted the first image in a month to link up with the last image of the previous month. I wanted to make it absolutely clear that they followed on because they had to abut, and that made it take on a rather dynamic shape on the wall which saved the whole thing from that conceptual 'look'. I was shooting black and white film, and decided to leave it in this rather stark mode to break with the sentimental image of pregnancy. It's an incredibly fertile *mental* time, quite extraordinarily rich, not just the body and its changes but the mind as well.

And then the text presented a particular difficulty. In the first half the text was subsidiary to the physical. I was dwelling on the physical changes, so I could put those underneath the images. But in the second half of my pregnancy I was quite tormented and perplexed by a number of things, for example, by observing myself being a participant and an observer, (I began thinking about mirroring, self-image this sort of thing), and I began theorising, reading a lot, trying to understand what I was going through. Thinking then became primary, so I put the text above the images, and it balances out symmetrically.

This piece has been quite contentious in England for a number of reasons. Women have made pieces on child-rearing, child-birth and a lot of other issues, but there has never been one on pregnancy. Since pregnancy has always been an important theme in art this piece disturbs traditionalists. Also, of course, it has explicit reference to landscape imagery. It seems to relocate the emotional source of those images right back to their origin in the female body. Some art historians found this incredibly subversive. Was I deliberately commenting on the British landscape tradition?... The piece was deeply disturbing to people who find it hard to accept the right of a woman to be the artist and the sexed subject of the work. When I got very depressed about it I used to think of that nice little drawing by Suzanne Valadon, *The Model Paints*. She did that little sketch of herself naked, doing a painting, which is marvellously unselfconscious, a brilliant little drawing, and I realised that there were precedents — there is a tradition and it's just as disruptive as it's ever been.

The final problem with this piece came when there was a big show in London called British Art 1940-1980. There is a very odd situation in Britain, very few women artists in the public collections, certainly very few contemporary women artists. The British art establishment is totally unapologetic — they think that no women make good art. However, this particular piece had had a lot of publicity, so they included it in the show, which meant that the public at large saw it. The exhibition was full of the reclining nude, in the British tradition, and you trailed through these endless corridors with all these women lying about in men's studios in various states of undress, and you suddenly came on what must have been a tremendous shock to some people, these very stark bellies all in rows, and it got some very snide popular press attention. To be absolutely realistic about it, it doesn't deserve that kind of snideness, because we've been working for a long time to bring women's experience into art practice. But when a woman speaks about herself and denies a male interpretation of the experience, it seems, no matter how much work has preceded it, that there will be this kind of reaction. This interests me — I don't know if you have the same problem in Australia — the same taboos...

90 Susan Hiller, *10 months*, black and white photographs, 1977-8 (series of ten)

ONE/ She dreams of paws, and of "carrying" a cat
while others carry babies. Later, all the cats pay
homage.

TWO/ She must have wanted this, this predicament,
these contradictions. She believes physical conception
must be "enabled" by will or desire, like any other
creative act.
(Pregnant with thought. Brainchild. Giving birth to
an idea.)

THREE/ She will bring forth in time. Their "we"
will be extended, her "I" will be altered, enlarged or
annihilated. This is the terror hidden in bliss — —
She keeps on describing bodily states, as though that will
help her incorporate the changes within her notion
of 'self'.

FOUR/ She writes: One is born into time. And in
time, introduced to language...
Or rather — One is born. And through language,
introduced to time...
Perhaps even — One is born, in time, through language.

FIVE/ She now understands that it is perfectly possible
to forget who one has been and what one has
accomplished.
Continuing the piece requires great effort. It is her
voice, her body. It is painful being inside and
outside simultaneously.

SIX/ She speaks (as a woman) about everything, although
they wish her to speak only about women's things.
They like her to speak about everything only if she
does not speak "as a woman", only if she will agree
in advance to play the artist's role as neutral
(neuter) observer.
She does not speak (as a woman) about anything,
although they want her to. There is nothing she
can speak of "as a woman". As a woman, she can not speak.

SEVEN/ Knots and knows, Some NOT's & NO's about
art—
1. The subject matter of a work is not its content.
2. A work's meaning is not necessarily the same
as the 'intention' or 'purpose' of the artist.
3. There is no distinction between 'reading' images
and reading texts.

EIGHT/ She is the content of a mania she can observe.
The object of the exercise, she must remain its subject,
chaotic and tormented. ("Tormented" is *not* too strong
a word, she decides later.) She knows she will never
finish in time. And meanwhile, the photographs, like
someone else's glance, gain significance through
perseverance.

NINE/ It is easier to describe thoughts than feelings.
It is easier to describe despair than joy. For these
reasons, the writing gives a false impression: there
is not enough exultation in it.
At that point, she writes: Time is no longer a
hindrance, but a means of making actual what is
potential.

TEN/ Ten Months
"seeing" (& depicting).......natural 'fact' (photos)
"feeling" (& describing).......cultural artifact (texts)
She needs to resolve these feelings of stress caused by
having internalised two or more ways of knowing,
believing, and understanding practically everything.
She affirms her discovery of a way out through
"truth-telling": acknowledging contradictions,
expressing inconsistencies, double-talk, ambiguity.
She writes that she is no longer confused.

Jacqueline Morreau: Can we talk about working as an artist in the 1980s? What, for instance is your response to Germaine Greer's conclusion at the end of her book *The Obstacle Race* — she writes that 'Feminism cannot supply the answer for an artist, for truth cannot be political. She cannot abandon the rhetoric of one group for the rhetoric of another, or substitute acceptability to one group for acceptability to another. It is for feminist critics to puzzle their brains about whether there is a female imagery or not, to examine in depth the relations between male and female artists, to decide whether the characteristics of masculine art are characteristics of all good art, and the like. The painter cannot expend her precious energy in polemic, and in fact very few women artists of importance do.'

Susan Hiller: She collapses a number of terms in that paragraph and mixes up the meaning of words like 'rhetoric' and 'polemic'. Still, it's thought-provoking. I do think it's an important point to discuss — whether art and politics are different discourses. Greer says that very few good artists concern themselves with political ideas, but what she really means is that they don't concern themselves with political subject matter. Actually, there's no reason not to adopt as a hypothesis, that everything one does and believes informs one's art. As a woman and artist, I am inevitably redefining what the category 'art' includes, and that's a cultural struggle.

It's all so much more subtle than Greer implies. All representation is political, and art carries meaning into the future. Whether or not these meanings coincide with the stated intent of the artist is another question.

Sarah Kent: You mean that you're not necessarily in control of the ideas that your work conveys?

S.H.: Yes that's part of what I'm saying. One of the more interesting fallacies in art is that of intentionality — that intention and interpretation ought to be, or even can be the same. One definition of art, for instance, might be of something open ended and productive of meaning. As far as politics goes, there's a whole range of possibilities — you can be an artist who is active in politics; you can declare a political intention in work designed for the gallery world; you can work within a community doing what might be thought of as agit-prop, and so on. Personally, I tend to reject any claim that there's a direct relationship between any artist's work and its political effect. It's more as though politics and art reflect and formulate the same terms — there's a kind of parallelism.

Each group and subgroup in society produces artists appropriate to its particular formation. Some artists have an archaic notion

of themselves as geniuses, speaking from some unexamined notion of authority, while others assume that their radical political sympathies give them a transcendent overview. In either case, the resulting arrogance is much the same and the different forms that the justification takes may simply be a matter of temperament.

Personally I believe the function of art is to show us what we don't know that we know — and this is definitely a social function with political implications... But I'm not interested in using art to present journalistic or sociological ideas — since I think art is of the same order of importance as other disciplines.

S.K.: There's a crucial distinction to be made, though, between those who work in a form that is easily understood, in an attempt to radicalise people through content, and those who want to radicalise their audience by introducing them to a new way of looking at and considering art by opening up the boundaries of art in unexpected ways.

S.H.: The whole issue of modes of representation is so complex. There are people nowadays who can relate more easily to a videotape than a painting. But the notion of radicalness or street worthiness of new media *per se* and their innate credibility — I'm not sure. It's true that the slender history of film, and particularly of video and performance art, means that the artist can start off fresh, without the weight of a long tradition, and this has certainly released a lot of creative energy amongst people excluded from the tradition of, let's say, painting — particularly women. On the other hand, the 'left' in art practice and the 'left' in politics hardly match up. We have 'left-wing' critics, for instance, equating art solely with traditional media and trying to exclude all the new stuff — just like the conservative critics.

J.M.: How does gender come in here and/or marginality?

S.H.: Well, since women are excluded from the tradition, when a woman makes art that speaks as clearly and adroitly as she is able, can the issue of gender not be present? I would say not. And to the extent that the artist speaks about herself as sexed, specific and particular, the work is located oppositionally. Of course, she can try to avoid issues of gender, thus betraying herself. Marginality means that you internalize two conflicting but sometimes overlapping sets of ideas about everything. I'm a marginalized person, because as a woman in this culture I do not have a female language. I am excluded from culture and from cultural traditions unless I speak as a man — have one-man shows, for instance! The work I find most interesting is a very sophisticated play on accepted and recognized systems of representation, format and

so on, with a desire to subvert, modify, change and, through this interplay, create a space, gap, hiatus or absence in which something new can come into being.

J.M.: I see in your work a relationship between what is sayable and seeable with what is unutterable, invisible, yet present. I see your work as dealing with archetypes, yet as an individual you are informed by politics, feminism, anthropology and so forth.

S.H.: You seem to be suggesting that there is conflict, or you feel these elements are contradictory. That's because you are making 'politics, feminism,' etc sound like abstraction. All my work is about *enunciation* — articulating the suppressed, the overlooked, the previously unsaid, unsayable and so on. Usually I begin with cultural artifacts that seem to me to embody the unconscious side of our collective social production — such as the *Rough Sea* postcards, for instance. And sometimes I start with my own personal productions — drawings, photographs, etc. but always there's an assumption of shared subjectivity. My work is located where my personal awareness intersects with the social — as is all art. So there's no contradiction.

J.M.: Nearly everybody writing for this book has been involved in creating a new context for her work. Without that activism, we would still be invisible, don't you think?

S.K.: It's more complicated than that. Feminist artists, film-makers and photographers have been caught in a double-bind of their own making. It's extremely important for them that their work should have some effect and reach large numbers of people, especially women. In order to be effective socially, the work must be accessible to people beyond the world of artists, critics, dealers and historians, but in order to be effective historically it has to be acknowledged as important by the artworld establishment. This means trying to aim the work simultaneously in two different directions where the requirements may fundamentally conflict. Also if you speak out, organise and are loud and vociferous that makes you an abomination, so you will be deliberately 'passed over'. If you remain quiet, polite and shy, you are also likely to go unnoticed. Either way, you will be written out of history and your work will have nil effect on the culture.

S.H.: Except that there are alternative histories being written of which this book is clearly an example. Let me sidetrack a bit — I've been throwing the word 'art' around very freely, but I'm not actually sure what 'art' is. I know what painting is; I know what performance is; I know what video is; but whether or not any work qualifies as art is an assessment that is made retrospectively.

We don't know which work will be judged positively in the future and this allows for some optimism.

In fact, we are helping to enable a particular future to come about — at least that is what I believe. You've talked about the disadvantage of being a woman in the arts, but for those of us who have a feminist perspective, there's a sense that what we are doing matters. As far as my own work goes — even if it's rejected or misunderstood, and always falls short of my ambitions — I still know that I am speaking on behalf of vast numbers of other women whose versions of reality have been misrepresented. This gives me a sense of rootedness, of community and is a source of strength.

S.K.: There are many different ways of mattering, though — that's the conflict.

S.H.: Well, different audiences bring different judgements to bear. But it's not a conflict for me! I think of art as a first-order practice — as important as sociology, psychology, physics, politics or whatever. Artists take shared internalisations and find a form for them, and certain social values are upheld while others are contradicted or modified. Art is a way of carrying ideas forward, of giving them a shape and making previously incoherent or unconscious feelings and attitudes articulate and available.

S.K.: So you think it would be feasible, for instance, to be a feminist and yet be an abstract painter?

S.H.: Sure, just as it would be feasible to be a Tory and a performance artist. Furthermore, as I said earlier, an artist's progressive theories and political intentions can be contradicted by the work, not so much by its content or subject matter, but by its rhetoric — that is by the means it uses and style it adopts to make its point — for instance, if the work is so difficult and esoteric that only the artist has the key to its understanding.

J.M.: So how does one make the work accessible without losing its complexity of meaning?

S.H.: Well, in my own work, I try to allow various levels or means of entrance. But for artists with a more overtly political aim, trying to achieve political clarity may mean losing everything that makes art, art. My position on this is changing. I would suggest that art practice with no overt political content may, nevertheless, be able to sensitize us politically. This is just a hypothesis, based on my observations and work on these issues over the past ten years. Conversely, and this is very important, political experience can sensitize artists and put them in touch with what their work is actually about, could be about, or ought to be about... But certain-

ly there's no simple relationship between the political content of an artwork and its effectiveness. 'Isms' within the artworld, whether socialism, feminism or any other 'ism' are used to define territory. Then once a territory has been established there are people inside it and those who are excluded. Claiming a territory has a lot to do with hustling for a place in the art world and excluding as a threat all those who don't immediately follow as acolytes.

S.K.: You've said many times that you're a feminist but not a feminist artist. I've never completely understood what you meant by that distinction.

S.H.: I refuse to be relegated to the sidelines or to collude in qualifying or limiting the nature of what I'm doing! I happen to believe that being a feminist is good for my work because it's crucial for me as a person. It enables me to understand some of the things I'm dealing with. Feminism is a profoundly significant perspective, which does not imply speaking exclusively about so-called 'women's issues'. In art the implication is that there's a quest for a language to express perceptions shared by more than fifty percent of the population — this matters, it indicates that art means something, is real and, thank goodness, I know I'm not just playing end-of-the-world type games... A few years ago I talked about 'truth-telling' in art practice, and for me, since gender, language and desire seem crucial to what I'm about, feminism has been of primary significance — though of course many other things feed in, too.

J.M.: What particular contribution would you say that women artists will be making in the future, then?

S.H.: Well, because of the proliferation of media images, there is an especial need for artists to stress other values. Artists must create substitutes, alternatives, for outworn meanings and second-hand images. We have an increased obligation to deal with contemporary reality without retreating into despair and fashionable nihilism. I think that anyone who has the guts to get through despair, poverty and fragmented time, and actually be productive — make work, find a way to say something — has already made a valuable contribution.

Art is an expressive practice that has social implications and social effects. It examines social trends and reflects them in complex ways. If you have a sense, historically and socially, of what you're doing then whatever form your work takes you feel impelled to clarify your notions, to bring the work into line with the values you treasure — the ideologies you're committed to, if you like.

Of course in England, at present, this obscures women artists because what they are expressing is in collision with so-called patriarchal notions, established power and vested interests. But if you see the future as being open to a certain extent — that is, amenable to change; if you have an optimism about shifting attitudes — then this art won't be marginalized as 'feminist' art in the future.

It'll simply be good art — the art that lived on, that proved relevant, beautiful, significant — while all the rest is forgotten. You need to have a sense that what you are doing matters, otherwise who would bother to persevere? It's a fantasy, a shared fantasy, that all artists have. I believe I know how the future will assess the art of our time — and that's how I see the gap as closeable.

Footnotes

1) Reprinted from *Artlink*, September/October 1982.

In Chinatown: Feminism and Photography
Joyce Agee

It is a neat trick, played upon the unsuspecting tourist. Near Piccadilly Circus men with small cameras hustle people to have their photograph taken for a pound. The men take the address of the visitors, their money, and guarantee delivery of the photograph by the time the holiday is over. The tourist hasn't realized that the camera contains no film.

Late one afternoon, walking down the Duke of York steps in Central London, I noticed a young couple watching three men working this trick. The young couple were enjoying the free sideshow, and I was enjoying the couple's amusement. Suddenly, two of the men bounded down the stairs and began to threaten the boy and girl, trying to force them to move away. With growing anger, I began to take photographs with the intention of reporting the episode to the police.

Then out of the corner of my eye, I saw a figure rushing towards me. It was the third partner. Instinctively, I whirled around and snapped a photograph of him. Abruptly, he stopped, raised his camera and — click. I raised mine — click. He raised his again. It was a duel with cameras. He yelled, threatening me. I yelled back. Turning, I ran to the nearest telephone and called the police.

The hustler was able to mask his face with his camera to 'frame' me on film. Would I have behaved so aggressively without a camera which offered me illusory protection and the curious power to record and thus indict? This strange episode also illustrated the mystical affinity between a camera and a loaded weapon in its power and aggression. Fortunately neither camera shot bullets.

A Social Photographer

I gravitated towards photography through a series of accidents with no particular preparation, except a few courses in drawing.

154

91 Joyce Agee *Shoot out on Duke of York Steps*, 1979

When I told my father, at the age of twenty four, that I wanted to be a photographer I didn't express the desire with bravado or assurance. I said it with relief. Here was something I actually wanted to aspire to. I wanted to assume the name of photogapher. But what was a photographer? How did they look, behave and think? I didn't know any photographers. My father's response was 'Don't you think there are enough photographers already?'

I like to think that this was an inspired challenge on his part but I believe it was a reflex response, a confirmation of the narrow expectations for a daughter and a sad glimpse of his own limited vision. But I acquired the basic skills and now at twenty eight, I have made photography my career. The work I do varies: from portraits, photojournalism and documentary to 'art photography'.

I like the old-fashioned term 'social photographer', a name given in the thirties and forties to the documenters of high society women and aristocrats. It suggests a direct relationship with people, frequently absent from modern titles. I don't focus on one class, but my work does reflect my relationship with society. My images challenge accepted values and comment on a society that underestimates women's ideas and perceptions and undervalues their achievements. Conversely society also influences me. I have gained in both political and personal awareness through my experiences as a photographer.

92 Joyce Agee, *Islington High Street*, 1980

Perception of Reality

'The notion of image and reality are complementary. The notion of reality changes; so does that of image and vice versa.'
Susan Sontag, *On Photography*

Photography has enabled me to learn about myself as a woman, about my relationships with other people, and my changing role in society. It has been a process of maturation. The images that I make and the image that I personally present can each contribute to a change in the way society views me and other women. Many of my photographs are, I believe, some kind of self-portrait reflecting personal feelings and ideas. Through my lens I observe myself enlarged; I refine and define my experience. Often this experience is fragmented. Photographs can reflect that fragmentation, isolating instances which are held and challenged. Perhaps with the camera I make myself and my experiences real.

As I retrieve myself and my photographs from between the images of women in magazines, TV, radio, film and newspapers, I put together, like broken mirror fragments, a crooked and distorted self-image, but one which is closer to a self-portrait than a shop window reflection. I endlessly piece together a picture puzzle image, which comes closer to defining my experience or my image than a direct portrait — one that is inextricably bound up with my secondary status as a woman in society.

93 Joyce Agee, *Café Society*, 1979

Analysing the effect of images on our understanding, Susan Sontag writes that photographs have conditioned our perceptions of reality: 'We equate reality with the photograph. Instead of experiencing a sunset as a fresh phenomenon, we see it as an image. It is so beautiful it looks like a postcard.'

As women making images we therefore have an assurance that the images we construct can change society's view of women and women's status. We can compose images which counter cultural stereotypes and offer 'proofs' or evidence of the alternative reality of women's perceptions of themselves and society. Diane Arbus, the American photographer, recorded a vision of dislocation and alienation in her portraits of dwarfs, giants and outcasts. Again and again, we see her reflection in her photographs — a kind of composite of an artist who is uncomfortable with herself and society.

Feminist photographers are currently examining the theory and practice of photography in order to construct images which counteract female stereotypes. I choose, on the other hand, to make images that comment directly on my daily experience in a patriarchal society. I wish to reclaim my actual experience as a woman rather than to manufacture a new one. I wish to present images which allow women and men to see themselves and their actions in a new way, which challenges their understanding and questions their assumptions.

The experience of men whistling as women walk by is a very familiar one. Often with a camera, I have discovered that men will respond flirtatiously and request a photograph. I am not seen as particularly powerful; a camera is seen as an accessory on a woman, but also as slightly provocative. I flirt with men's images of women. Partly as a response to this, I have adopted a code of masculine dress, which gives me greater physical mobility and comfort but intentionally neutralises my sexuality.

You sense that you are taken more seriously if you appear in something which doesn't emphasize your feminity, you become 'one of the boys'. This asexuality places you outside sexual competition with other women and men don't feel that they must respond flirtatiously with you so, ironically, it gives you greater flexibility with both sexes. Also you appear less vulnerable to sexual harassment in situations which might become uncomfortable or even dangerous.

Molly Haskell, in an essay from the book *Women Photograph Men*, observes that society's expectations of women's behaviour affects their ability as photographers. 'Have they not been conditioned by the social necessity of being at once alert and self-effacing to develop that special quality of muted observation? Women are able to establish rapport with their subjects for what

we now think of as 'good' and 'bad' reasons that are madly intert-wined. Because women have not been taken seriously by men as sexual competitors, they are less threatening, their presence less disturbing to a male ego.'

Molly Haskell suggests that my reception as a female in society contributes to my talent as a photographer. As a woman I am muted and rejecting this, I seek to replace this anonymity with another kind — an androgynous identity — neither at ease with the image and expectations for a woman, nor prepared to assume the image of a man. My self-image and even my ability as a photo-grapher is linked with my status in society. Society's expectations of me as a woman, and my expectations of myself as a person are in conflict — this creates a tension which is rarely reconciled.

Photoworld

When I first began to teach myself the rudiments of cameras and printing I would regularly read photographic magazines. Inevit-ably, on the cover would be 'glamour' photographs of women reminiscent of soft-pornography. Increasingly angered by this, I would tear the covers off before reading the magazines. I became aware of a contradiction — I wasn't the intended audience for these magazines; women were shown as subjects or handling photographic equipment in sexually suggestive ways — using lenses as though they were male genitalia. Women were rarely shown using cameras to make images.

These magazines regularly encourage amateurs to participate in 'glamour' weekends. I attended the largest event of this kind, *Photoworld*, a ten day marathon held annually in London. Female models were available throughout the day for photo-sessions, wearing T shirts emblazoned with sponsors' names, mod-elling lingerie or posing topless. Men of all ages, with eager cameras and flash units, aimed and shot, using their cameras like weapons in a firing squad. The aggression of the men towards the models, as they jostled one another for the best 'angle', reminded me of the rowdiness and violence of football crowds.

One young model who noticed me taking photographs said jokingly 'you must be a liberated lady.' I was seen as an extension and imitation of the men's attitudes and behaviour. She assumed that my presence was an acceptance of their values. Dale Spender writes in *Man Made Language*, 'Women have been silenced by society, and that silence has been assumed to be an acceptance of male values as the only view of the world.' In a patriarchal society I am not seen as powerful enough to comment on an event or consequently to change it.

Photography has been dependent upon a man-made visual

language which has generally produced images of women that
reflect her specific sexual roles: wife, mother, sexual partner or
sexual fantasy. Women's individuality has been reduced to
stereotypes of dependence, passivity and uniformity. *Photo-
world* exemplifies the general social acceptance of exploitative
images of women in media and advertising and is especially appall-
ing when you realize that all the men were virtually taking the
same photograph.

As an event celebrating the popularizing and making of images,
the implications of a *Photoworld* are disturbing. One of the organiz-
ers was quoted as saying, 'There was no doubting the popularity of
the *Daily Star* Studio with its succession of 'Star Birds' (topless mod-
els). The fighting, heaving mob of amateur photographers which
surrounded the stand from morning till night proved this.'

I am interested in women as individuals not as passive objects
and wish to make images of women who are active, not acted
upon. At *Photoworld* the models were separated from their
humanity to become one-dimensional objects, while the men
acted as a dehumanized 'mob'. The event was a celebration of the
deadening of perceptions.

94 Joyce Agee, *Photoworld*, 1981

Publishing

Unwritten rules exist in publishing and the media, based on classist, sexist or racist criteria and images which do not conform to the accepted viewpoint are rarely published. A publisher proposed a book on video and its techniques. Illustrations were needed for a section encouraging people to explore unusual situations with video. Science fiction conventions were nominated as a good subject and I took a varied selection of photographs that included a colourful and bizarre dress competition in which enthusiasts adorn themselves in elaborate costumes, emulating their particular science fiction hero or heroine from TV, film or literature.

The highlight of one such event, was an award given for the 'Least Best Dressed'. A handsome black man wearing silver boots, silver helmet, cardboard gun and little else was awarded the title. My photograph is taken from behind and its impact rests on various audience reactions, their expressions ranging from the distaste of two girls to the wild hilarity of the judges, all distinguished science fiction writers.

The women in the publishing firm were delighted with the image, 'Finally' they said 'a photograph using a naked man' though in this instance the result was more comic than sexual. This shot was featured prominently in the layout. But I later discovered that it had been dropped altogether. It clearly contained too many disturbing elements for a publishing establishment that was primarily white and male; the presentation of a man as a sexual object, the fact that the model was black and that the men in the audience were reacting with laughter and applause (perhaps suggesting homosexual overtones) were considered too alarming for the prospective buying public also considered to be white and male.

The rarity of images depicting a physical relationship between men beyond certain codified instances, as in a sports context or gay magazines, makes such reactions almost inevitable. The image expressed vulnerability and a loss of dignity and power. By violating the 'rules' of acceptable representation, the image had become subversive and, therefore, inappropriate for a mass market publication.

Miss Chinatown

With some misgivings, I ventured that early morning, through the doorway of a popular London nightclub. Inside the building, the day was already over; it was dark and cold. The rehearsal for the Miss Chinatown pageant was taking place in an enormous

cavern of a room with hundreds of empty, ghostly chairs and tables. Twenty young Asian women wearing bathing suits silently entered onto the stage and stood stiffly in rehearsed places waiting for a voice from the back of the room to issue instructions or a spotlight to spring to life and break the gloom.

Since the women's movement began, beauty pageants have been targets for feminist agitation because they celebrate sexual stereotyping and epitomize the marketing of women's sexuality. Nonetheless I was interested in the Miss Chinatown pageant for a number of reasons. Isolated in the centre of London, the Chinese community has maintained a distinct identity yet has incorporated certain sexist aspects of western culture. The pageant had been in existence for only two years. What did this recent development indicate about changes in their culture? How did this affect the women in the pageant? What were their feelings and what were my responses to the event and the women involved as opposed to my preconceptions of it? And, finally, could any of these questions be illuminated by my images?

My photographs reveal my ambivalence — black and murky, the figures of the women, half in shadow, seem to swim into the light, unrecognizable. Most of them unintentionally perpetuate the sexual stereotypes of women. Their high heels and bathing suits trigger a reflex response, through association, with the archetypal images from fashion and pornographic magazines so that the women lose their identity and individuality. Only one image avoids this trap; one group stand shivering, two others put on sweaters over their bathing suits. One of the contestants stares at me suspiciously. These women are shown cold and uncomfortable — they are human. But none of this was apparent in the glamorous images which appeared in the newspapers the following day.

Yet my Chinatown images have a curious power. They may deny the Asian women's individuality, but they succeed in expressing my alienation from the event. In developing its own code of practice, feminist photography must avoid the production of a new set of stereotypes. As women seek to find their own forms of expression, the pressure of conforming to some 'right way' of seeing or knowing can only lead to a new uniformity of vision and ideas. It is too early in the evolution of the women's movement to define what can be considered appropriate subjects. This would counter the very essence of feminism as it challenges woman to define herself.

My feminism and my photography are linked — one grew up with the other. The opportunity to pick up a camera offers women the chance to formulate their own view of reality and to develop an authentic mode of expression freed from the confines

of a repressive socialization and education. I make choices, and construct images that offer a model of myself and other women, around which to alter our self-images. I take photographs to alter my feelings about myself and society; to encourage change by indicating in pictures women's true capacities and identities. Finally, I record for the pleasure of it; for the joy and sense of personal odyssey and to make visible a constantly changing view. In seeing society more clearly, I discover myself for, as Berenice Abbott observed 'The eye is no better than the philosophy behind it.'

95 Joyce Agee, *Miss Chinatown Pageant*, 1981

Floating Femininity: A Look at Performance Art by Women
Catherine Elwes

A Look at Performance Art by Women

A nameless life model turns away from the camera while the beaming artist indicates his surname freshly printed across her body. Piero Manzoni intended his 1961 *Living Sculpture* to offer a critique of the art market and its equation of value with authenticity. His gesture inadvertently illustrated the marketing of femininity under patriarchy. By signing the woman, Manzoni symbolically established his ownership, giving her that stamp of sexual approval which traditionally buys her a name, a home, material necessities and some kind of social significance. Manzoni's *Living Sculpture* represents woman as a sexed commodity. She also embodies the traditional model/mistress/muse who supplies material, sexual and spiritual nourishment for the delicate palate of male genius.

However, Manzoni's model was not fantasy; she was part of a live action, a performance staged for the camera with rebellion continually implied in her over-evident submissiveness. At any moment she might abandon her pose, break her silence and address the audience directly without the mediation of a male author. Performance art offers women a unique vehicle for making that direct unmediated address. Performance is about the 'real-life' presence of the artist. She takes on no roles but her own. She is author, subject, activator, director and designer. When a woman speaks within the performance tradition, she is understood to be conveying her own perceptions, her own fantasies and her own analyses. She is both signifier and that which is signified. Nothing stands between spectator and performer. There is no man-made script to give the male spectator an easy escape via author-identification — nothing can protect him from direct confrontation with the women who returns his gaze and demands freedom of speech and equality of communication.[1] But for women, the real advantage of performance lies in its structural

flexibility. Performance deviates from theatre in introducing fine art; where fine art recedes, politics and pure spectacle take over. The limits of spectacle are extended with ritual, magic and fantasy while music and dance are used to transport the spectators or root them in the present with demonstrations of pure sound and movement. Performance is a state of flexibility — so, too, the language of women's consciousness. We need the flexibility of an art form whose distinguishing features are its propensity for change, the interchangeability of performer, author and subject-matter and an ability to express a range of political positions. A woman performer combines active authorship and an elusive medium to assert her irrefutable presence (an act of feminism) within a hostile environment (patriarchy).

In the following pages, I will discuss my ideas, observations, enthusiasms and criticisms of that performance presence, beginning with a selective historical introduction. I do not intend to present an anthology of women's activities in live art. Instead I will concentrate on work that interests me or which is significant to my thesis.[2] My experience as a performer and video-maker has played a significant part in moulding my preferences and prejudices as well as my analyses, so I will occasionally refer to works of my own that clarify my position.

From Image to Image-Maker: Women in the Early Years of Performance

Performance entered the fine art arena around 1912. It coincided with the politicisation of a younger generation of artists anxious to expose the hypocrisy of the establishment's claim to political neutrality. The Dadaists, Italian Futurists, Russian Constructivists and later the Surrealists used performance as propaganda. Theirs was the radical voice of dissent, attacking social and political institutions as well as the reactionary values of the art world.

The performances and spectacles of the Russian Constructivists achieved the most direct expression of a political position. Their 'production art' was a jubilant celebration of the revolution. The artist abandoned his visionary, god-like status and joined forces with designers, actors, and workers on ambitious collective projects.[3] Agit-ships and trains were fitted out with banners, posters and performers to take news of the revolution all over the Russian continent. Political pageants were staged by theatre directors and artists to celebrate historic victories of the people over the Tsarist regime. Performances involved dancers, circus artistes, army battalions and hundreds of citizens, many of whom had participated in the original events. The much debated divid-

ing line between performance and theatre was virtually non-existent in these mass political productions.

In both theatre and performance, old boundaries were broken down. At a former level, this meant that any material, any medium and any discipline could be art. At the level of content, politics were now the legitimate concern of artists. In terms of audience, the masses now displaced the aristocracy.[4]

If anything could be art, then anyone could be an artist — soldiers, entertainers, peasants, even women, many women. Although early performance art held radical implications for women, as far as we know it was dominated by men with women playing a secondary, collaborative role. Lynn MacRitchie has suggested that the activities and philosophies of the Italian Futurists were antipathetic to contemporary women. Futurism contained a strong element of middle class rebelliousness, bad boys flexing their muscles at the establishment.

The Italians made an art out of scandal. They delighted in abusing their audiences, taunting them with scatological acts, insults and long nationalistic tirades. Futurist evenings typically ended in fights and the imprisonment of the performers. This would be reported in the papers the next day much to the satisfaction of the artists. It is not surprising that few women could identify with the machismo and underlying misogyny that informed the futurist manifesto:

> 9. We will glorify war — the only true hygiene of the world, militarism, patriotism, the destructive gesture of the anarchist, the beautiful ideas which kill and the scorn of women. 10. We will destroy museums, libraries, and fight against moralism, feminism and all utilitarian cowardice![5]

Some women did, however work under the Futurist banner, the most interesting example being Valentine de Saint-Point. Although she shared Manzoni's enthusiasm for war, she saw lust as the key to artistic liberation. In her *Manifesto of Lust* (1913), true desire involves equal and consenting individuals and dispenses with the hunter and prey of conventional couples as well as the 'sentimental veils' which society throws over them. The phenomenon of a woman claiming the respectablity of art and simultaneously declaring her sensuality must have confused the double-standards of her middle-class audiences. Acceptable subject matter for women artists did not stretch to overt sensual references. *Poem of Atmosphere,* first performed at the Comédie des Champs-Elysées in Paris involved coloured lights and mathematical equations projected onto large sheets as a backdrop for the mysterious 'poems' which she danced, to the music of Debussy and Satie. The contrast between her celebratory performances

and the destructive exhortations of her male colleagues is signifi-
cant in that the Futurists were able to confirm the 'masculinity' of
their manifestos through the 'femininity' of her sensual
preoccupations.[6] However, she enjoyed considerable success and
was the only Futurist to be invited to perform in the United States.

Valentine de Saint-Point's solo career was unusual enough but
writing a manifesto that guaranteed her place in the history of art
was equally exceptional. The Futurists and Dadaists knew the
importance of propaganda and published volumes of manifestos
that were widely distributed. Lynn MacRitchie has noted that few
women performers contributed to these texts, making it hard for
us to assess the extent and precise nature of their involvement.
She gives an example, Emmy Hennings, co-founder of the
Dadaist Cabaret Voltaire in Zurich in 1916.

> 'She was an already established Cabaret Artiste and no doubt
> brought considerable skill and knowledge to nightly events.
> Indeed, in the most practical way, it is difficult to see how they
> could have taken place without her, as the Cabaret was initially
> set out to be just that. However, it is Ball, Tzara and the rest
> who are credited as the founders of the movement and it is
> their statements of aim and purpose which are reproduced in
> the official texts.'

Here we see the importance of documentation and publicity in
the life of a performance artist. If the threat presented by a
woman's prominence proves too disturbing to the male establish-
ment, simple exclusion from exhibitions, catalogues, reviews and
manifestos is extremely effective. A performance cannot be resur-
rected from the bowels of the Tate like a painting — the colours as
fresh today as they were to the people of the time. A performance
is a time-based, ephemeral experience and only partially survives
in the commentaries of contemporary art criticism and the
memories of its dead or dispersed performers and witnesses.[7]

Early women performers tended to be professional singers,
dancers or cabaret artistes rather than fine artists. Perhaps for the
first time, the skills valued by leaders of contemporary art were
the province of disciplines outside the fine art arena, and in the
realm of entertainment women were well represented. The
scarcity of women fine artists in early performances might also be
explained by the traditional association of actresses with prostitu-
tion. Only in the last 60 years or so has acting become a respect-
able profession for middle-class women. (For many years the fact
that my grandmother had been on the stage was a closely guarded
family secret. My great aunt finally decided that my mother, then
in her late fifties, was old enough to know 'the truth' about her
own mother and the scandal was revealed).

The skills of early women performers and the incongruity of their presence were instrumental in breaking through centuries of fine art conventions. Together with male Dadaists and Futurists, they proclaimed the death of painting and challenged the passivity of their audiences by astonishing them with fragmented spectacles of dance, song, acrobatics, poetry and speech making. The Surrealists shared the Dadaists' love of improvisation and chance, but their aim was to liberate the anarchy of the Freudian unconscious through free-association, automatism and dream.

Marinetti was determined to cancel the 'ill-effects' of painting which, he said, reduced spectators to 'stupid voyeurs'. Painting was accused of masquerading as communication while, in fact, erecting a barrier that re-inforced the ideology of the dominant class. Performance artists now broke down the barrier and dispensed with the art object. Painting and sculpture not only drove a wedge between artist and viewer but between art and life. Their reconciliation became a fundamental objective of much performance art, taking on particular significance in the early seventies with the emergence of feminism.

The Constructivists brought art and life together by making their work synonymous with political activism. The Futurists and Dadaists created provocative live situations which denied their spectators any imaginative escape into illusion. Isadora Duncan, one of the few independent women performers of that era, advocated a free flow of life into art pursuing 'dance as a way of life'. In 1904, she dismissed conventional dance training and developed movements that became the lyrical and emotional expression of her day-to-day existence. She performed in the streets, amongst ruins and in gardens, only returning to the theatre if all illusionistic lighting effects and props were removed. Hers was an emotive expressionism rooted in her unfailing personal commitment to dance. In presenting her life as the raw material of her art, Isadora Duncan was reversing centuries of artistic tradition which concealed women's experience, while those of men were presented as *human* experience and immortalised in the iconography of art. If life was art, then the invisible private lives of women could enter the public arena.

The implications of this were to lie fallow for several years. In the 1920s, the Bauhaus stage created a formalism that was almost diametrically opposed to Isadora Duncan's idiosyncratic expressionism. The body was stripped of any human dimension and reduced to a mechanical device describing space, articulating objects and animating eccentric costumes. Attempts to tame highly charged forms (human beings) with geometric structures produced images that were poignant, absurd or singularly beautiful. Echoing the Futurists and Constructivists, Oscar Schlemmer and

his colleagues aimed at the perfect synthesis of art and technology, man and machine. Again, few women are recorded as having orchestrated these human puppet-theatres, technology being presumably as much a male preserve then as it is today. Bauhaus women took on the roles of performers, designers, seamstresses and collaborators, employing old skills in the interpretation of male ideas.

When the Nazis closed the Bauhaus in 1932, many artists found refuge in the United States. Black Mountain College in North Carolina provided the setting for a flowering of Bauhaus formalism. 'Art is concerned with the HOW and not the WHAT; not with literal content, but with the performance of the factual content. The performance — how it is done, that is the content of art'[8] Josef Albers' words heralded the anti-illusionism that later formed the core of John Cage's musical performances. With the dancer Merce Cunningham he reintroduced the audience to the '...open, unpredictable, changing world of everyday life'. Familiar sounds, gestures and chance encounters became the material of performance. The emphasis was on audience experience, on the act of looking and listening rather than on the performer's daily existence as had been the case with Isadora Duncan. But like her, they rejected the idea of the artist playing a part — the performer played her/himself.

The work of the 1950's was overlaid with an interest in mysticism, in particular Zen Buddhism. The 1960s pursued their own quest for self-knowledge through sexual liberation, drugs, alternative therapies and religions. The meditative elements in Cage's work could now be seen as a programme for enlightenment. In the 1960s enlightenment was often a group activity. For women, 'togetherness' and participation were an important step towards solidarity and sisterhood.

In 1967, Ann Halprin filled a room with newspapers and played her audience drum music for an hour, whilst they meditated or responded spontaneously. She conceived of her work as a form of theatre in which '...everything is experienced as if for the first time, a theatre of risk, spontaneity, exposure and intensity'. Echoing Isadora Duncan, her own life and that of the performers together with the training, rehearsals and performances formed a process, in itself the experience. Her relationship with the audience took the form of a partnership which 'involved people with their environment so that life was lived whole'. [9] A sense of alienation from oneself and one's environment was seen to be a product of a mechanised, industrialised world. By prompting an audience to take creative responsibility within a work, the artist sought to raise their consciousness and galvanise them into action in the real world of politics.

In 1964 the first Free Speech Movement demonstration shook the University of California in Berkeley. Civil Rights, Black Power, Anti-Vietnam, Gay Liberation and Women's Liberation all followed as a whole generation became convinced of its ability to change the world. The corridors of power were no longer impregnable; every second-class citizen claimed entry to the white, middle-class, male institutions that governed society.

The art world was infiltrated by a new brand of strong, committed women — both in Europe and America. Often having started out in familiar roles as collaborators or models, large numbers of women now began to perform in their own right. Before I embark on a description of the trends that emerged, I want to consider some basic questions that arise when a woman abandons her pose and begins to 'speak' herself through the language of performance. What pitfalls lie in wait to undermine the authenticity of her voice and which strategies can counter these most effectively.... How do women fit into Performance Art?

From playing the part to calling the tune

'Women had always lived in a transitory world where they were expected and conditioned to be both solid and real as well as magical and illusory at the same time. The performance vehicle was made for women and now they were finally demanding to publicly play their own parts.'

Ardele Lister/Bill Jones 1979

In one sense, the term 'performance' can mean the acting out of a prescribed role over which one has limited control. John Berger pointed out that performance is a basic condition of womanhood and need not involve the presence of an actual audience.

From earliest childhood, she had been taught and persuaded to survey herself continually. And so she came to consider the surveyor and the surveyed within her as the two constituent elements of her identity as a woman.[10]

The image we continually cultivate is not of our own making,[11] but the skills we develop for the impersonation of 'femininity' can and should be exploited to our own ends. So how do we move out of the old configuration of viewer and viewed, how do we usurp the authority of the patriarchal surveyor and begin to 'publicly play our own parts'?

It has been suggested that a performance can come dangerously close to the wilting ballerina and the raucous comedienne who all reinforce stereotypes and gratify male desires. It is certainly true that in a performance which represents provocative

nudity the male contingent in the audience will generally respond with delighted approval. However, even a striptease contains within it certain important contradictions. Firstly, the male-oriented sexuality that the stripper projects, the content of her work, is undermined by the visible mechanisms of the illusion she is creating. Her audience can never totally believe in it since their own presence, the lights, the stage, the exaggerated behaviour of the performer and the inevitable flaws in her act all serve to emphasise the artificiality of her act.

The skills which a woman develops as an entertainer provide further difficulties for the male audience. Sally Potter has argued: '... The ballerina's physical strength and energy is communicated despite the scenario; the burlesque queen's apposite and witty interjection transform the meaning of what she is doing and reveal it for the 'act' it is'.[12]. We can see this phenomenon perhaps most clearly in opera where the plot often acts as a supporting structure for a series of arias rather than an attempt to build a convincing theatrical illusion. The arias are designed to demonstrate the virtuosity of the singer, the power and range of her voice as well as her ability to project the emotional intensity of the music.

Where the acting abilities of an entertainer produce a positive image of exposure. Mary-Anne Doane has observed that the female masquerade, over-acting the woman '...constitutes an acknowledgement that it is femininity itself which is constructed as a mask — as the decorative layer which conceals a non-identity... The masquerade, in flaunting femininity holds it at a distance. Womanliness is a mask which can be worn or removed.'[13]

Parody offers a stage on which the artificiality of 'normal' womanly behaviour can be underlined and the masculinist expectations of the audience revealed as the active agent in the (mis)representation of femininity.

Parody has been widely used in British feminist theatre, and to some extent in performance. Silvia Ziranek's suburban housewife is way over the top in pink fluff and affectation, but she is essentially a study in conformity.

> 'There again, I recline in the pure knowledge of the successful purchase. What a stroke of luck Sidney was, he's so... so adequate. But sometimes I am alone, desperately alone at the sink, dripping with diamonds. Maybe I should take more hair care.'[14]

But parody has to go to extremes of exaggeration to expose a femininity that has established theatricality and excess as the norm. If it is too subtle, a woman's masquerade can simply be seen as a narcissistic celebration of her own 'nature'. Alternatively, if

she ridicules the behaviour of other women she only establishes herself as a sophisticated exception that proves the rule. All male impersonators of women reinforce stereotypes — only the most cunning of female *masqueraders* can turn the spotlight on the mask and those for whom it is worn.

Returning the gaze of the male spectator can also block the voyeurism and fetishism that are often cited as a problem with women's performance. To explain briefly the terms: Freud claimed that man perceives woman as a castrated male embodying the threat of his own castration. I prefer Susan Lurie's emphasis on man's fear of the mother's power and his own desire for primal reunion with her (or her successors) in which femininity would predominate. 'And while this seems to have been a satisfactory even delightful arrangement during infancy, his present individual/sexual self symbolised in the penis could not survive such an arrangement.'[15] Loss of the penis primarily entails loss of patriarchal privilege — the cornerstone of male identity.

In Freud's view, men try to alleviate their castration anxieties via two somewhat unstable psychic processes. With voyeurism, the original discovery of woman's 'lack' is re-enacted in a symbolic scenario that results in her punishment or redemption. In fetishism, the whole body of the woman is transformed into a phallic symbol which both restores and reiterates her absent penis. It has been shown that voyeurism and fetishism operate very effectively in mainstream cinema.[16] A wholly credible fantasy world is created in which the fear of woman can be safely experienced and dispelled — if temporarily. The spectator is given a cloak of invisibility that allows him vicariously to reveal, possess and punish the woman via the male protagonists; he can fetishise her body isolated in lingering close-ups, and finally appropriate the look of the camera itself which ultimately controls the feared object of his desire.

As I have suggested, theatre and live entertainment cannot achieve the perfect illusion so necessary to the operations of voyeuristic narratives. The performer and spectator occupy the same physical/temporal space and the required suspension of disbelief that distances the performer into fantasy is difficult to achieve. Traditional live entertainment is therefore heavily dependent on narrative and on the woman 'acting' the roles she has demonstrably escaped. With the odd variation an entertainment scenario will always be resolved in the same way. The stripper ends up naked, the heroine sinks into the hero's arms, the lustful or murderous woman comes to a sticky end, the singer pines for her lost love and the mother-in-law in perenially hateful. Performance art abandons these narratives and denies voyeurism its safe dénouements leaving a man exposed to the fearful proximity

of the performer and the dangerous consequences of his own desires. His cloak of invisibility has been stripped away and his spectatorship becomes an issue within the work.

The denial of illusionistic space has long been a concern of artists like Sonia Knox who floods herself and the audience with uncompromising light. Like John Cage, she maintains emphasis on the act of looking. The French performer Orlan took the implications of voyeurism and patriarchal power literally by offering her body to a succession of male art critics. She subsequently performed in public as the Virgin Mary wrapped up in the stained sheets of her fornication.

Where voyeurism depends on narrative structures, fetishism operates on the static image — on photography, painting, sculpture, cinema stills and those 'timeless' moments in movies when the star's beauty temporarily halts the narrative. Images in fine art that capture the woman in mid-flight repeat this process. The hunting Diana, fleeing Daphne and scattering Sabine women are arrested by the male eye and transformed into frozen fetishes. The American artist Carolee Schneemann has noted: 'With paintings, constructions and sculptures, the viewers are able to carry out repeated examinations of the work, to select and vary viewing positions (to walk with the eye) to touch surfaces and to freely indulge responses to areas of colour and texture at their chosen speed.'[17] Only the tableau vivant and the motionless life model can recreate this luxury. By contrast, the woman performance artist is a mobile creative agent. She never stays the same long enough to be named, fetishised: '...the spectator is overwhelmed with changing recognitions, carried emotionally by a flux of evocative actions and led or held by the specific time sequence which marks the duration of the performance.'[18] The artist determines the way in which she is experienced by her audience. In defining the rules of the game and holding the element of surprise as her trump card, a woman may take unprecedented control of her own image.[19]

By blocking fetishism, the performer opens up the psychological processes produced under patriarchy. She exposes the principal fear of the dominant sex — loss of power. But performance implies more than a simple reversal of oppressor and oppressed. Unlike film, it is a live activity which involves direct confrontation between individuals. As we have seen, many artists' performances were conceived specifically as opportunities for audience participation and inter-active response; and within this lie the seeds of equality.

In Defiance of Definition

'The actual creative project of woman as subject involves *BET-RAYING* the expressive mechanisms of culture in order to express her self through the break, within the gaps, between the systematic spaces of artistic languages. This is not a matter of accusation or vindication, but of *TRANSGRESSION* (closer to madness than to reason).'

Anne-Marie Sauzeau-Boetti 1976

Similarly the unknown territory of a woman's own desire can intensify the threat she embodies. For this reason I believe that the sexual aspects of woman's physical presence in performance should be consistently explored and exploited.[20] Of course the stripper/entertainer is hovering in the wings ready to re-appropriate our work, but her image is very specific. The 'act' of sexuality she performs precludes all other human or cultural attributes. Public women in other walks of life — scientists, teachers and academics — have often felt obliged to suppress their sexuality in order to reassure male colleagues that nothing more frightening than a few blue stockings was invading their territory. Being one of the boys often means becoming indistinguishable from them. When a women is both publicly active *and* sexual, i.e. a whole woman, she challenges the social structures which reduce women to domestic drudges, sexual servants or neutered males orbiting man's social centrality.

An artist operating within a cross-disciplinary performance tradition can refuse easy categorisation and begin to put together what patriarchy has pulled apart. A performer may be sexual, but she is not a stripper, she may act, but she is not an actress, she may be intellectual but she is not an academic, she may employ political analysis, but she is not a politician, she may be active in the art world, and be neither mistress/muse nor passive prop in male productions. Carolee Schneemann perfectly embodied this dangerous creature in her 1968 *Naked Action Lecture* at the ICA. As she gave a talk about her work, discussing aspects of perception and spatial organisation, she repeatedly undressed and dressed. The work raised the questions: Can an artist be a naked woman? Does a woman have intellectual authority while naked and speaking? What multiple levels of uneasiness, pleasure, curiosity, erotic fascination, acceptance or rejection were activated in the audience? [21] By being both intellectual *and* erotic, she escaped categorisation into existing disciplines with their attendant pigeon-holing for women. But it was a close thing. Performance picks its way across a minefield of stereotypes, but with a little skill and much careful analysis of patriarchal precedents, we can begin to exploit our mobility, our unpredictability and the

contradictions inherent in women-as-spectacle. We can exacerbate the psychic threat we present to men in terms of our symbolic associations with castration. At a political level we can deny social stereotypes — the palliatives with which public women traditionally reassure men that despite our being as it were, matter out of place, we constitute no real threat to the status quo. As artists, we can displace the patrist male author by becoming the subject of our own scrutiny. In performing we may, at last, take control of the ways we are seen, drawing out meanings from the language of our art that reflect our own consciousness rather than the expectations of that internalised and actual patriarchal surveyor.

Feminism and Performance — 1970 to the Present

'Deeds not words'.

Emily Wilding Davison, 1913

The 1960's bequeathed to the next decade two main strategies for liberation: collective political activism and individual liberation through self-knowledge. Feminist performance art engaged directly with both these approaches, while simultaneously pulling them together under a single objective: the emancipation of women.

'Agit-prop' feminist performance exists within the tradition founded by Russian Constructivists who first proposed political gesture as art. But its political history begins with the symbolic acts of British suffragettes. For the first time political demonstrations were staged by women drawing attention to specifically feminist issues. After 45 years of politely asking for the vote, '...women resorted to actions so opposed to the accepted views of womanly behaviour that it broke down centuries of taboo.'[22] These Edwardian ladies became uncharacteristically public and adopted a variety of disruptive tactics reaching a climax in 1913 with the dramatic, if unintentional, death of Emily Wilding Davison who threw herself in front of the King's horse on Derby Day. Recently women have used symbolic gestures to protest the threat of nuclear annihilation. In 1983, thirty thousand women went to Greenham Common where an American air base was being prepared to receive cruise missiles. Surrounding the base in a human chain, the women attempted to absorb the nightmare with their bodies, their children, and with webs of wool and cherished objects, woven into the high wire fences.

Women have used political gestures to demonstrate against a wide range of discriminatory social practices. In the art world, women contested their gross under-representation in galleries,

museums and national exhibitions. In 1970 women artists pick-
eted the Whitney Museum in New York, demanding fifty percent
representation in their annual survey shows of American art.
They got twenty two percent. British women in 1975 held a pro-
test outside the Hayward Gallery where thirty six men and four
women were considered to reflect *The Condition of Sculpture*. In
1977, Hannah O'Shea drew activism into art with her *Litany for
Women Artists*, a celebration of those ignored by art history. The
names of over 700 artists were ritually chanted in a measured,
emphatic tribute to our *Hidden Heritage*.[23]

96 Hannah O'Shea, *A Litany for Women Artists*, Frankfurt, Berlin, N.Y.,
photograph by Rose Finn-Kelcey

Sexist imagery, the visual condonation of men possessing women, also came under severe attack. 'Harmless' entertainment was targeted as well as more virulent forms of pornography. Alison Fell's *Flashing Nipple* routine was a focus of the demonstrations against the 1971 *Miss World* contest. Inside the hall, women threw flour bombs at Bob Hope, temporarily breaking the stream of jokes about udders and cattle markets. The American group Ariadne, founded by Suzanne Lacey and Leslie Labowitz, developed the art of protest to a considerable degree of professionalism. In 1977 as the link between pornography and violence against women was being vigorously debated, Ariadne performed *In Mourning and in Rage*, a work that drew public attention to the ninth rape and murder committed by the Hillside Strangler in Los Angeles. A group of seven-foot veiled mourners performed on the steps of the City Hall. They ensured that their performance received maximum media coverage so as to counter-balance press sensationalism which had reduced the murders to sadistic entertainment. Political activism and art became virtually interchangeable in the context of these works.

In advocating liberation through self-awareness, the second strand of feminist performance created a synthesis of politics and individual creativity which neither the expressionism of Isadora Duncan nor the reductivism of John Cage had achieved. Life, art and politics came together under the feminist dictum of 'The personal is political'. This asserted that patriarchy shapes every aspect of our lives, both the private and public. As Sally Potter puts it, 'Ideology is not merely reflected, but produced in the context of the family and personal relations'.[24] By exchanging and analysing their histories in consciousness-raising groups, women were able to conceive of personal difficulties as an effect of collective oppression, rather than the result of individual weakness or neurosis.

When the American feminist Judy Chicago initiated the Women's Art Program at Fresno State College in 1970, consciousness-raising became synonymous with performance. The women used their art to '...work out their own experiences, to see how the personal *was* political, to analyse their own lives in the light of a feminist perspective... Women worked collectively, learned new skills, (male skills), explored traditional women's skills and aimed at opening up their whole range of emotions for creative work... to link the public with the private in our schizoid world, to embrace the whole of life.'[25] In *Ablutions* of 1972, Judy Chicago, Suzanne Lacey, Sandra Orgel, and Aviva Ramani forced the experience of violence into the realm of art. In a long ritual of immersion and cleansing, binding and combining, they worked with eggs, kidneys, blood, bandages, rope and clay while a tape described women's experiences of rape.

Around this time feminists were excavating their historical heritage in ancient matriarchal cultures. Their rituals and those of contemporary primitive groups that value and honour women offered strong alternatives to the masculinist traditions of fine art. Story-telling and other female rituals surviving under patriarchy were similarly drawn into performance. Many of these stories were, of course, autobiographical and Lucy Lippard has suggested that they may have reinforced a trend in self-revelation and self-abuse in men's art — Chris Burden being shot in the arm, Vito Acconci masturbating under a floor — but she distinguishes between male masochism and the careful exposition, analysis and exorcism of painful experiences that is characteristic of feminist work. It is often asked whether consciousness-raising and autobiography can qualify as art — a question that is rarely asked in connection with male work, although men's desires, fears and obsessions have dominated the development of Western art.

A more important question concerns the relationship of autobiographical art to politics. When *is* the personal political? Not, said Martha Rosler when '...the attention narrows to the privileged tinkering with, or attention to one's solely private sphere, divorced from any collective struggle or publicly conjoined act and simply names the personal practice as political. For art this can mean doing work that looks like art has always looked, that challenges little, but about which one asserts that it is valid because it was done by a woman.'[26] It is plain that political analysis must be brought to bear on personal experience, but perhaps less obvious that there is more than one way of making that analysis. It has been assumed that didactic work which emphasises its theoretical sources is more politically effective than poetic, speculative work employing visual or gestural metaphors. I have always advocated the necessity for stong political statements, but I also value work that tackles ambiguity and contradiction. This approach invites the audience to make its own discoveries and decisions without losing sight of the artist's own position — a kind of internal democracy.

What all feminist or woman-oriented art has in common is its address to a female audience. Historians and critics have underestimated the importance of that audience. Exhibitions, publications and organisations of women artists and historians disseminate a feminist consciousness out of which new meanings can emerge — culture is *not* static. Film theorists represent the woman spectator oscillating between passive identification with the female object on the screen and adopting an active, masculine position at the expense of gender. But feminist art creates an *active* image of womanhood and performance offers conscious engagement, not so much through identification (an imaginary

loss of self) but through dialogue: 'in a society which isolates women and inspires competition (the work) seeks to encourage solidarity amongst women through emotional appeal, ritual form, and the synaesthetic effects of performance.'[27]

Taking Control — Some Individual Strategies

Control of self-image through a strategy of 'impassive' resistance was adopted by Yoko Ono in 1965 when she invited an audience at the Indica Gallery to cut her flimsy dress away with scissors. As all the jokes and cat calls died down it became obvious that no-one dared approach the motionless figure of the performer. Finally a student and the gallery porter snipped off tiny fragments from her hem. This refusal to emulate the brash confidence of male public appearances also manifests itself in the work of the British artist Annabelle Nicolson. Her performances are slow meditative pieces in which her quiet voice insists on a similar stillness in the audience.

At the other end of the scale, Carolee Schneemann takes her audience by storm with Dionysian pageants overflowing with an eroticism that was, until recently, a taboo area for many feminists.

'*Meat Joy* (1964) has the character of an erotic rite; excessive, indulgent, a celebration of flesh as material; raw fish, chickens, sausages, wet paint, transparent plastic, rope, brushes, paper, scrap. Its propulsion is towards the ecstatic — shifting and turning between tenderness, wildness, precision, abandon; qualities which could at any moment be sensual, comic, joyous, repellent.[28]'

Certain stills from *Meat Joy* could well double as *Playboy* centre-folds and to my mind do not escape re-appropriation. But the performances themselves defy objectification with their insistent, active sensuality. The artist's evident authorship is an additional obstacle.

'If I had only been dancing, acting, I would have maintained forms of feminine expression acceptable to the culture; 'be the image we want'. But I was directing troupes of performers, technicians; creating lights, sound, electronic systems, environments, costumes — every aspect of production, and then physically moving in what I had created. Some people wanted to constrain our actions as seductive, provocative, obscene, but the tenderness, boldness, spontaneity and pleasure which the performers communicated forced them to question their own attitudes.'[29]

Carolee Schneemann's celebratory performances should not be confused with the sado-masochistic performances of male *Aktionists* working in contemporary Vienna. These artists were convinced that catharsis could liberate audiences from the alienating effects of a mechanistic society and put them in touch with primal, animalistic drives long suppressed by civilisation. Hermann Nitsch directed violent performances in which animals were disembowelled and their entrails smeared over naked individuals who were then 'crucified' to the accompaniment of ear-splitting noise-music. [30] Where the victim was male, shades of Christ-crucified enobled his plight, but when the woman was subjected to similar physical abuse, the implications were less than heroic.

I have sat through Kurt Kren's documentary films of work by Nitsch, Muehl et. al. with a gathering sense of revulsion as a succession of women were doused in blood, shit, paint and jets of water — their biology, as it were, thrown back in their faces. I was heartened to find that my response to Nitsch's work was not unique.

> 'Much of this art also includes a ferocious misogyny and this is especially so in those scatological actions where the ingestion of urine, faeces and other products of elimination, stands as a symbol for an envy of the womb and its functions, as a kind of exorcism of the terror of openly competing with the female genitals. This is true and proper gynaephobia.'[31]

Fear of female biology and sexuality seems so deeply ingrained in men that its free expression is profoundly threatening. 'I was astounded when in the midst of *Meat Joy* a man came out of the audience and began to strangle me. Steeped in the writings of Wilhelm Reich I understood what had affected him but not how to break his hold on my neck!'[32] Without its status as fetish, the female body holds untold terrors of castration and death.

There are women who have used pain and self-mutilation in their work. Gina Pane, the Italian performer, calmly lacerated her body with razor-blades as a *Psychic Action* in a ritual mourning for the inevitable severance of the symbiotic mother/child relationship. In this country, Sonia Knox trod through a tangle of barbed wire during her performance *Echoes from the North* (1978/9). The gesture conjured up the suffering that has resulted from the rift between Catholic and Protestant in Northern Ireland as well as the painful lurch into womanhood heralded by the onset of menstruation. When a woman harms herself as part of a controlled artistic statement, she inhibits the usual dismissal of women's pain as, pathology or female masochism. Where the

Viennese actions were designed to *cause* distress in their audience, the women's pain is distanced into a powerful *re-presentation* of distress. While Sonia Knox's self-mutilation functions as an act of reparation *Echoes from the North* is principally a political analysis, drawn out of fragmented memories from the artist's own past. The pieces are put back together to create an understanding of the social situation which produced the personal dilemma. The artist attempts to free herself from her own past, whereas Nitsch simply wallows in a long drawn-out primal scream.

Menstruation and Motherhood — Unravelling Biological Binds

'The whole of (woman's) bodily beauty is nothing less than phlegm, blood, bile, rheum and the fluid of digested food.'

John Chrysostom

The fear of woman's tethered power has at times driven men into desperate attempts to control their sexual desires, while the life-giving power of her biology has inspired further taboos.

'When a woman has a discharge of blood, her impurity shall last for 7 days; anyone who touches her shall be unclean till evening. Everything on which she lies or sits during her impurity shall be unclean... If a man goes as far as to have sexual intercourse with her and any of her discharge goes on him, then he shall be unclean for 7 days and every bed on which he lies shall be unclean.[33]'

Contemporary western society deals with its aversion to menstruation by pretending it doesn't exist. It is an unmentionable, dirty process that must be disguised by invisible tampons and pain-killing drugs. Feminists have explored menstruation as part of a general re-evaluation of woman's much maligned biology. In 1971 Judy Chicago created a menstruation bathroom at *Womanhouse* in California. A white, sterile space could be observed through a thin veil of gauze and 'under a shelf full of all the paraphernalia with which this culture 'cleans up' menstruation was a garbage can filled with unmistakeable marks of our animality.'[34] Later, Leslie Labowitz performed a *Menstruation Wait* in Los Angeles. She sat on the floor and recorded her pre-menstrual feelings, the audience's reactions, and memories of her mother telling her about menstruation and the pill. The performance ended when she started to bleed.

Exploring the isolation of menstruation was the aim of my own work in 1979. The 'menstruation huts' of early societies were established by women to protect them during during menstruation and childbirth. As patriarchal religions gradually reversed matriarchal values, menstrual isolation became enforced and

women were excluded from religious worship and other forms of public life. By enclosing myself in a glass-fronted compartment in the corner of a Slade studio and visibly bleeding for several days, I confronted the forcible eradication of women's biology from culture. I used menstrual isolation in its original function, concentrating on physical and psychological changes as a source of knowledge and creative energy.[35] Judith Higginbottom, another British artist, was similarly convinced that menstruation was a 'lost' source of creativity. In *Water into Wine*, a slide-tape installation from 1980, she combined the ancient menstrual associations of the moon, the sea and the tides with the menstrual experiences of 27 women recorded over a period of 13 lunar months. Menstruation, dreams and creativity were linked in a kind of poetic survey of women's unspoken physical and psychic lives.

The suppression of woman's creativity has involved the equation of femininity with nature as a counterpoint to man's higher involvement in culture. The woman who is creative both as child-bearer and 'cultural worker' is therefore a highly disturbing phenomenon. Not only does she disrupt patriarchal organisation by becoming unclassifiable (neither truly woman/nature nor artist/culture) but she threatens the exclusive masculinity of culture that compensates men for their limited roles in the 'creativity' of procreation. In *10 Months* Susan Hiller documented the slow swelling of her belly and juxtaposed the resulting photographs with extracts from her diaries: 'Six/ She speaks (as a woman) about everything although they wish her to speak only about women's things. They like her to speak about everything only if she does not speak 'as a woman', only if she will agree in advance to play the artist's role as neutral (neuter) observer.'[36]

Where many professional women have concealed their motherhood, some performers emphatically assert their biological creativity within their art. Shirley Cameron has toured and performed with her twin children since they were three weeks old. At a performance festival in Portugal, in the absence of the promised creche, the artist constructed one of her *Cages in the Park*. 'My presentation was 'merely' myself sitting with the children'[37] Tina Keane has performed with her daughter Emmeline on several occasions. Together they explored the rituals of childhood — the songs, games, nursery rhymes, and stories that are passed down from mother to daughter — speaking with 'the voices of different generations to give women a mystical place in art.'[38]

It has been suggested that art which focuses on woman's biology inadvertently supports the arguments of biological determinism. The feminist excavation of 'authentic' womanhood has also been criticised for its apparent similarity to the patrist pursuit of

97 Shirley Cameron, *Inside*, Liverpool Academy

'essential' femininity — the 'other' to masculinity's primary status
in western culture. In attempting to avoid these associations,
some feminists have reduced sexual difference to social con-
ditioning. They employ a variety of political, psychological and
linguistic theories to explain femininity and minimise the use of
empirical evidence (biological experience) in their analyses. Such
an approach fails to explain the experience of oppression — if
culture's grip were indeed so tight, our conditioning so total, no
repressed potential would surface as frustration and anger.

183

More seriously, the denial of women's psychological and biolo-
gical experience reinforces existing censorship and taboos laid
down by patriarchy. There are dangers in both theoretical and
empirical (subjective) approaches to feminism. For me, the
answer lies in refuting patriarchal censorship with an insistence
on the centrality of women's experience; continually testing
theory against practice and resisting the polarisation of instinc-
tual 'wisdom' and 'rational' thought — an artificial split through
which patriarchal society enforces hierarchical divisions.

The Debunking of Domesticity

'You start by sinking into his arms and end up with your arms in
his sink.'

Feminist poster

In the 1970s society began to acknowledge the culpability of
domestic life in the growing incidence of alcoholism and depress-
ion among women. Feminists precipitated this realisation by insis-
tently contrasting the reality of domestic isolation, the drudgery
and tedium in endless rounds of cooking, cleaning and washing,
with the romantic image of connubial bliss and mythic mother-
hood that patriarchy markets through advertising. Although in-
dispensable to the operations of a capitalist system, domestic
labour is unrecognised, unpaid and provides no social status for
its workers. Feminists have attempted to reinstate traditional
domestic crafts such as embroidery, cookery, dress and quilt-
making by deliberately introducing them into their art practice.

In her performance *My Cooking Competes* at the ICA, 1980,
Bobby Baker contrasted the invisibility of women's culinary skills
with the prominence of the masculine traditions. With deliciously
understated irony, she displayed nine different meals for nine
different occasions on a long table draped in a starched white
cloth. The budget-meal for two, the supper party for four, sun-
day breakfast and so on were described with cosy middle-class
care for maximum efficiency. Behind her hung a series of glossy
photos of the display taken by a professional photographer. Per-
fectly mounted and framed, her 'worthless' products acquired
monetary value now that they were dissociated from manual
labour by the highly marketable medium of photography.

Mary-Anne Doane describes voyeuristic desire — active male
looking — as dependant on the distance of representation, and
the absence of the signified object. She quotes Christian Metz: 'It
is no accident that the main socially acceptable arts are based on
the senses at a distance, and that those which depend on the
senses of contact are often regarded as 'minor' arts (culinary arts,
arts of perfumes, etc.)[39] And it is no accident that women are the

main practitioners of these minor arts.

Masks, Make-up, Doubles and Disguises

Woman is split three ways: (1) the internalised patriarchal sur-
veyor (2) the mask of femininity which he demands and (3) that
unknown quantity which the feminine *I* singularly fails to repre-
sent. Unmasking the mask — revealing it as a charade — was an
early objective of feminist performance. In 1971 at Woman-
house, *Lea's Room* contained a young woman sitting at her dres-
sing table repeatedly making herself up, wiping it off and starting
again. The ideal image was never to be achieved.

In her slide-tape piece *Short Cuts to Sharp Looks* Roberta Gra-
ham explored the lengths to which women will go in pursuit of
the perfect mask. Images of surgical instruments were inters-
persed with models' faces marked up like dress patterns and the
artist's own face with its imperfections measured. A sound track
of blood-curdling screeches brought home the horror and
absurdity of this desire to 'cut up and restructure, to disguise the
ageing process, so that it conforms with the socially prescribed
aesthetic of youthful beauty.'[40] If our faces can be carved into
shape, then our bodies must follow suit. The disparity between
the anorexic proportions of the model figure and the reality of
the average female form produces many perverse relationships
with food. Both the compulsive eater and the anorexic are caught
between the contradictory pressures from different interest
groups. The food manufacturers say eat, eat, the fashion pages
say slim at all costs and the diet industry cashes in on all the
confusion. The American Eleanor Antin wryly conformed in
Carving, a traditional sculpture. She documented a ten pound
weight loss in 144 deadpan photographs of her body gradually
acquiring the shape of social and sexual desirability.

It isn't surprising that women are willing to discard the mask of
femininity in favour of more positive personas. In her photo-
graphic study of posture, the German artist Marianne Wex disco-
vered that girls take up masculine poses with the greatest of ease
while boys are highly resistant to the symbolic loss of their man-
nish authority. Women's ability to play the often contradictory
roles of womanhood and their simultaneous desire to transcend
them have flourished in the multiple personality of performance.
Eleanor Antin explored a number of potential selves — as the
ballerina, the king or the black movie star. These fantasies
allowed the artist a broader experience of life, (however vicar-
iously) and revealed repressed or socially unacceptable aspects of
herself. The external trappings of sex and age are seen as 'merely
tyrannical limitations upon (her) freedom of choice.'[41]

Multiple selves can reflect the fragmentation of the female psyche into surveyor and surveyed or embody aspects of the creative process itself. Rose Finn-Kelcey has used the magpie as a kind of alter-ego. In 1977, she caged herself in the window of the Acme Gallery with two live birds and a quantity of precious looking objects. These beautiful thieves, much abused by folklore exemplified the woman artist's predicament as she attempts to 'steal' from a language that is not her own, and squeeze new meanings out of images and words fashioned to perpetuate her silence.

98 Rose Finn-Kelcey, *Magpie's Box*, 1977, photograph by Pica

99 Rose Garrard, *Surveillance*, Lyons 1980, photograph by Pierret

In *Surveillance* at the Hayward Gallery (1979), Rose Garrard juxtaposed a facsimile of her surveyed self with her live presence. Under the glare of two video systems and a large audience the two Roses were moulded into the image of a Spanish woman whose portrait the artist had associated with feminine perfection since childhood. My own work at the time involved an analysis of Catholic conditioning through 'impossible' exchanges between myself and the ten-year-old Catherine Elwes on video. In 1980 I pointed to contemporary conflicts through the problematic relationships of three daughters to a common mother. Besides being the initial source of gratification, security and love, mothers are also our earliest tutors in the repressive ideology of patriarchy. Untangling infantile anger from ideology can be a difficult task. 'She built an admirable fortress, a fabulous fable — happy trap, lined in soft pink comfort and loving words. It caught her too, even as she pulled us in. Sweet innocents that we were, up to our necks in sticky sentiments...' During the performance, I drew three 'daughters' from the same faint image of a monumental mother.[42] As the drawings emerged each 'daughter' told the story of her relationship with her mother, while pursuing one of the solutions offered by the analytical feminist, the housewife, and the career woman.

Much of this work hinges on a floating feminine identity that allows the artist to explore the cultural boundaries of femininity. When, in the past, countless women performers, painters and writers impersonated men (Vesta Tilley, Rosa Bonheur, George Sand), professional survival was often at stake. Although a need might still exist to identify with the aggressor and diffuse attendant anxieties, the acquisition of manhood is principally a desire

100 Catherine Elwes, *Each Fine Strand*, ICA 1980, photograph by Joyce Agee

187

for the active selfhood that society consistently denies women and unquestioningly confers on men.

A man's gender eases his passage into the public world, while his voice commands a wealth of meaning that is traditionally unavailable to a woman. Laurie Anderson has a remarkable ability to impersonate a whole cast of American personas without altering her androgynous appearance. When speaking (electronically) with a man's voice she finds that her range of subject matter is significantly extended.

It has often been said that playing the man ultimately signifies reversal and reinforces the roles from which the impersonator deviates. Cross-dressing in performance is rarely intended as true disguise.[43] The actual image produced is of two disguises (male and female) continually pointing up each other's inadequacies. But when a whole generation of young women give themselves short back and sides and dress identically to their male colleagues, their masculinisation can no longer be re-appropriated as sexual titillation or role reversal. It is a collective refusal to conform to sexual stereotypes.

This should not be confused with a male artist's interest in androgyny and cross-dressing. The Surrealists deliberately stimulated their latent femininity: Duchamp as Rrose Selavy and Picabia's bearded ballerina. In 1970, the performance artist Vito Acconci made various attempts to acquire a female form: pinching his nipples, pulling out his chest hair and finally having his penis 'disappear' into a woman's mouth. Lucy Lippard sees this as birth envy while Griselda Pollock and Rozsika Parker identify the surrealist work as an attempt to appropriate a feminine sensibility, and extend expressive dominion into the ghetto that they themselves created. But whereas effeminacy or homosexuality has been heavily censored in politicians, teachers and other political figures, society has always tolerated 'feminine' poets, musicians and artists. In fact, their role is often to provide the opportunity for other men vicariously to experience their buried femininity. The power and prestige of the artist's biological masculinity is *reinforced* rather than undermined by artistic forays into the feminine. His status as an artist partly depends on this poetic femininity. Where men enrich their imaginative lives with androgyny, women often take on masculinity simply to acquire a voice.

In (Provisional) Conclusion

'Thus a woman's (re)discovery of herself can only signify the possibility of not sacrificing any of her pleasures to another, of not identifying with anyone in particular, of never being simp-

ly one. It is a sort of universe in expansion for which no limits could be fixed and which, for all that, would not be incoherency.'

<div align="right">

Luce Irigary, 1977

</div>

In the course of this essay, I have argued the value of performance as a vehicle for the expanding universe of women's creativity. [44] The pluralism and structural mobility of live art, its disposal of patriarchal pigeon-holes, its disruption of male voyeurism, the emphasis on female authorship and desire all open up a space for '... an 'other meaning' which is constantly in the process of weaving itself, at the same time ceaselessly embracing words and yet casting them off to avoid becoming fixed, immobilised.'[45]

While the content of performance may take the form of speculative journeys, the fact of live art is the irrefutable public presence of woman. She both signifies and denies the old significance of woman. She stands as a symbol of the alternative political consciousness which links her to half the audience. The performer and her *'spectatrices'* are constant reminders of patriarchal instablity both social and psychic. The continual rumble of resistance is echoed in every aberrant gesture, every discordant turn of phrase, each new image that simply cannot fit the old order of representation.

101 *Meat Joy* 1964, Carolee Schneemann in performance with Dorothea Rockburne, photography by Al Giese

Performance, video, slide-installation and other time-based media are now evolving 'New Narratives' while the art world courts easel art as the new avant-garde. The old alliance between performance and popular culture is being renewed and commercial outlets are attracting new audiences. Many women are already involved in these developments. What we now need in this country is a substantial documentary, critical and theoretical literature to contextualise and nourish the work — something on a par with independent film criticism. Issues of female spectatorship, sexuality and cultural (dis)placement are as yet poorly theorised in relation to performance and video has generally been assumed to operate in the same way as film. The art is there, all we have to do is experience it and respond to it.

Footnotes

1) Nowadays, a performance generally involves an artist or group of artists who carry out a series of actions producing visual, aural, physical or emotional experiences for themselves and an audience. The actions can take place in a gallery, on the street, in someone's front room, up a mountain and, more rarely, on television — whatever seems most appropriate to the work. In terms of materials, artists have used everything from traditional sculptural objects to their own blood and more recently, the technologies of stereophonic sound, film and video.

2) For a more comprehensive survey of British work, see Lynn MacRitchie's contribution to the *About Time* catalogue, ICA, London, September 1980.

3) This is perhaps the closest artists got to democratizing art production. Since it was generally against their own interests to do so, they subsequently rebuilt their status until the 1970s when feminists gently rocked the boat once again by staging collective political performances.

4) Much contemporary feminist art other than performance stretches the concept of art to include political activism. For example, Margaret Harrisons's 1980 exhibition at Battersea Arts Centre showed photographs, artifacts and documents that exposed the exploitation of women homeworkers in England.

5) MacRitchie

6) In their book *Old Mistresses, Women, Art and Ideology,* London 1981, Rozsika Parker and Griselda Pollock describe this process in painting.

7) This is why the continued exclusion of women's performance from contemporary criticism becomes an important

issue. With few exceptions, feminist historians and critics are absorbed in historical excavations of women's art, political analyses of that history or the analysis of more tangible contemporary work. If women's performance is not more substantially recorded it will be lost.

8) Josef Albers quoted by Roselee Goldberg, *Performance, Live Art 1909 to the Present,* London 1979.

9) Anne Halprin quoted by Udo Kulterman in *Arts Events and Happenings,* N.Y. 1968.

10) John Berger, *Ways of Seeing,* London 1972, p. 166.

11) The American performer Adrian Piper perfectly embodied this phenomenon in *Some Reflective Surfaces,* 1976. With a painted on moustache, she danced to the song *Respect* while a man's voice (her internalized surveyor) criticised her movements. She corrected her dance accordingly.

12) Sally Potter, *About Time* catalogue.

13) Mary-Ann Doane, 'Film and the Masquerade: Theorising the Female Spectator', *Screen,* volume 23 no. 3-4.

14) Silvia C.Ziranek *Rubbergloverama Drama, About Time* catalogue.

15) Susan Lurie quoted by Lucy Fisher and Marcia Landy, 'The Eyes of Laura Mars — A Binocular critique', *Screen,* vol 23 no. 3-4.

16) See Laura Mulvey page 20 'Visual Pleasure and Narrative Cinema' *Screen* Vol. 16, no. 3, p.6; also Paul Willerman, 'Voyeurism, the Look and Dwoskin', *After Image,* no. 6.

17) Carolee Schneemann, *More than Meat Joy, Documentext,* NY 1979.

18) Ibid.

19) This hard-won control of self-image explains the reluctance of many women to being photographed while performing and the care with which they select and publish representative images of their work. To 'steal' the image of a woman performer, to photograph her without her knowledge and withold or publish the result without her permission is not only simple theft, but it undermines the strategies by which she attempts to subvert the patriarchal eye. It effectively destroys the work.

20) I am as yet unconvinced that the use of sado-masochistic pornography is a radical strategy for women. However, the representation of desire divorced from the duties of marriage and child-bearing can subvert the narrow view of female sexuality that patriarchy propagates.

21) Schneemann.

22) 'Men against Women', Jill Craigie, *Observer magazine,* 16 January 1977.

23) *Our Hidden Heritage,* New York 1974, by Nora Lufts is one of the important anthologies of forgotten women artists that feminist art historians have produced.

24) Sally Potter, *About Time* catalogue.

25) Judy Chicago, *Through the Flower,* New York 1977.

26) Martha Rosler statement made in a discussion *Is the Personal Political?* ICA 1980.

27) Judith Barry and Sandy Flitterman, 'Textual Strategies: The Politics of Artmaking', *Screen,* vol. 21, no. 2.

28) Schneemann.

29) Ibid.

30) In a pamphlet on menstrual taboos, Jo Nesbitt has suggested that the crucifixion is the ultimate image of male womb-envy. 'It is no accident that Mary is portrayed as giving birth in tranquillity or ecstasy as a reward for her asexuality, while her son takes on the suffering and dramatic role of the mother. The figure displayed on the crucifix is a male parody of the female experience of menstrual bleeding and childbirth.' Jealous of women's power to give birth, the male god must control the life of the spirit — which then takes precedence over mortal life and death.

31) Lea Virgine, *Il corpo come linguaggio, (La Body-art e storie simili),* Milan 1974.

32) Schneemann.

33) *Leviticus 15;19;42.* The pre-menstrual period is often experienced as a time of heightened sexual desire and implies a rejection of motherhood. At one time people believed that the menstrual flow was the remains of a dead child. Not only could a woman give life but she could also kill, her sexuality playing the part of the executioner. Menstruating women have been accused of blighting crops, rusting iron and causing mares to miscarry — many of these powers also being attributed to witches.

34) Chicago.

35) *The Wise Wound* by Penelope Shuttle and Peter Redgrove shows how the Delphic seers were consulted during the heightened sensitivity of menstruation. They also suggest that much male ritual of trances and blood-letting was modelled on women's dramatic menstrual and perinatal transformations. My own sense of being mimicked by the Slade fashion in bleeding, shitting, and vomiting was deepened when my menstrual work provoked intense hostility in male students. This was something their 'superior' biology simply couldn't stretch to.

36) Susan Hiller, *About Time* catalogue.

37) Shirley Cameron in correspondence with the author 1981.

38) The documentary work of Mary Kelly on the mother/son relationship theorized from a Lacanian psychoanalytic position constitutes the most extensive study on the subject to date.

39) Christian Metz quoted by Doane.

40) Roberta Graham, *About Time* catalogue.

41) Eleanor Antin quoted by Lucy Lippard, *From the Center*, New York 1976, p. 105.

42) *Each Fine Strand*, ICA London 1980

43) An exception is my own work in 1977. Using some make up skills learnt in a previous incarnation at the BBC, I transformed myself and Annie Wright into reasonable approximations of our masculine equivalents in the hope that our disguise would reveal the magic of male privilege. My most enduring memories of this piece were the novel experience of holding men's gazes while losing (deflecting) women's, and sitting unaccosted in a pub. An attempt to give a man the reciprocal experience failed.

44) I distinguish absolutely between feminist eclecticism and the aimless history-hopping that painting is currently adopting in a desperate bid to re-vamp an exhausted modernist tradition.

45) Luce Irigaray, *Ce Sexe qui n'en est pas un,* translated by Claudia Reeden, Sussex 1981.

Women's Images of Men
ICA October 4-26 1980

List of Artists

Joyce Agee
Glenys Barton
Philippa Beale
Jo Brocklehurst
Lill-Ann Chepstow-Lusty
Helen Cherry
Sue Coe
Eileen Cooper
Erica Daborn
Gertrude Elias
Elisabeth Frink
Sally Greenhill
Mandy Havers
Roberta Juzefa
Mouse Katz
Deborah Law
Jane Lewis

Barbara Loftus
Mayotte Magnus
Suzi Malin
Jacqueline Morreau
Ana Maria Pacheco
Robin Richmond
Carole Robb
Annie Ross
Marisa Rueda
Elena Samperi
Tessa Schneideman
Anya Teixeira
Christine Voge
Joan Wakelin
Helen White
Pat Whiteread
Jenni Wittman
Evelyn Williams

Note:
The Publishers and Editors have made every effort to contact all those who have contributed to this re-issue. In some cases this has proved impossible and they apologise for this.

Bibliography

(See also footnotes)

Ableman, P. (1982), *The Banished Body*, Orbis, UK.
Adler, K. and Tamar, G. (1986), *The Correspondence of Berthe Morisot*, Camden Press, UK.
Archer, J. and Lloyd, B. (1982), *Sex and Gender*, Penguin, UK; Cambridge University Press, US.
Bashkirtseff, M. (1985), *The Journal of Marie Bashkirtseff*, Virago, UK; Salem House, USA.
Beauvoir, S. de (1979), *The Second Sex*, Penguin UK; Random House, US.
Berger, J. (1980), *About Looking*, Writers & Readers, UK; Pantheon, US.
Berger, J. (1980), *The Success and Failure of Picasso*, Writers & Readers, UK; Pantheon, US.
Betterton, R. (1987), *Looking On*, Pandora, UK and US.
Borzello, F. (1982), *The Artist's Model*, Junction Books, UK.
Borzello, F. and Rees, A. (1986), *The New Art History*, Camden Press, UK; Humanities Press, US.
Broude, N. and Garrard, M. (1982), *Feminism and Art History*, Harper & Row, US.
Calvert, G. and Katz, M. (1984), *Pandora's Box*, Rochdale Art Gallery, UK.
Chesler, P. (1978), *About Men*, The Women's Press, UK.
Chicago, J. (1982), *Through the Flower*, The Women's Press, UK; Doubleday, US.
Clark, K. (1956), *The Nude*, John Murray, UK; Princeton University Press, US.
Coward, R. (1984), *Female Desire*, Paladin, UK; Grove, US.
Ecker, G. (1985), *Feminist Aesthetics*, The Women's Press, UK; Beacon Press, US.
Eichenbaum, L. and Orbach, S. (1983), *What do Women Want?*, Fontana, UK; Berkley Publishing, US.
Eisenstein, H. (1984), *Contemporary Feminist Thought*, Unwin Hyman, UK; G.K. Hall, US.
Elias, G. (1977), *The World As We See It*, Camden Council for International Cooperation, UK.
Elwes, C. and Garrard, R. (1980), *About Time*, Institute of Contemporary Arts, UK.
Firestone, S. (1979), *The Dialectic of Sex*, The Women's Press, UK.
Friedan, B. (1983), *The Feminine Mystique*, Penguin, UK; Dell, US.
Fromm, E. (1984), *On Disobedience*, Routledge & Kegan Paul, UK; Harper & Row, US.
Gamman, L. and Marshment, M. (1988), *The Female Gaze*, The Women's Press, UK.
Gerrard, N. (1989), *Into the Mainstream*, Pandora, UK and US.
Greer, G. (1979), *The Obstacle Race*, Secker & Warburg, UK; Farrar, Straus & Giroux, US.
Greer, G. (1984), *Sex and Destiny*, Secker & Warburg, UK; Harper & Row, US.
Griffin, S. (1981), *Pornography and Silence*, The Women's Press, UK; Harper & Row, US.
Harris, A. and Nochin, L. (1976), *Women Artists 1550–1950*, Los Angeles County Museum, US.
Haskell, M., *Women Photograph Men*.
Henley, N. (1977), *Body Politics*, Prentice-Hall, US.

Hess, T. (1973), *Art and Sexual Politics*, Macmillan, UK; Collier, US.
Hudson, L. (1982), *Bodies of Knowledge*, Weidenfeld & Nicolson, UK.
Humm, M. (1986), *Feminist Criticism*, Harvester Press, UK; St Martin, US.
Jeffrey, I. (1989), *La France: Images of Women and Ideas of Nation*, South Ban
 Centre, UK.
Kroker, A. (1988), *Body Invaders*, Macmillan, UK.
Kruger, B. (1983), *We Won't Play Nature to Your Culture*, Institute of
 Contemporary Arts, UK.
Kuhn, A. (1985), *The Power of the Image*, Routledge & Kegan Paul, UK and U!
Lippard, L. (1976), *From the Centre*, E.P. Dutton, US.
Metcalf, A. and Humphries, M. (1985), *The Sexuality of Men*, Pluto Press, UI
 Longwood, US.
Millett, K. (1977), *Sexual Politics*, Methuen, UK and US.
Morgan, E. (1972), *The Descent of Woman*, Souvenir Press, UK.
Muenk, D. (1977), *Kunstlerinnen International 1877-1977*, NGBK, W. German
Nairne, S. (1980), *Women's Images of Men*, Institute of Contemporary Arts, UI
Nunn, P (1986), *Canvassing*, Camden Press, UK.
Oakley, A. (1985), *Sex, Gender and Society*, M.T. Smith.
O'Faolain, J. and Martines, L. (1979), *Not in God's Image*, Virago, UK; Harp
 & Row, US.
Olsen, T. (1980), *Silences*, Pete Smith, US.
Orbach, S. (1978), *Fat is a Feminist Issue*, Paddington Press, UK; Berkley
 Publishing, US.
Panofsky, E. (1955), *Meaning in the Visual Arts*, Penguin, UK; Doubleday, U
Parker, R. (1984), *The Subversive Stitch*, The Women's Press, UK; Salem Hous
 US.
Parker, R. and Pollock, G. (1982), *Old Mistresses*, Pandora, UK and US.
Parker, R. and Pollock, G. (1987), *Framing Feminism*, Pandora, UK and US
Paz, O. (1985), *Labyrinth of Solitude*, Penguin, UK; Grove, US.
Peckham, M. (1971), *Art and Pornography*, Icon, US.
Petersen, K. and Wilson, J. (1978), *Women Artists*, The Women's Press, UK
 Harper & Row, US.
Pollock, G. (1988), *Visions and Differences*, Routledge, UK.
Riencourt, A. de (1983), *Women and Power in History*, Honeyglen, UK.
Robinson, H. (1987), *Visibly Female*, Camden Press, UK.
Rose, J. (1986), *Sexuality in the Field of Vision*, Verso, UK.
Rowbottom, S. *et al.* (1979), *Beyond the Fragments*, Merlin, UK; Alyson Pubs., U
Rubinstein, C. (1982), *American Women Artists*, Avon Books, US.
Sazeau-Boetti, A. 'Negative Capability as Practice in Women's Art', in *Stuo
 International*, 1976.
Smith, J. (1989), *Misogynies*, Faber & Faber, UK.
Sontag, S. (1978), *On Photography*, Allen Lane, UK; Dell, US.
Spender, D. (1982), Man Made Language, Pandora, UK and US.
Spender, D. (1985), *For the Record*, The Women's Press, UK; Salem House, L
Sullivan, C. (1980), *Nude Photography 1850-1980*, Harper & Row, US.
Tickner, L. 'One for Sorrow Two for Mirth', in *Oxford Art Journal*, 1980.
Tickner, L. (1987), *The Spectacle of Women*, Chatto & Windus, UK.
Tocqueville, A. de, *Democracy in America*.
Walters, M. (1980), *The Nude Male*, Paddington, UK.
Whitmont, E. (1983), *Return of the Goddesss*, Routledge, UK.
Williamson, J. (1978), *Decoding Advertisements*, Marion Boyars, UK.
Woolf, V. (1929), *A Room of One's Own*, Hogarth, UK; Harcourt Brace
 Jovanovich, US.
Woolf, V. (1938), *Three Guineas*, Hogarth, UK; Harcourt Brace Jovanovic
 US.

Index